# DRAWING: SEEING AND OBSERVATION

# DRAWING: SEEING

## IAN SIMPSON

VNR VAN NOSTRAND REINHOLD COMPANY
NEW YORK  CINCINNATI  TORONTO  LONDON  MELBOURNE

A & C Black (Publishers) Ltd
35 Bedford Row, London WC1R 4JH

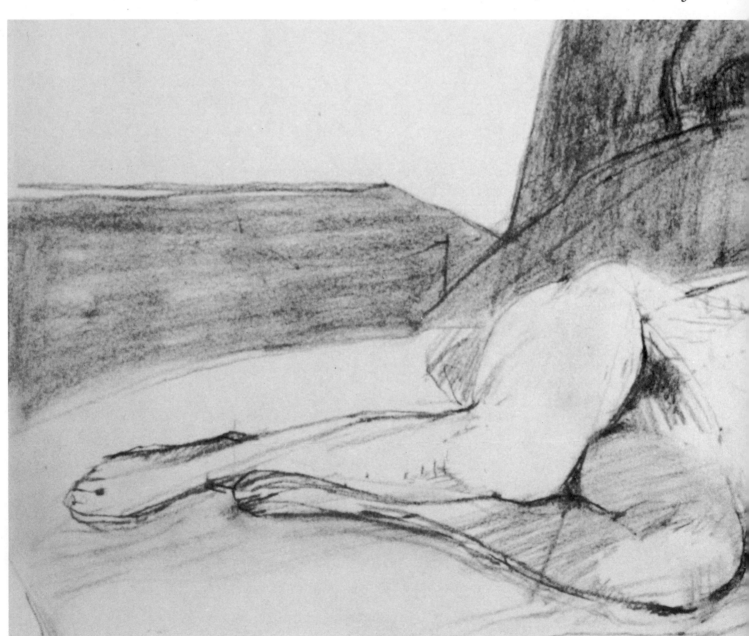

# AND OBSERVATION

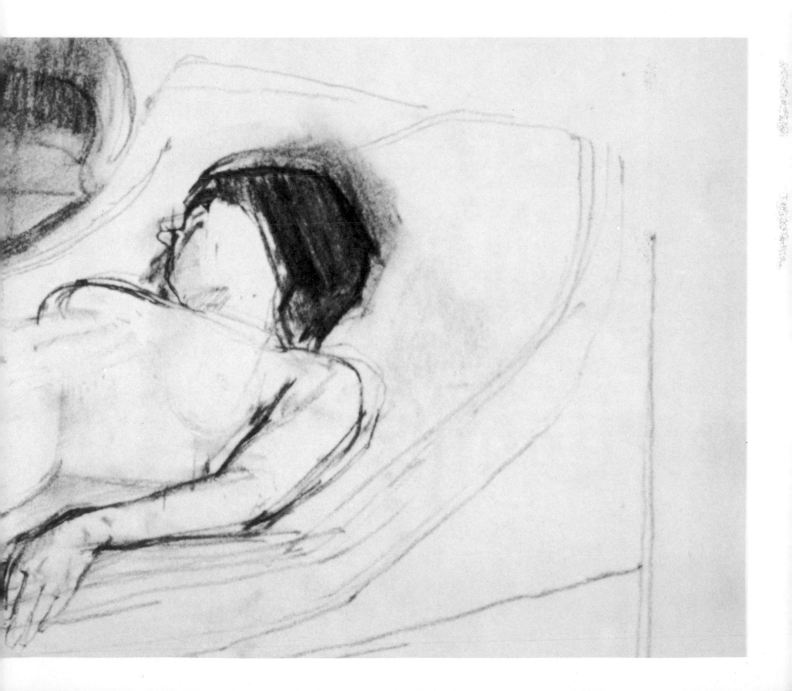

Frontispiece. *Sleeping Nude* (I.S.)

US edition first published in paperback in 1981
Reissued 1982 in the UK by A & C Black
(Publishers) Ltd
Copyright © 1973 by Ian Simpson
Library of Congress Catalog Card Number 77-39808
ISBN 0-442-27220-0 (US)
ISBN 0-7136-2211-3 (UK)
Printed and bound in the United States of America by
Halliday Lithograph, West Hanover, MA.

Van Nostrand Reinhold Company
135 West 50th Street, New York, NY 10020

Van Nostrand Reinhold Ltd.
1410 Birchmount Road, Scarborough, Ontario M1P 2E7

A & C Black (Publishers) Ltd
35 Bedford Row
London WC1R 4JH

US edition first published in cloth 1973 by
Van Nostrand Reinhold Company

16 15 14 13 12 11 10 9 8 7 6 5 4 3 2

# CONTENTS

Fig. 1. *River Medway* (I.S.).

# FOREWORD

This book is an introduction to learning to see and learning to draw. It does not assume much knowledge of drawing, but it is not intended only for beginners as it provides a basic course which is planned in a systematic way so as to allow people with considerable experience of drawing to re-examine the fundamentals. It is also true that little formal teaching of drawing now exists and students learn to draw, if they learn at all, in almost the same way as a person learns to play a musical instrument by ear. In the same way, they learn that while they can achieve a certain facility, their lack of understanding of the basic principles of drawing limits them severely. It would be easy to dismiss learning to see and learning to draw as, in the first case, unnecessary and, in the second, impossible. I intend to show in the following chapters how, although most people can adequately find their way around the world we inhabit, and apparently see very well, they see in general terms and not in the specific way which is necessary for drawing. As for learning to draw, I maintain that it is demonstrably possible, as long as it is seen in the right context. Much has been made in recent years of the distinction between artists and designers. I do not consider that drawing should be restricted to artists only. Drawing has traditionally been done for a purpose and relatively few drawings in the history of art have been intended as an end in themselves. The eventual end product may be produced by the application of an aspect of observation to a functional design just as readily as the application to the non-functional two- and three-dimensional fields of fine art.

This is not just a book for reading. To understand it you must participate in the practical work which is set out in the text from Chapter 1 onwards. It is intended as a guide which can extend an individual's ability to see and draw, or alternatively it can be used by a teacher as the basis for a systematic course in drawing. The illustrations in the book are basically of two kinds. There are drawings by master draughtsmen, and others by myself, by colleagues and by students. These are to illustrate specific points, but are not in any way a substitute for your own attempt to solve the problems posed. There are also photographs of 'situations' set up to illustrate particular points. These are sometimes groups of objects. It is most important that you should appreciate that these photographs are not substitutes for the groups themselves. Drawing in the context of this book is concerned with looking at the three-dimensional world and recording information on a two-dimensional surface. Photographs are only two-dimensional and, as you will see as you progress through the book, it is therefore necessary to examine the actual three-dimensional world if you are really to come to terms with drawing. The photographs of groups should be seen only as guides which will enable you to arrange or otherwise find your own objects for study.

form. It is doubtful whether he can be taught to be a great poet or a great playwright. In the same way this book deals with visual language and demonstrates how the visual world can be analysed and translated into what I have referred to as 'drawing'. It doesn't claim to be able to make you into a great artist. This depends on the use that you make of visual language and this is where aspects of personality come into play. These may be able to be conditioned or they may be the 'artistic gift' that is often referred to; but they are outside the scope of this book.

Paradoxically, to learn to draw you don't primarily have to learn special techniques and develop manual dexterity. You have to learn to see. The ability to see and the ability to draw are closely related but, of course, just as it is generally thought that drawing cannot be taught, so it is held that people can see adequately – after all, we can identify things and we usually manage to find our way around without too many calamities.

## Observation

Let us consider how we see. It would seem that here we are dealing with a perfectly natural function which leaves nothing to be taught – our eyes are like cameras giving us ever-changing pictures as we observe the world. But this is not the whole story by any means. The eye operates, to some extent, like a camera in that it receives images that are not only very small but are turned upside down as well. But how do we see these pictures? In fact we don't. The eyes don't translate objects into pictures in the way that a camera does. The eyes work in conjunction with the brain and send the brain coded information in the form of electrical impulses. This information is arranged in such a way that to the brain it represents the objects. There is no picture (how would the brain see it?), rather the information acts as a substitute for the object in the same way that a word can be a substitute for an object without in any way making a picture of it. Again, I am deliberately citing an example from the communication of verbal language as I intend more and more to demonstrate that drawing is a parallel visual language.

The brain is amazingly adept at decoding the information it receives and informing us about the visual world. It can operate very efficiently from clues in the absence of complete evidence and it can both organize scanty information into objects and also be deluded by information received, so that it comes to the wrong conclusions. Significantly, however, and this is most important in drawing, the brain is always trying to find objects in the information it receives from the eyes and it needs very little stimulus in order to produce them.

A problem that has faced many abstract artists is that while they want to produce work which is removed from the association of objects, this can prove to be almost impossible. If a horizontal line is drawn across a rectangle, we tend to see this as the horizon in a landscape with the lower part of the rectangle a ground plane and the upper part sky. Drawings make great use of this important function of the brain – that given a small piece of information it is capable of building up a large picture for us. I have now used the analogy of verbal language several times in connection with drawing, and of course if we write 'tree' it clearly stands for an object that we could describe in another way in a drawing. 'Tree' means something only to a person who understands our particular language and drawings represent objects only to those who, again, know the particular visual language.

When we are young our seeing, drawing, reading and writing develop alongside each other, but there is particular emphasis in our society on literacy and the ability to comprehend mathematical concepts. As the teaching in these subjects propels us forwards, our ability to communicate in visual terms remains undeveloped until eventually we discard this means of communication, since it compares so unfavourably with our developing abilities in other directions. The cult of 'child art' and the belief that creativity must be allowed to grow unhindered and uncorrupted also play their part in slowing down our visual development.

Let us consider the necessity for teaching people to see. Anyone who has ever attended a drawing class knows that many students will say that they cannot assess directions; they say that they just cannot tell the precise angle at which the side of a table is turned away from them, for example. But they can be taught how to see such an angle. Angles can be measured by comparing the unknown direction with a known one (usually a horizontal or vertical) and although, with experience, this can often be achieved without conscious thought, in the early stages of learning to draw (and see) a plumb-line (i.e. a weight suspended on a string) can be used and angles assessed by using this vertical as a reference. This device has been used by artists for centuries as an aid to the exact assessment of angles.

In mentioning the eye and the brain and, in particular, the brain's ability to decode information, I explained the operation of only a single eye. The two eyes operating together enable us to perceive the depth between objects. This is because when we look at a point in space our two eyes converge on this point and the angle at which they converge indicates to the brain where the particular point is in relation to us. Added to this is the fact that we receive slightly different views from each eye and this disparity

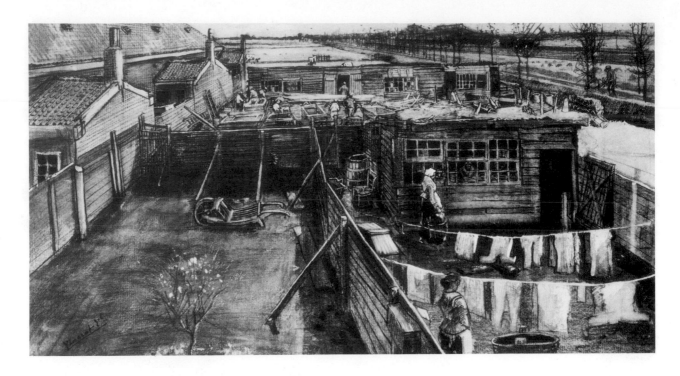

Fig. 3. *Carpenter's Workshop seen from the Artist's Studio Window* by Van Gogh (Kröller Müller Stichting).

again gives the brain information on depth. That we see two views and that our vision is stereoscopic is easily demonstrated. If you look through a window at some verticals outside (say a fence or a tree or the edge of a building) and cover first one eye and then the other, you will see that the objects through the window appear to move in relation to the window frame. The different views from each eye can be clearly observed.

Scientifically, it is possible to present a viewer with the stereo picture reversed – with the right eye receiving the left eye's view and the left eye the right's view. This can, in some cases, cause depth reversal; projections become hollows and so on. It is interesting to note that artists have traditionally viewed their paintings in small mirrors while working on them to check whether in fact the 'new view' of the picture given in the mirror gave the same effects of depth as the 'familiar' view they had while painting.

In drawing we have to make marks on our paper that simulate in some way the effects that the visual world has on our eyes. Much work has been done recently in painting to produce optical illusions of various kinds and many of the pictures deliberately give confusing information which the eyes can see in a variety of ways (fig. 12).

So far I have described seeing as a purely scientific activity with the eyes acting as viewers and the brain decoding the information sent to it in a completely impassive manner. However, we become conditioned to seeing in certain ways, or our brain realizes certain expectations for us, and it is in this aspect of seeing that we have

most to learn as far as drawing is concerned. Just as the child makes important objects large in his pictures, so we refuse to see the true relative sizes of things because we have preconceived ideas about them. In drawing, too, we have preconceived ideas about how things look, often based on other drawings we have seen. Anyone who has attended a life class will know that the drawings tend to be anything but an objective study of the model. They are inclined to be either idealized versions of what the human form might be like, or else compilations of all the studies of the life figure of which the student is aware.

A simple but effective demonstration of our preconceived ideas when looking at objects is described in Gombrich's *Art and Illusion*. If you look at your face in a mirror you always recognize the image as the actual size of your head. However, if you mark the mirror at the points where you see your chin and the top of your head you will make the surprising discovery that the mirror image is in fact only half the actual size of your head. It is not untrue to say that frequently we are unable to believe our eyes.

We have seen that the eye stimulates the brain into perceiving objects. I have also shown that, because the brain is eager to compose the tiniest scraps of information into something meaningful, provided we give it significant information we don't necessarily have to tell it a great deal. The techniques of drawing – lines, dots, textures – can be shown to anyone in a few moments. What is important is the way that these marks are used so as to stimulate the brain into understanding the visual message we want to convey. We have to analyse our vision, that is, to understand what we see. Then we have to extract from all the

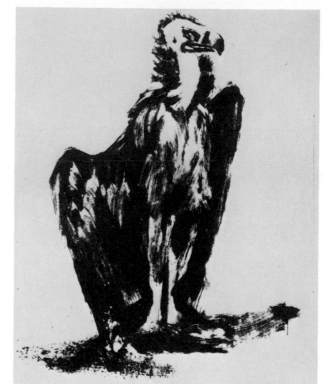

Fig. 4. *Mechanized Forest* by Grace Hertlein. A computer produced picture made with Rapidograph Pens.

Fig. 5. *Vulture* by Harry Baines.

general information in front of us what is significant and particularize from this, so as to produce the right responses in the person viewing our drawing. This important translation of the general to the particular will be dealt with again, at length, later in the book.

I do not want to give the impression that 'art is all science' or that drawing can necessarily be carried out logically step by step to a foreseen conclusion. I make no apology for stressing a thoughtful, analytical approach, but much is inevitably achieved by trial and error and sometimes by plain accident.

## Drawing from Observation

Let us consider for a moment the act of drawing directly from observation. If we look at a landscape there may be a mile in actual distance between us and the furthest point we can see. In this area between the foreground and background there will be various points in space that are significant: the position of a tree or the corner of a field or, perhaps, a building. When we come to draw, however, we have only a flat piece of paper and some device (let's say a pencil in this instance) for making marks on it. The basic problem is that of creating an illusion of depth on a surface that itself has only height and width. There are also, of course, the associated problems of making objects appear to be solid and giving them, at least in some instances, the right textural qualities. Drawing, in the context of this book, excludes

using colour, so if references to colour are made these, too, have somehow to be indicated by the use of monochrome marks on a flat surface.

I have said that the technique of drawing is something that can be quickly demonstrated. The range of marks can be extremely subtle in practised and imaginative hands but basically, even so, it is limited when one is trying to describe the whole range of effects in the visual world. Objects are recorded as symbols that will trigger off the appropriate response in the viewer and one has to search for the particular symbol to produce the precise response.

If we refer back to the map (fig. 2), the information to be passed on is of a general kind; for example, we need only to know that certain areas are wooded, so a generalized symbol for a tree will suffice. In representational drawing, however, it is the particular tree demanding a particular symbol that is required and this calls for keen observation, analysis and precise description. In describing the object, we draw on the visual language at our command. The basic components of this language, which can be taught, are set out in the following chapters, and there are infinite subtle variations. There are, however, many difficulties involved in translating the visual world into symbols, even if we can remove some of our preconceptions. The most obvious problem is that while the drawing media (e.g. pencil, pen, charcoal, conté crayon) most readily make lines (we always associate drawing, automatically, with

Fig. 6. *The Great Dome 1927* by Paul Klee (Paul Klee Foundation, Museum of Fine Arts, Bern © by S.P.A.D.E.M. Paris).

drawing lines) there are few lines in the visual world. If we draw a box on a table, we almost always draw a line at the edges of the box, but we cannot usually see a line. The line describes the point of change where the colour of the box stops and the colour of the table starts, and we show it by translating what we see into something that our drawing tool can easily produce. Because we are familiar with this language, our eye and brain decode the information without any conscious effort.

Of course it is possible to develop an entirely personal language – artists often develop a kind of personal shorthand that rapidly records information for further scrutiny – but unless the language is such that it can be readily assimilated, communication problems will obviously result.

A viewer will often see things in our drawings that we don't intend and, on the other hand, we may fail to communicate information that we believe to be in our drawing. Another significant point, which will be considered later, is that the viewer almost always assumes that our drawing is one view – a study made as if we had our eyes to a peep-hole with restricted ability to move our head about. In practice, when we draw we change our position, move slightly from side to side and up and down, and the information gained from the various positions goes to make the sum total of what is eventually considered as being viewed from one limited, fixed position.

To summarize, the drawing process involves

seeing, in which previous experience of the objects can be both a help and a hindrance; it also demands comprehension and from this an analysis of the particular – that is, what we consider to be significant. The process of translation to paper then occurs and this is assisted by our technical ability and knowledge of visual language; and since much of this is a trial-and-error process, it is monitored by our self-criticism. Finally, the whole process is, to some extent, tempered by our knowledge of the history of art and of drawing in particular. We mentally compare our efforts with what we know to be possible.

Often students will try to explain that although they can see objects, they cannot draw them. They become confused and feel that what is holding them up is some failure of technique. This is the point at which they can become convinced that the whole drawing process is indeed a gift possessed by the very few. Although this is impossible to prove, my experiences indicate that when this situation arises the objects are clearly seen but there has been a failure to analyse and relate the subject; and the knowledge from which the drawing is being attempted is far from complete. Generally, when people say, 'I can see it but I can't draw it', they cannot really see (and thus understand) their subject.

While dealing with this general introduction to drawing and its problems, there is one much discussed aspect that I would like to touch on, that of copying. Frequently one hears drawings referred to as 'just copying', or there are the oft-repeated, drawing-studio strictures on not copying shadows or local colour. Whatever we do, we cannot 'copy' a three-dimensional subject in two dimensions. What can happen is that a rather pointless attempt is made to translate the subject into something resembling a photograph; or, more usually, a rather mindless translation takes place in which the selective process of the use of line to depict where one form ends and another begins alternates with the more direct translation of, say, a dark area in the subject matter into an equivalent dark area in the drawing. 'Copying' is impossible, and if the emphasis is put on observation and translation into drawing, it is irrelevant whether the use of the drawing language is literal or more abstract.

### The Aim of this Book

From Chapter 1 onwards the book sets out a series of drawing problems. These are two-part, that is, they are problems of observation and problems of translation, and I will outline ways in which the problems can be analysed and the information recorded.

The subject matter is designed to be readily obtainable, but the book has one great drawback over, for instance, demonstrating in a studio. I

Fig. 7. A Technical Illustration. Student drawing.

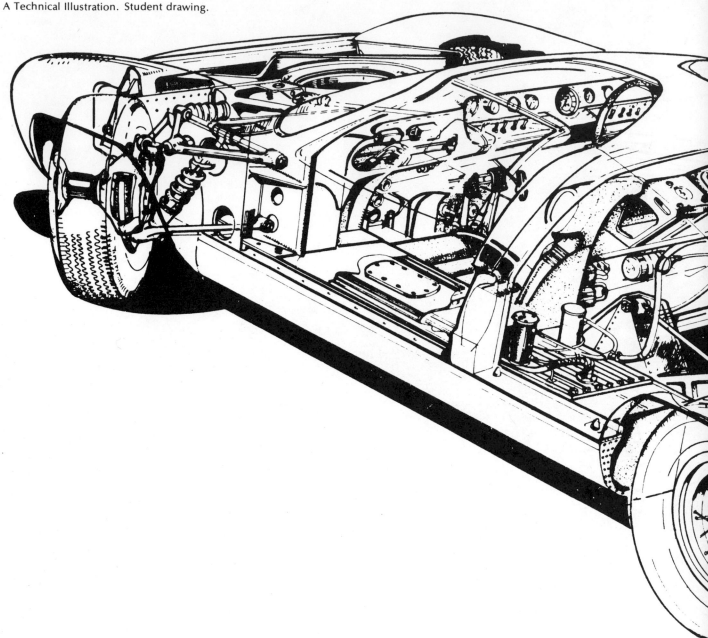

can include photographs of subject matter but these are already two-dimensional recreations of a three-dimensional world ('light drawings', if you like). You are not meant to draw from these photographs. To obtain the maximum degree of understanding from the book, you must set up or find equivalents to the demonstration subjects; one of my intentions is to get you to look at objects similar to those I have chosen and to see if your observations agree with mine.

It is impossible to cover the infinite variety of subjects which you might want to draw: a whole book could be written solely on the topic of the choice of subject matter. In passing, though, I should like to make one observation: some subjects have 'artistic connotations'. First and foremost is the nude figure. Alternatively, some sub-

jects are not generally considered capable of offering artistic possibilities (a view of a suburban semi-detached house, for example). I have already touched on the problem of preconceptions in drawing, and subjects with 'artistic connotations' are loaded with preconceptions. So, to some extent, the drawing problems in this book are deliberately slanted away from such subjects.

I must stress that this book does not aim to teach you how to draw dogs or how to draw landscape. Apart from the above consideration of subject matter with artistic associations, subject matter is not dealt with as a thing in itself. The aim is to explore drawing problems rather than subjects and, to some extent, this can best be done with subject matter which is slightly unusual.

There are a few other general points before

we begin on the practical work. To learn to draw demands accuracy and this means being self-critical. It is easy to convince yourself that something is accurate although you know that it is only approximately right. It is necessary to appreciate that involvement in drawing can come (in fact, invariably does come) from the research or discovery aspect which is part of the whole drawing process. It is often thought that unless you are interested (some would say totally involved) in a subject before you start nothing interesting can come out. Certainly artists have been emotionally involved with their subjects, and this involvement can be clearly understood from their work, but there is nothing to indicate that this is a prerequisite of drawing. The beautiful girl as model does not necessarily produce a

beautiful drawing. In fact involvement and close identification with the subject is potentially as bad as it can be good. It can lead to a deep understanding and thus the ability to translate the objects into drawing. On the other hand, familiarization can lead to the sweeping generalizations and preconceptions that have already been mentioned, because we think we know what is there and don't concentrate on looking.

The practical chapters start with the drawing of simple geometric forms like rectangles and cubes and the understanding of these as the basis of much more complex forms. There are several reasons for starting with basic drawing from geometric forms. Primarily these forms are easily understood and, equally important, they make it easier to view and record with accuracy. If you

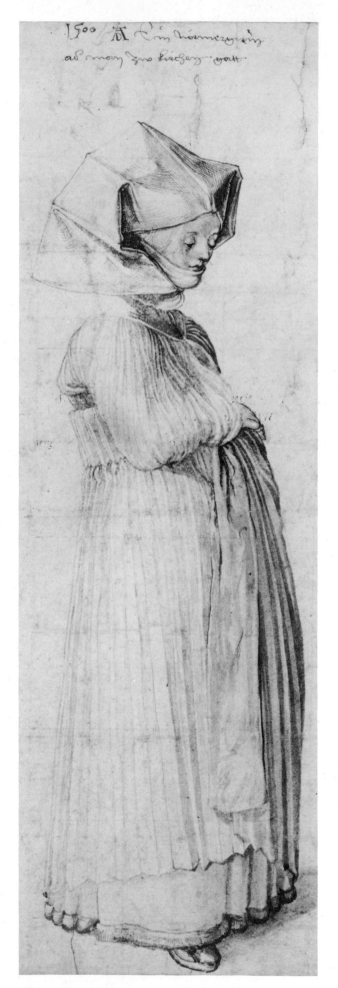

make a drawing of a plant, for example, it is difficult to be very critical about the precise shape of the leaves. It is easy to delude yourself into imagining that you have an accuracy of observation which, in fact, you do not possess. But it is difficult to fool yourself about drawing a square or a cube. You know instantly whether what you have translated to paper is really what you can see in front of you.

**Drawing Materials**

There is a vast amount of information readily obtainable on drawing materials. Basically, you require something that will support your paper, a smooth board of some kind onto which you can pin, tape or clip the drawing surface. The paper should not be too small, say 22 inches by 15 inches at least, and it should be fairly smooth (as opposed to the rough-textured papers sold for watercolour painting) and white. Large drawing books are possible, and a medium-price drawing paper is appropriate. It is a good idea to have an easel or some other means of support for your

Fig. 8. *A Woman of Nuremberg going to Church* by Dürer (Trustees of the British Museum).

Fig. 9. *Studies of Cliffs* (I.S.).

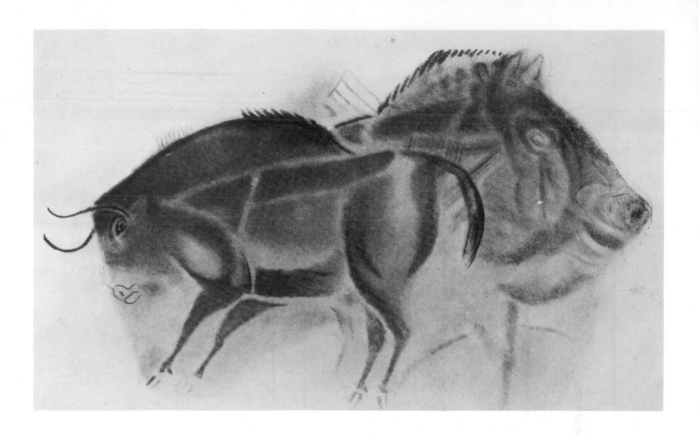

Fig. 10. Altamira Cave Drawing (Mansell Collection, London).

Fig. 11. Child's Drawing.

board or book, as there are great dangers in drawing with a board laid on your knee. Ideally, the drawing surface should be about vertical and at arm's length from you. A great deal of inaccuracy takes place when you have to readjust what you have observed in order to make up for the distorted view of the actual drawing when the board is almost horizontal on your knee.

The usual drawing media – pencil, ink, charcoal, conté – make lines easily and areas of tone less easily. Much the easiest way of making areas of tone is by using a brush and diluted ink or watercolour paint. Pencil is a difficult medium to use. Its range of marks is relatively small and it can lead to a very tentative approach. Often pencil has to be the first medium used by someone learning to draw because it offers a kind of security (through previous use) with which conté or ink are unable to compare. Ultimately, though, anything that will make a mark can be used to draw on any flat surface. Gradually, as you gain experience, you should try different media, and multi-media drawings are well worth exploring. Traditionally, ink for lines and wash for tonal areas have been advocated, but drawings can be developed by means of a wide variety of monochrome media, each offering its own particular properties.

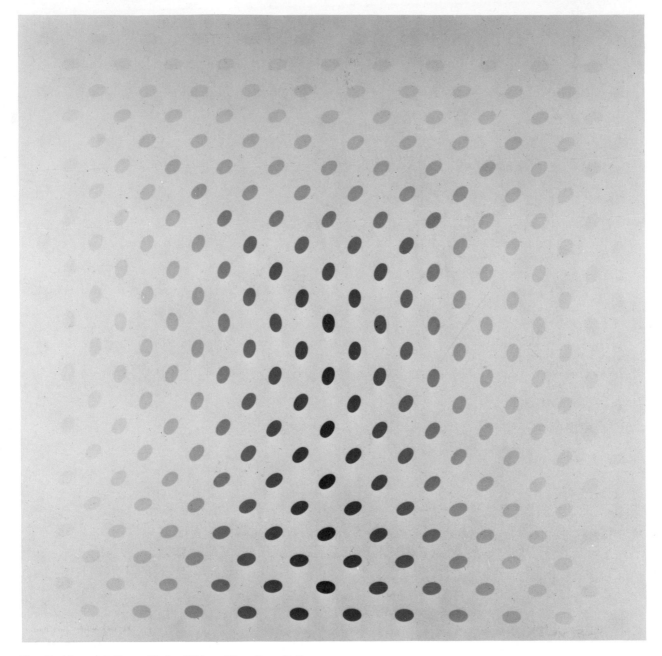

Fig. 12. *Nineteen Greys (iii)* by Bridget Riley (Tate Gallery, London).

Fig. 13. *Seated Woman* by Matisse (Courtauld Institute Galleries, London).

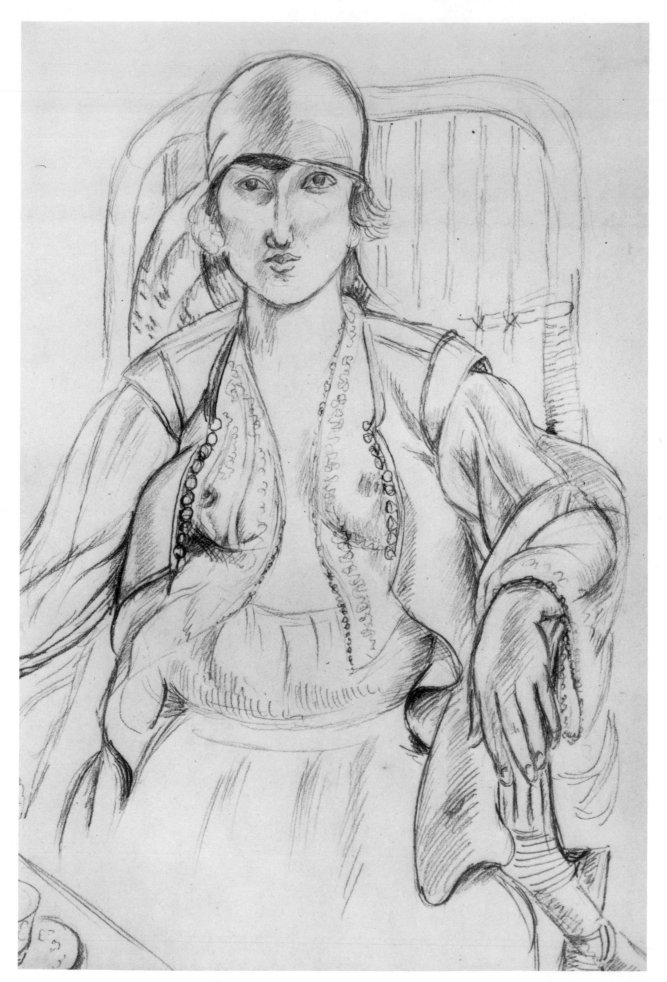

# 1 ASSESSING AND DRAWING TWO DIMENSIONS ~HEIGHT AND WIDTH

from the subject to your drawing. Devices such as this are of little use, for unless your head is fixed in one position and your arm always stretched to exactly the same degree, very large errors can result. The proportions and the precise shape of an object have to be found by relating its parts and the object as a whole to everything round it. The eye is required to scan quickly over the subject and compare and contrast directions, curves, angles and shapes, rather like working on a visual jigsaw. If you concentrate too much on one particular section, there is a tendency to see and draw it in a manner different from the rest of the subject, and one of the first things to learn in the development of observation is that your eye must be kept active. Everything has to be compared, related, taken apart and fitted together again, and the complete subject is analysed and then translated into drawing terms.

The first observation and translation problem involves using limited means to describe a limited aspect of what you see. Look at an object like the jug in fig. 14 placed in front of a curtain in a room. I want you to consider what is the most simple information about this subject you can transfer to a sheet of paper and the easiest method of translating it.

The most basic information is the shape of the jug. Shapes are the easiest elements of the visual world to identify as they involve merely drawing flat patterns on the paper and ignore the complex problems of creating the illusion of depth that I touched on in the introduction. If you are simply going to draw shapes, the easiest way to record the information will be to draw with lines. So in this first practical problem you are immediately involved in many fundamental drawing problems. You are isolating, that is selecting, shapes from all the other information presented to you, and you are consciously translating this information into lines, although lines do not exist in reality at the places where the jug and the background meet. The actual drawing of lines is not going to cause too much trouble, but they have to be positioned accurately. How, then, is it possible to assess the proportions of the jug? You can start by saying that the height is greater than the width, but how much greater? The sides are curved, but how is it possible to assess the curvature? We are now embarking on a series of comparisons – relating the height to the width, relating one curve to another – and the establishment of relationships is one of the first things you have to learn in developing your ability to observe. I have already mentioned one aid to observation, the plumb-line, and sometimes in drawing classes you are told to measure by holding up a pencil and transferring distances measured

Fig. 14.

Of course you have to start somewhere and, as a general rule, it is a good idea to draw something you are sure you can record accurately and then move on from there in the searching way I have described. 'Something you are sure you can record' may be a single direction, and if it is a vertical or a horizontal it can be particularly useful as a reference. If it is a vertical, for example, other near vertical directions can be checked to see just how far they deviate from it. References of this kind are of the utmost importance as aids in establishing the particular curve, direction or shape that exists in front of you.

It is appropriate now to mention the 'I cannot draw a straight line' syndrome. As I have said before, the eye and brain working in conjunction are particularly adept at making something from almost nothing, and providing that the eye is given sufficient clues it can overlook wobbles and hesitancy in lines. In fact these can add a spontaneity and charm to a drawing, rather in the same way

that slight imperfections or oddities in a person's handwriting reveal his personality. This is not something that should be contrived or that one should be conscious of in any way. The point in mentioning it at all is to destroy the idea that somehow one must be able to draw ruler-straight lines in order to be able to draw at all. ('After all, what can I do if I cannot even draw that?' is a question often posed by students.) Drawing ruler-straight lines freehand is extremely difficult. The necessary degree of control can be achieved by practice but it will not necessarily make your drawing any better. If you want precise straight lines, it is much better to use a ruler to draw them.

Another point worth spending a moment on is that of correcting statements when you draw. Generally I consider it unwise to remove sections of the drawing that prove to be inaccurate. It

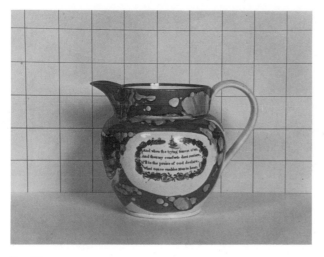

Fig. 15.

is much better to allow your observations and the recording of them to develop, so that a complete record appears on the paper. If you keep restarting a drawing, almost inevitably the same errors will appear each time (after all something made you put down the information in the first place); and at least if you continue to work on the same drawing it is unlikely that you are going to continue to draw over the same lines. You should look on drawing as research: a way of getting to know the subject matter thoroughly, a way of finding out about the visual world. Whether the result is something that makes a frameable picture should be a secondary consideration.

Let us consider fig. 14 again. The vertical folds in the curtains, the book on which the jug stands and the far edge of the table all give references against which you can assess the object. There are two other methods worth examining. It would be possible to take a sheet of glass (or preferably

of transparent plastic) and trace the subject on it with a suitable drawing medium such as a wax crayon or a fine brush with oil or household paint. (If you try this, a small amount of experimenting will be required to discover a convenient drawing medium.) A useful exercise is to make a drawing from direct observation and then a 'tracing' as described above and compare the two. A second method of drawing the jug would be to examine it against a grid which would give precise and regular references, as in fig. 15. This again is an extremely useful way of practising observation and translation, and the habit of scanning the background for useful references should be encouraged, so that when a more usual still-life situation is observed the search for references is almost automatic. It is worth underlining here that in making a drawing of any object, even an isolated one such as you have been considering here, it is important that the background, the foreground and anything possible is searched for information that will be of assistance. The eye approaches the object from every direction and checks what it sees. This is then translated to the paper, but the checking procedure continues and the drawing is constantly being compared with the object.

In these first practical studies objects of any kind can be used. I shall, however, stress again that you must set up groups of objects for yourself. You should not draw from the photographs in the book. Household objects such as teapots or cooking utensils are particularly good but anything of a fairly complex shape with some projections is suitable. The object should be placed against a background that will offer some references, and then your research begins (fig. 16). Remember that the spaces round the objects are as important as the objects themselves and that at this stage you are considering only two dimensions – height and width. Fig. 15 shows that regular grids can be useful drawing aids and it is worth considering extending your studies by using ready-made grids. Objects outside can be seen against fences or brickwork or against the grids formed by the windows and other surface divisions of large modern buildings. Window frames, particularly those divided into small panes, make good drawing grids and objects can be studied in this way by looking out through the window. The windows of greenhouses and conservatories offer exciting possibilities – a foreground of organic shapes seen against the pattern of windows and related to objects in the garden beyond.

Most important, whatever you draw, is that absolute concentration is demanded. And if you feel by now that I have been presenting something as logical and straightforward which in practice you have found extraordinarily difficult, do not be discouraged. Drawing *is* difficult, and accuracy

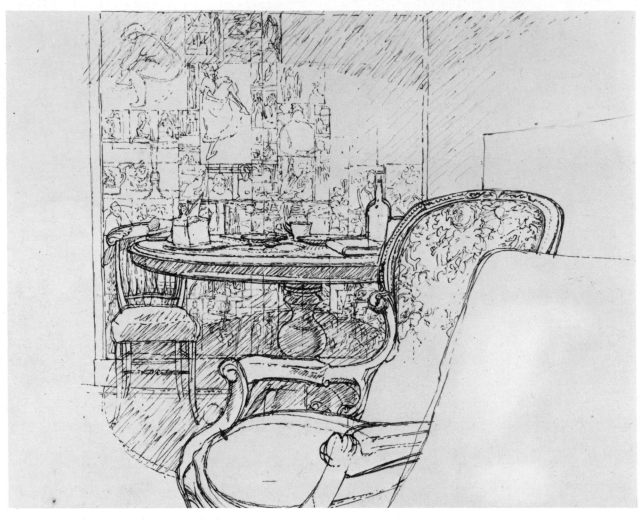

Fig. 16. *View of an Interior* by John Titchell.

Fig. 17. *Female Nude* by Degas (Victoria & Albert Museum, Crown Copyright).

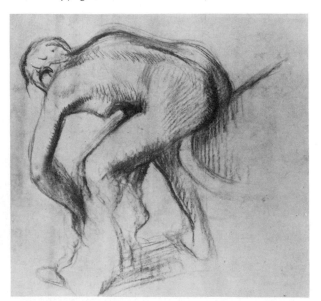

of observation and translation needs practice. For encouragement, however, look at the two drawings in figs. 13 and 17. These are by experienced, mature artists, recognized as geniuses. Notice, though, the search for truth in their drawings; look at the number of attempts Matisse has made at getting the girl's shoulder in exactly the right position. The idea that you sit in front of the object and a line pours out of your pencil, tracing just the right pattern onto the paper, is a myth. Some people have greater facility than others, but it is the quality of the seeing that counts, not some kind of magician-like sleight of hand.

Fig. 18. Memory drawing from Titian's *Laura di Dianti* by G. Bellanger from *Training of the Memory in Art* by Lecoq de Boisbaudran.

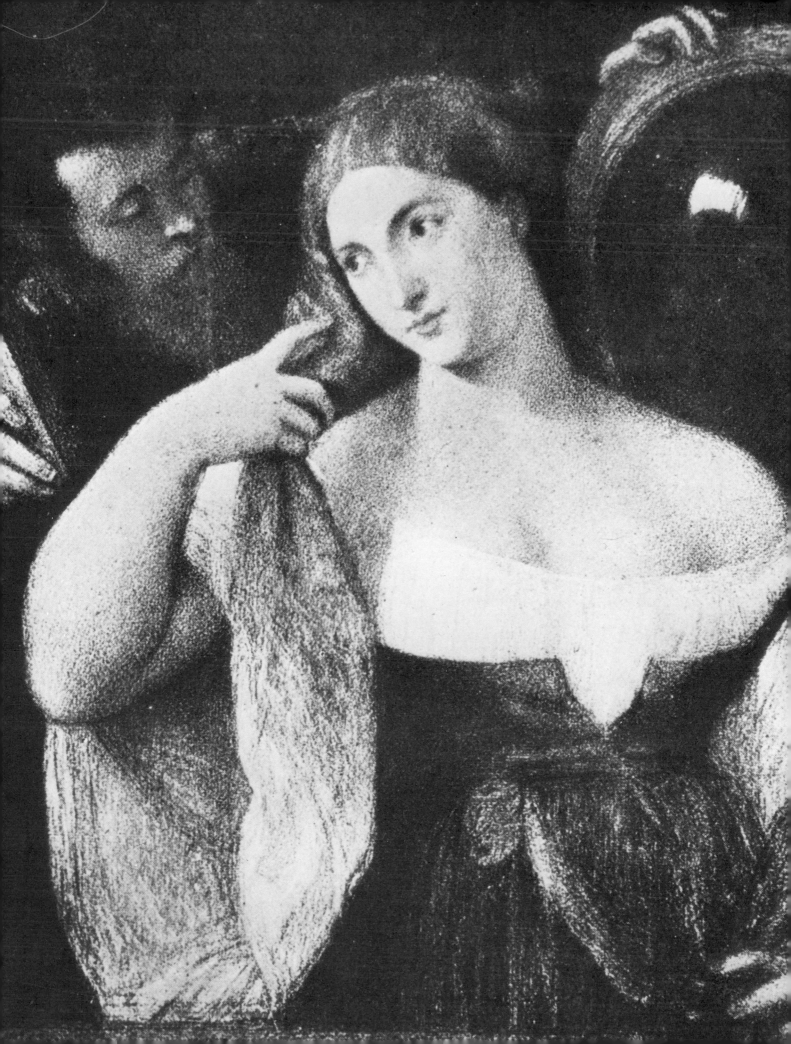

# 2 ASSESSING THREE DIMENSIONS~ HEIGHT WIDTH AND DEPTH

Chapter 1 considered the translation from your observations of only two dimensions, but I have already referred to the fundamental drawing problem as being that of creating the illusion of a third dimension – depth – on the paper, which has only a two-dimensional surface. When someone looks at your drawing he wants to understand where an object lies in relation to the surface of the paper. The paper is sometimes referred to as the 'picture plane' and there are a variety of ways in which the illusion of space can be created both in front of and behind this picture plane. One method is to observe carefully and record where one object overlaps another. If you look at the drawing of a still-life group in front of a patterned wallpaper (fig. 19), you

Fig. 19.

assume that the objects are some distance in front of the wall; you do not imagine that someone has cut the precise shapes of the objects out of the wall and enabled you to see through it. You assume what you normally find to be true in a

similar situation that you have experienced. The same is true of the drawing of the jug in front of the grid (fig. 15). Shown a drawing like this, you immediately assume that the jug is positioned in front of the grid, and if you describe as 'space' the depth between you and objects you can say that it is apparent from the drawing that the jug is positioned 'in space' in front of the grid. Showing overlapping objects in your drawings, however, has limitations, as it is usually difficult to say precisely where the objects are in space; all you can indicate is that one is in front of another, without saying precisely where.

Fig. 20 demonstrates this. It shows a series of rectangular cards set up on a table. As with the demonstrations in Chapter 1, the intention is that you set up this subject yourself. You should take a viewing position from a low point so that you cannot see the surface of the table, and if you make a silhouette drawing in line as was done

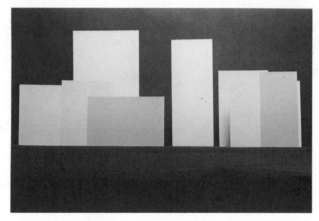

Fig. 20.

with the first drawing problem in Chapter 1, you will produce a drawing similar to the one in fig. 21. Incidentally, you will discover just how difficult it is to draw and relate even a series of rectangles like these and you will also see what I meant when I said that simple geometric shapes do not

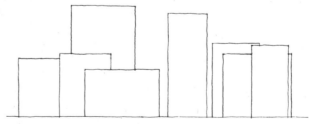

Fig. 21.

offer much in the way of possibilities of self-deception concerning accuracy. From the drawing (fig. 21) we are able to understand that certain rectangles are in front of others, but we cannot say where their precise positions are in space. Notice also

the central isolated rectangle. Where is it placed spatially in relation to the groups of rectangles on its right and left?

The understanding of this drawing depends on accepting that it is improbable that several of the cards have small pieces cut out and that they are all really on the same line in space. In most cases this is a perfectly reasonable assumption

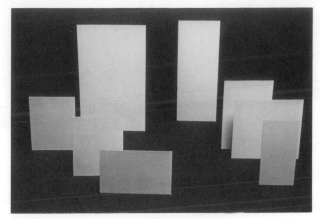

Fig. 24.

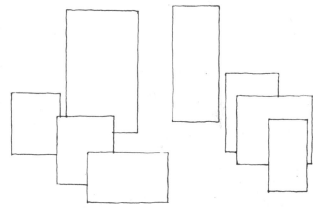

Fig. 25.

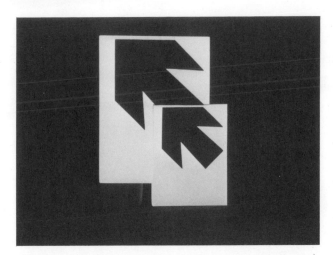

Fig. 22. A view from a predetermined position which makes the smaller card seem nearer.

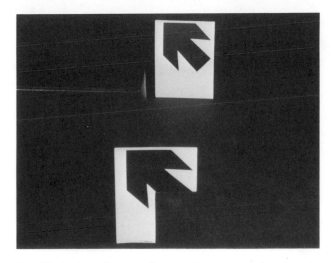

Fig. 23. A view showing the actual positions of the cards.

to make, but now look at figs. 22 and 23. Here our knowledge of what is normal in the world of objects can lead us into difficulties. This is a visual perception experiment and the two identical cards are carefully arranged with pieces cut out of the overlapping one. The result is that when a viewer looks at the cards their places are reversed in space. Thus when we look at things, our brain assembles the information but it does not necessarily arrive at the correct result every time.

In fig. 20 we had a viewing position where we were unable to see the surface on which the cards were standing. Fig. 24 shows the same group seen

from a higher position which reveals exactly where the cards stand on the surface of the table. This information has been translated into a line drawing (fig. 25) and the viewer is clearly given clues as to where the cards are in space or in relation to one another.

You have seen how without real 'space clues' your observation can be inaccurate, so your drawing will not be able to recreate the effects you have observed unless you can give the viewer accurate space clues. If you take a viewpoint that shows no ground plane this gives particular problems, as you have seen, but even in this situation the drawing of overlapping objects is a significant way of giving at least limited information about the third dimension. Fig. 26 shows a drawing making extensive use of overlapping shapes.

If you have carried out drawings based on some of the extended study suggestions in Chapter 1, you will have covered already some of the material dealt with in this chapter. It would be useful, however, to make some further drawings, selecting subject matter with the possibilities for creating an illusion of space by drawing overlapping shapes. So far, the problems I have set have involved drawing silhouettes. Some of the illustrations like fig. 26 on page 26 have, however, shown objects that in themselves occupy space. Before

Fig. 26. Natural form study. Student drawing.

we begin to examine how we can translate three-dimensional forms into drawing, there is one significant observation that should be noted. It is so obvious that it can be overlooked completely, even though the evidence has already appeared in several of the illustrations. You will notice that identical measurements appear to shrink as they are placed farther and farther away in space, and you can see an obvious example of this in fig.

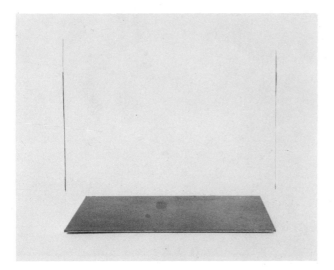

Fig. 27.

27. If you examine a rectangle from a similar viewpoint to that in the photograph the far side looks shorter than the near side, and this is most important in making forms appear solid and in establishing their positions in space when you make drawings.

Before you go on to the next set of practical problems I want to mention the importance of how you set up your board and paper when you start to draw. You may have an easel available or you may be drawing propping up the board on your knees. The aim, however you achieve it, should be to have the board near vertical and at arm's length and you should resist at all costs the more comfortable position possible with the board almost horizontal on your knees. It is most important, too, to take up a viewing position relative to your subject which necessitates the shortest possible movement of the head when you look from the subject to your drawing. It is interesting to look at fig. 18 which shows the standard that it is possible to achieve when drawing from memory. There is a book *Training of the Memory in Art* by the nineteenth-century French artist and teacher Lecoq de Boisbaudran, which shows a system of memory drawing and although pupils may have shown considerable natural ability for drawing previously, this particular ability – to

memorize the most elaborate visual information – was certainly something taught.

Although 'memory drawing' is usually thought of as being the recording of visual information away from the direct reference, in fact all drawing is memory drawing. It is impossible to look at the subject and the drawing at the same time, and even though the visual information only has to be carried in the memory for a short period of time it is quite surprising what a difference can be made by this time occupying a fraction of a second more than is necessary. Sometimes, particularly in a life class, a student will take up a position which necessitates his almost looking over his shoulder to see the model. Consequently a movement of his head from there to his drawing board probably takes more than twice the time that would be required with a direct viewing position. The errors that occur because of this time gap are tremendous. Try it for yourself. Try drawing from a position which means you have to turn your head through at least ninety degrees to get from subject to drawing and see what kind of problem this causes. You will find that in addition to the memory problem it is difficult to transfer information seen looking in one direction, to your drawing, which is viewed in a completely different direction. What should be aimed at is a situation where you can transfer your attention from subject to drawing by only moving the eyes and keeping the head still.

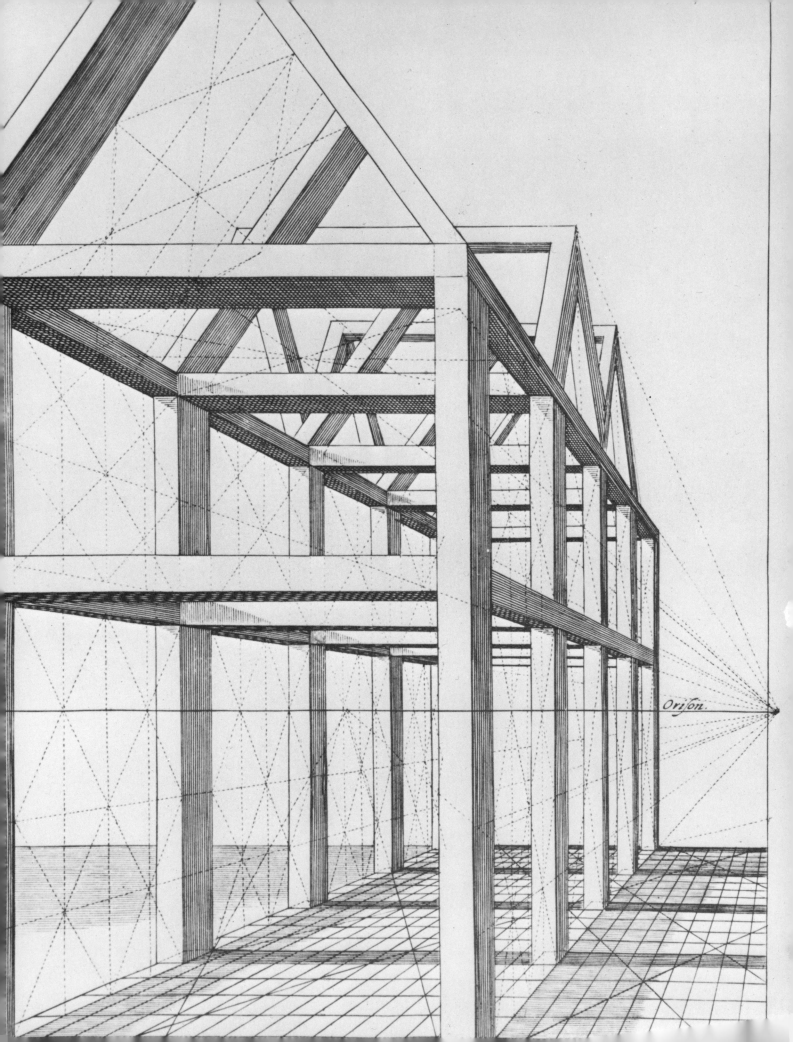

Orifon.

# 3 THE THIRD DIMENSION~ RECTANGLES FLAT~ON

Fig. 29.

I have already pointed out the importance of observing the way in which identical objects appear to get smaller as they recede in space. The first practical work in drawing the third dimension is in relation to the observation and translation of objects which are based on squares and rectangles. I regard simple geometric shapes and forms as extremely important in making the initial steps in observation and drawing. I know that they can seem alien, cold and mathematical elements to those who consider drawing to be, first and foremost, expressive and intuitive, but if you can set these prejudices aside for a moment and revert to the practical analysis and translation of observation, you will understand that geometric shapes (in this case, constructed entirely of straight lines) are easy to comprehend and that when translated it is easy to assess the accuracy of the result. I am careful not to say that they are easy to translate. Drawing is difficult and when you attempt drawings of these simple shapes it can be disconcertingly so. Do not be discouraged; accuracy grows with experience. With very complicated shapes it is possible to fool yourself into thinking that your description of the objects is better than it really is. These geometric shapes will reveal clearly just how good your observation and drawing are.

The previous chapters have been concerned with two-dimensional shapes described by lines. If you hold up a rectangular piece of paper in a vertical position, it appears as a flat rectangle. If you tilt it backwards towards the horizontal the shape of the rectangle appears to change (fig. 29). If you then place this rectangle so that it

lies horizontally its shape appears to change completely. Varying the height of the horizontal rectangle from the ground gives different views (figs. 30–3). These various views describe the depth (third dimension) of the rectangle. You can see that the angles at the corners of the rectangle

Fig. 30.

Fig. 31.

Fig. 28. Illustration from *Perspective* by Jan Vredeman de Vries (Dover Publications).

29

Fig. 32.

appear to change, as does the distance from front to back depending on the rectangle's position. Ultimately, it can be drawn as just a straight line when it is seen at a certain height in the horizontal position (fig. 34).

It is interesting to speculate why you see these shapes as actually being rectangles in three-dimensional space. They could, in fact, be objects of different size and shape seen in a vertical plane. In the absence of further clues, however, your brain generally deduces that shapes like these are views of rectangles.

We have considered the rectangle by looking at it at various heights; now put it on the floor some distance away from you and still looking

Fig. 33.

Fig. 35.

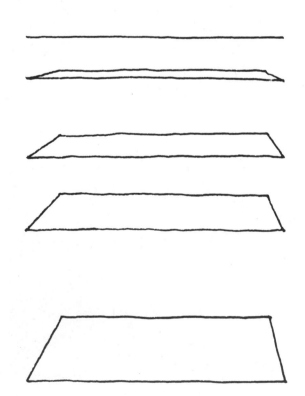

Fig. 34.

at it 'flat-on' (i.e. with one side straight in front of you), consider how the shape of the rectangle appears to change as you move it from left to right across the floor in relation to your viewing position (fig. 35).

Now that you have moved into considering three dimensions, you can approach solid objects. An enormous amount of the visual world is based on box-like structures (buildings, for example) and, of course, boxes are based on rectangles. You can now add various analytical constructive skills to your observation of rectangles. Just as you can find the centre of a rectangle by drawing its diagonals, so you can do the same in the kind of illusionary drawing we are considering, and by analysing the relationship of one rectangle to another and assessing where points are positioned in space in relation to these rectangles you can construct a drawing as in fig. 36. Figs. 37–8 show drawings based on observation of the relationships of rectangles seen flat-on.

The extended study of rectangles is limitless. Piles of books can offer interesting problems. A particularly good subject is a chest of drawers with one or two drawers pulled partly open. Other groups of objects can be produced from various

Fig. 36.

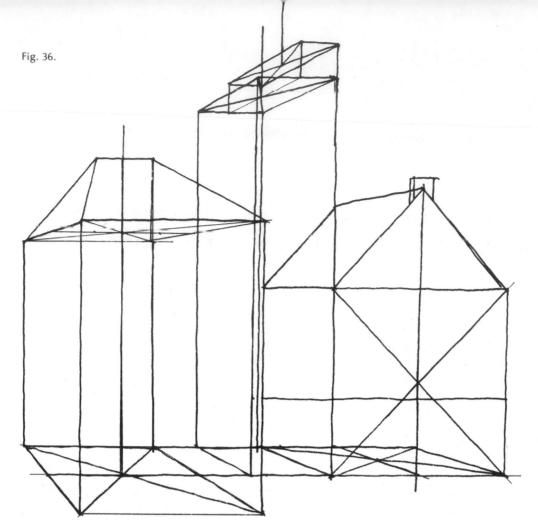

Fig. 37. *Roofs, Chatham* (I.S.).

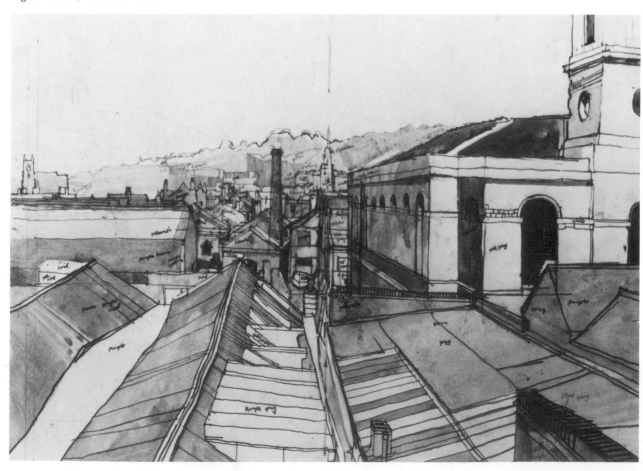

Fig. 38. *The Corn Exchange* by Alfred Daniels.

cardboard boxes, and outdoors there are crates and boxes piled up in yards or markets, or perhaps at a greengrocer's. There are also buildings, with doors, windows and flights of steps offering their own particular problems. Remember that at this stage you should choose an angle which gives a full view of one side of the rectilinear object. It is also well worth considering the medium which is to be used. All the practical work so far has been in line, but the materials section indicated a variety of suitable media and it is a good idea to experiment now with ink, for instance, or the use of a fibre-tipped pen.

The 'constructional' illustration (fig. 36) shows a building as if it were transparent. Obviously you cannot see through most buildings, but in making drawings the constructional element is important, and it is often necessary to consider what it is impossible actually to see, but which you know exists. Frequently this means that you have to gain a thorough knowledge of the appearance of the objects you are drawing by looking at them from every possible point of view, not just the one from which you are drawing. In mak--

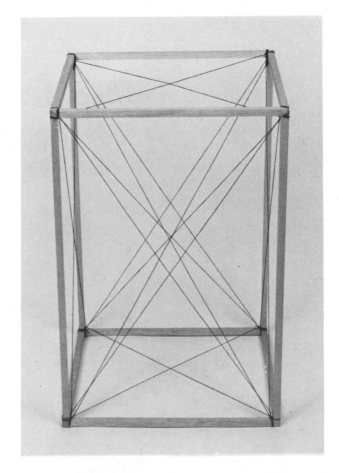

Fig. 39.

Fig. 40. *Dockyard Catwalks* (I.S.).

32

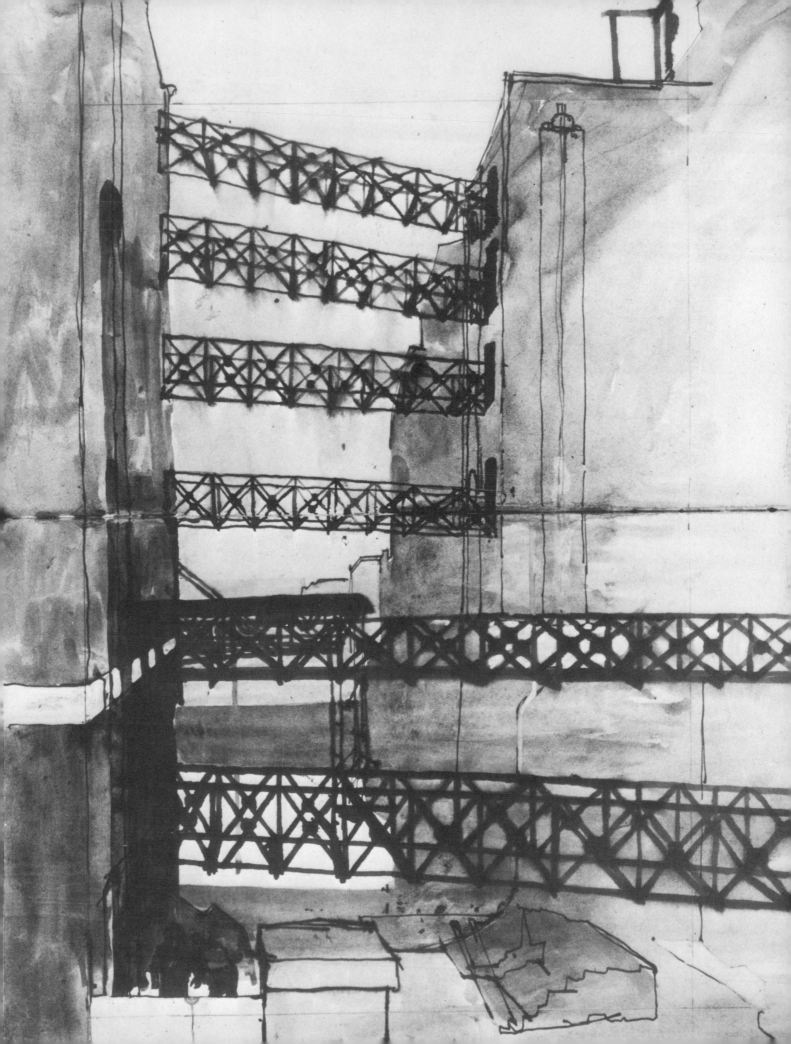

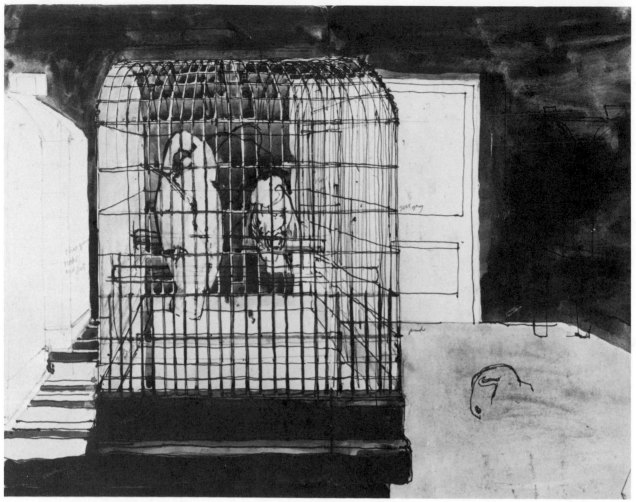

Fig. 41. *The Bird Cage* (I.S.).

Fig. 42. *Industrial Drawing* (I.S.).

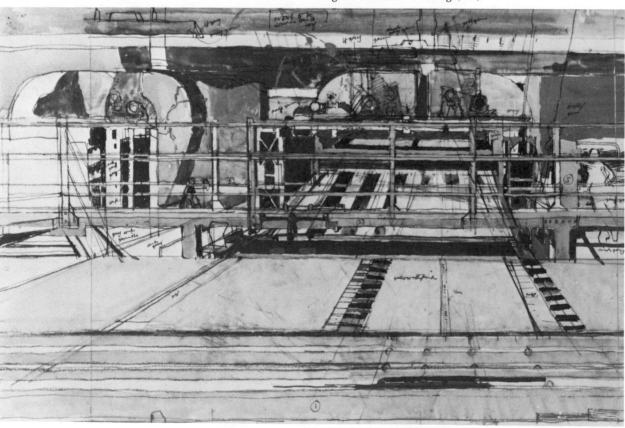

ing drawings of buildings, for example, some rapid drawings from different points of view and a plan (i.e. the shape of the building on the ground) can be useful in helping to establish exactly what you can see and understand from the viewpoint taken for the sustained drawing.

Another helpful aid to developing the ability to see and understand the problems of the linear representations of rectangles and three-dimensional space is a 'space frame'. A simple, table-standing frame can be made from balsa wood with thread used for stringing (fig. 39). A rectangular frame of this kind can pose fantastic problems. It is, in effect, a transparent, rectangular solid which clearly reveals where each string or section of framework lies in space. As you join up the relevant points in your drawing you can check these against the angles formed by the same elements in the actual object. A word of warning: this drawing exercise is extremely difficult because it can clearly show limitations in both observation and recording accuracy. Aim for as accurate a statement as possible and do not be discouraged by error or even complete failure.

There are some fascinating extensions of study possible in the form of ready-made space frames, such as children's climbing frames, scaffolding on building sites, cranes, bird cages and all kinds of devices used in gardens for stringing up plants (figs. 40–2). These are just a few examples of subject matter which pose this drawing problem, and you should extend this list from your own

Fig. 43.                                  Fig. 44.

experience. Remember that you are still considering rectangles 'flat-on' and using line only as your medium of translation.

Let me underline the translation element again by pointing out something about observing rectangles. You have already established that identical measurements appear to shrink as they are positioned farther and farther away from you. If you stand and look at a box as in fig. 43, the top of the box would be translated into drawing as fig. 44. The side of the box, however, is at a similar angle to you as the top and should be represented in a similar way (fig. 45). This, however, produces a drawing which gives the illusion not of a rectangular-sided box but of a box with tapering sides, and it is usually necessary (in the absence of other visual clues) to make vertical directions in reality into vertical lines in drawing. Here is an instance where in your translation you have to disregard something you have observed in order to create an illusion that is comprehensible. It is important constantly to check the information you are putting down so as to determine whether it is creating the illusion you want to convey. This also shows that while on the one hand drawing has an aspect which is logical, controllable, even mathematical, on the other hand, there is an aspect that is without rules and is dependent to some extent on trial and error.

Fig. 45.

35

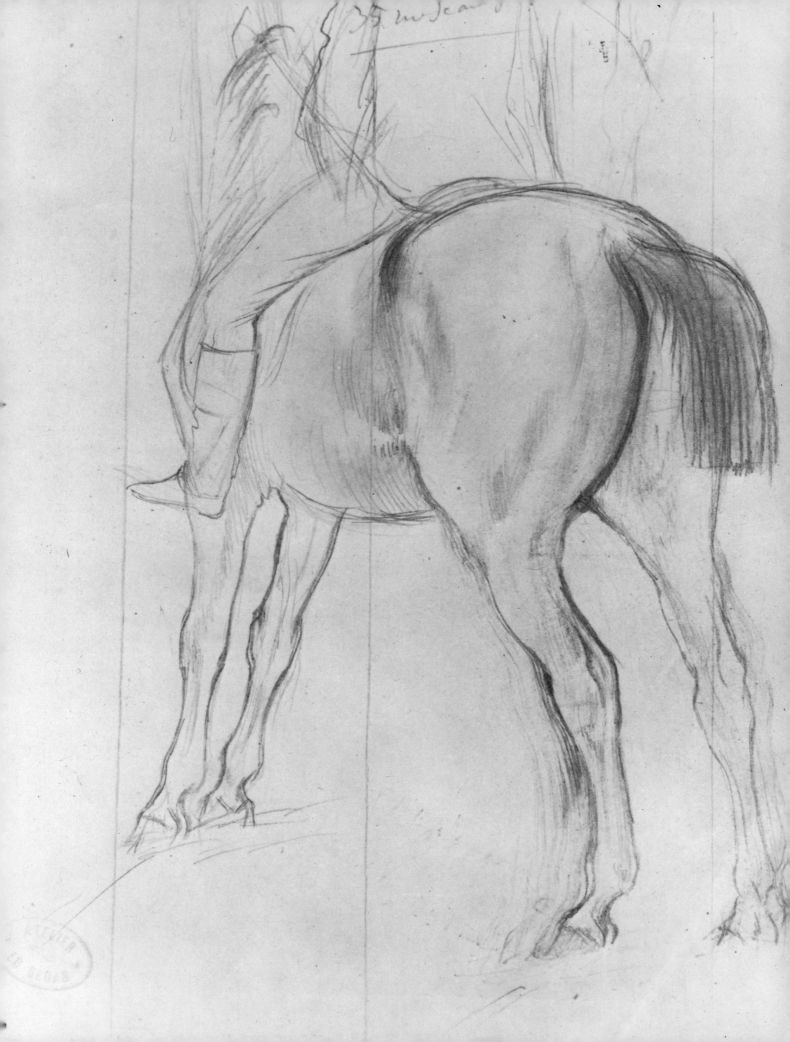

# 4 RECTILINEAR FORMS FROM DIFFERENT VIEWPOINTS

In the last chapter, the viewpoint of rectangles and three-dimensional objects made from them (rectilinear forms) was limited to one in which the rectangular surfaces were seen with one side 'flat-on'. Let us now examine what happens when alternative views are offered by looking directly at one corner of the rectangular surfaces rather than one side. For these initial observations the rectangular sheets of paper and the space frame are used again. In the previous drawings of rectilinear objects you had the security of a series of horizontal lines (the 'flat-on' sides of the rectangles) and against these you could observe the corner angles. Now all the sides of the rectangles are running away from you at varying angles (figs. 47–8) and the problem is to be able to assess these angles accurately and record them. As with the previous drawing problems, you must relate things which are relatively difficult to assess (in this instance directions) to things easily assessible. With the 'flat-on' rectangles, the horizontal directions could be drawn easily and made excellent visual measuring lines. With the corner-on view of the space frame, the verticals can be used as visual measuring lines and these can be supplemented by any available background information.

Assessing angles and the relative sizes of objects poses a problem which artists have often attempted to solve in the past by using drawing aids of various kinds (figs. 49–50). The viewing screen that Dürer used is of limited use in my opinion (though worth experimenting with) as it really requires the position of the viewer's head to be fixed, which is not easy to arrange. A plumbline, on the other hand, is extremely useful, and

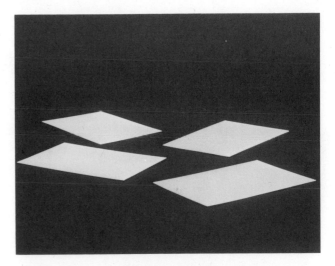

Fig. 47.

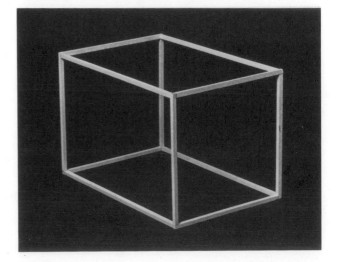

Fig. 48.

Fig. 46. *Back View of a Horse with Rider* by Degas (Collection of Mr. and Mrs. Eliot Hodgkin).

the often encouraged practice of trying to hold a pencil up vertically for use as a reference is a very poor and inaccurate alternative.

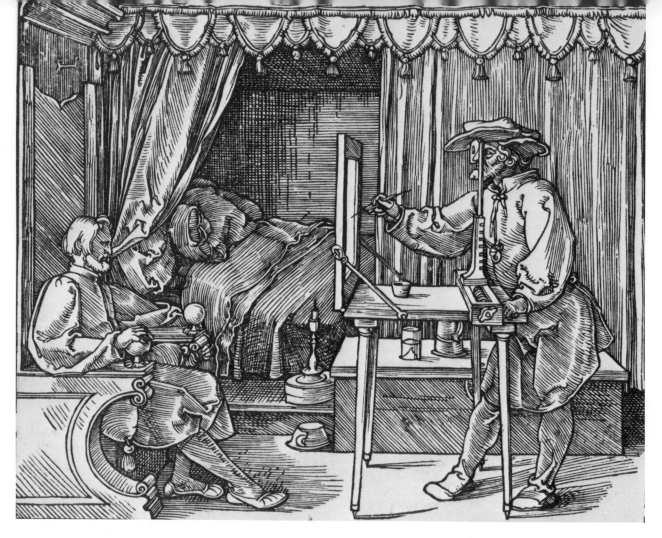

Fig. 49. *An Artist Drawing a Man* by Dürer (Trustees of the British Museum).

The subjects suggested in the previous chapter are all relevant again with the difference that the viewpoint is changed from 'flat-on' to 'corner-on'. The chest of drawers offers excellent problems, particularly in relation to the construction of the drawing, and it can be a help that it is an extremely familiar and predictable object.

If you choose subject matter outdoors for study, it will often be difficult to find objects based on rectangles and isolated from other kinds of objects which may be basically cylindrical or perhaps free forms such as carts, trees and so on. At this stage you should try to extract from the visual world the objects based on rectangles and leave out the others.

As you are now building up experience of both seeing, analysing and translating into drawing, your range of suggested subject matter is increasing, and from the drawings illustrated you can see that corner-on and flat-on views of rectilinear objects offer a wide variety of opportunity (figs. 51–4).

Fig. 50. *Standing Nude* (I.S.). A vertical line drawn from the neck shows where a plumb-line was used to check the position of the figure's left leg.

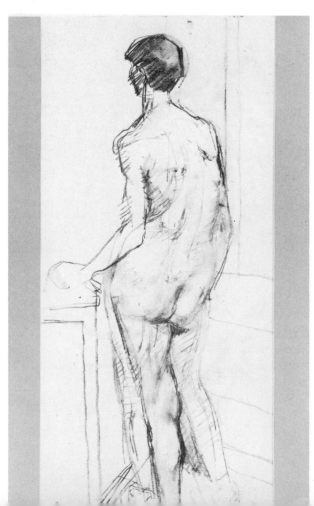

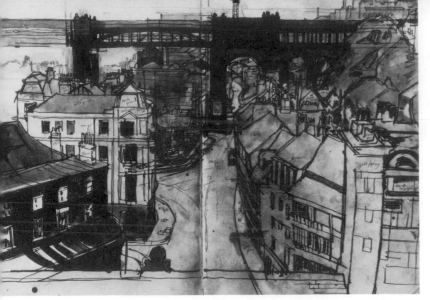

Fig. 51. *Buildings and Bridge, Newcastle* (I.S.).

So far in suggesting practical work I have stressed drawing problems and these have been considered irrespective of the nature of the subject matter. Obviously, however, you will have preferences in subject matter. Certain specific objects or visual phenomena can intrigue an artist the whole of his life (figs. 55–6), and the subject matter and the particular viewpoint taken form part of the selection procedures which serve to assist in expressing an artist's individuality. I will

Fig. 52. *Interior of St. Mark's, Venice* by Canaletto (Victoria and Albert Museum, Crown Copyright).

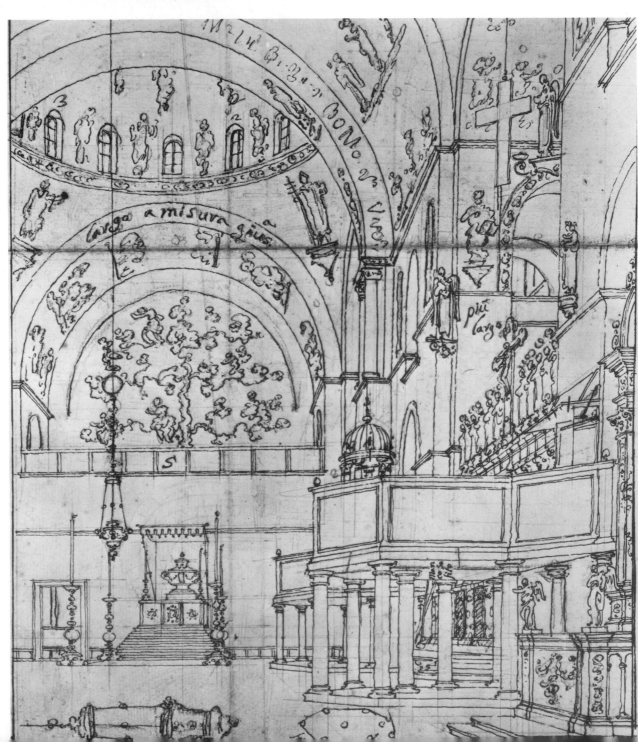

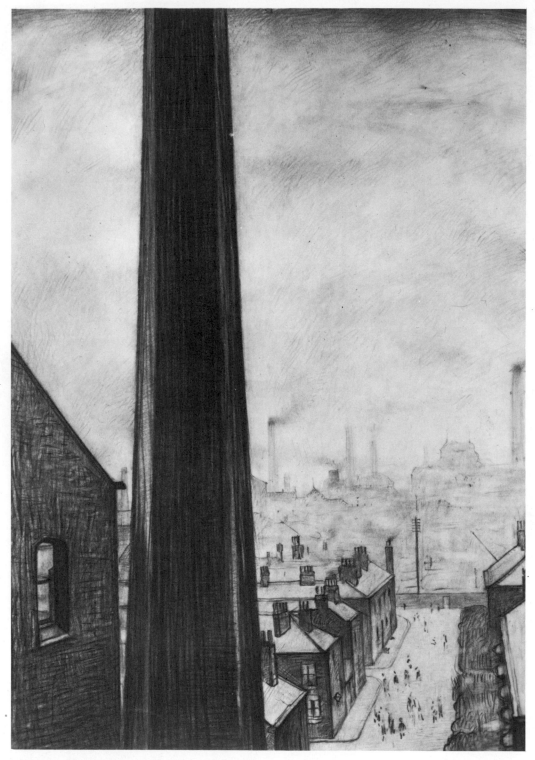

Fig. 53. *View from Window of Royal Technical College, Salford*
by L. S. Lowry (City of Salford Art Gallery).

return to this later. If you have already developed strong interests in subject matter, then pursue them without losing sight of the drawing problem. Running side by side with your developing visual awareness should be an added awareness of the possibilities of various media. So far you have only considered drawing in line, but now give an extended try-out to each medium possible and

particularly to those like ink or a fibre-tipped pen that commit you to taking a positive decision. Even if you use a medium which can be erased, resist the temptation to rub out. There are no prizes for neatness. The problem is one of seeing and translating and the number of attempts required to reach an accurate solution is irrelevant (figs. 57–8).

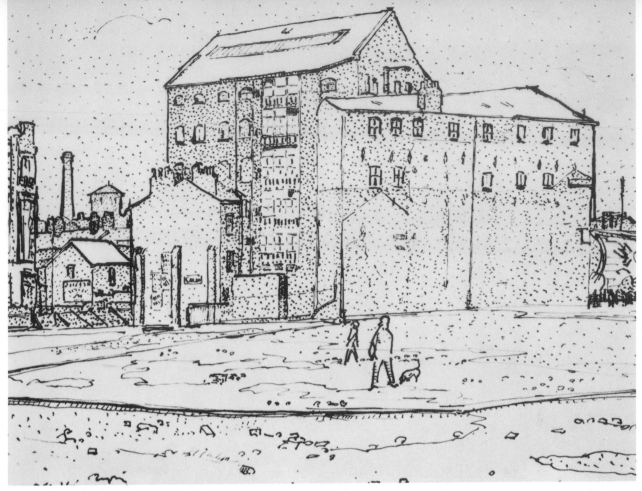

Fig. 54. *The Factories, Leeds* by Harold Gilman (Victoria and Albert Museum, Crown Copyright).

Fig. 55. *Still Life* by Morandi.

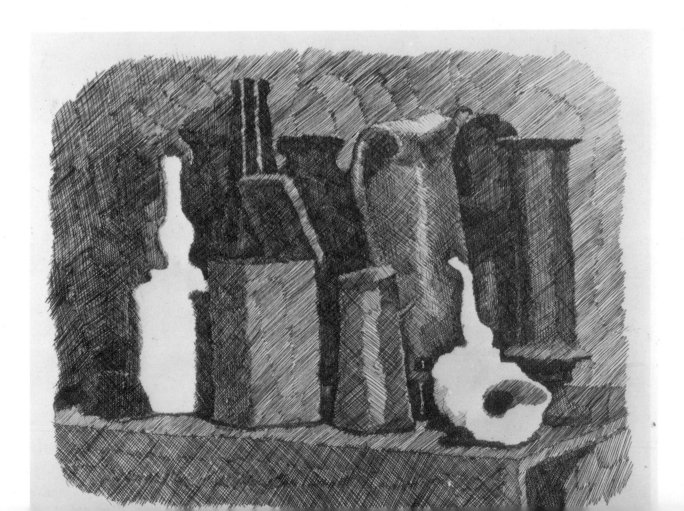

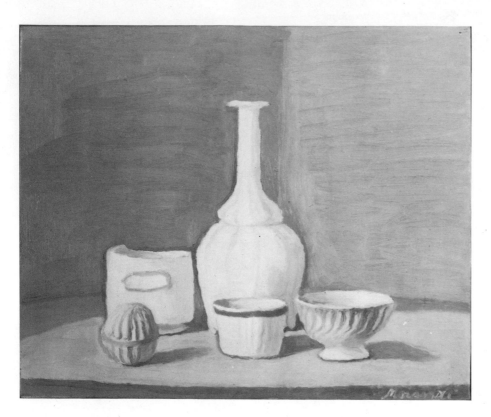

Fig. 56. *Still Life* by Morandi (Tate Gallery, London). The subject of groups of simple, domestic objects in drawings, etchings and paintings is one that is used continuously in Morandi's work.

Fig. 59. *View Down a Hill*. Student drawing.

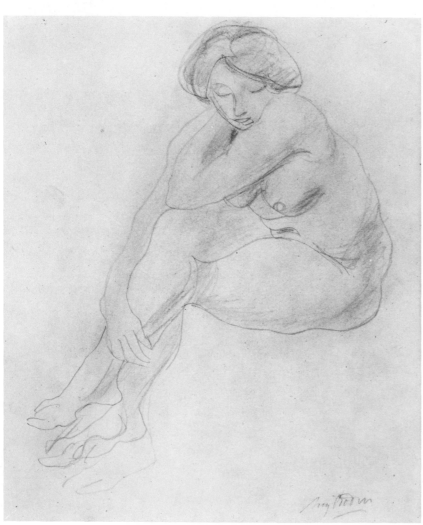

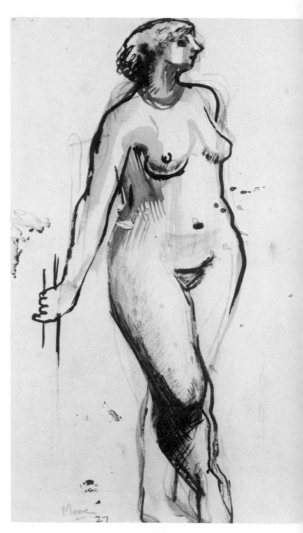

Fig. 57. *Seated Nude* by Rodin (Courtauld Institute Galleries, London).

Fig. 58. *Standing Figure* by Henry Moore (Tate Gallery, London).

# 5 RECTANGLES AND GRADIENTS

ground plane. Make a study group by positioning some rectangular pieces of card so that some are on the flat ground plane and others are at

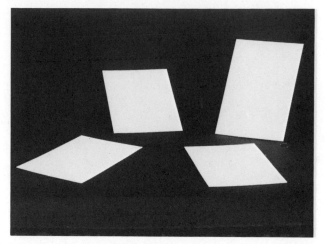

Fig. 62.

So far, in considering rectangles and rectilinear forms there has been a flat ground plane on which the objects have rested. Figs. 60 and 61 show the rectangles and space frame raised at one end so that they are at an angle to the

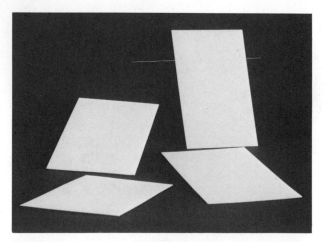

Fig. 60.

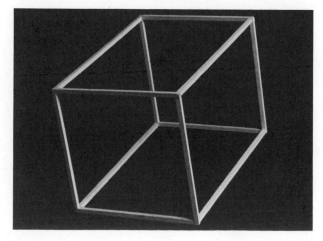

Fig. 61.

an angle to it (fig. 62). Then make line drawings of these rectangles so that the different gradients are clearly shown. We have already, to some extent, examined this problem in the two previous chapters, as drawing different views of vertical faces of boxes or the vertical sides of the space frame is similar to drawing views of rectangles which are at an angle to a horizontal ground plane. The solution to the problem lies in the accurate assessment of directions and angles. I am bringing your attention particularly to gradients because in the visual world few ground planes are flat and perfectly horizontal and it is important to examine the principles which underlie, for example, making drawings of buildings on hills (fig. 59). Notice that when a surface is tilted up towards you, you see more of it. When it is tilted downwards away from you, you see less (fig. 63).

Extend this study either by having a group of boxes (or similar rectangular-based objects) piled up so that some are at an angle to the ground

Fig. 63.

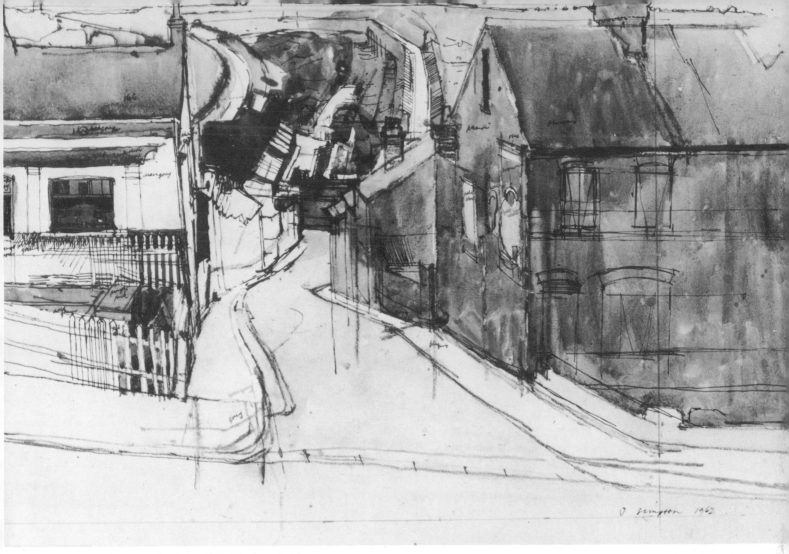

Fig. 64. *The Steep Hill, Chatham* (I.S.).

or by finding an outdoor situation that poses a similar problem. Roads going up or down hills are excellent examples (figs. 64–5). In making these drawings consider how much of the impression of gradient is conveyed by the contrast of

Fig. 65. *Buildings on Hills* (I.S.).

one direction with another which is assumed by the viewer to be horizontal. For example, windows and doors in buildings have horizontal and vertical sides. If you have a building in your drawing, there are automatically strong indications of horizontal directions and thus something with which to compare the gradients.

Barnes

# 6 CIRCLES CYLINDERS AND CONES

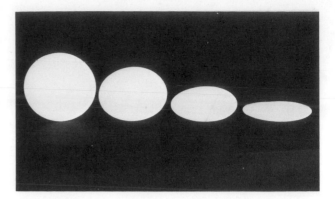

Fig. 68.

The study of rectangles has so far involved considering objects drawn solely in straight lines. The next problems involve the drawing of curves and, again, initially we will examine simple, regular, predictable curves forming circles and cylindrical forms. When you drew horizontally positioned rectangles from a point looking full on to one of their sides, you discovered that this side preserved its full width but the depth of the rectangle was optically reduced. A similar effect can be observed when you examine circles (fig. 67). If you take a circle cut from cardboard

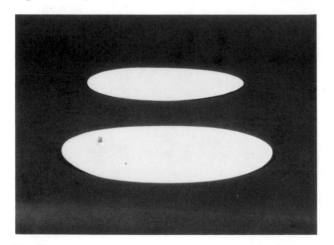

Fig. 67.

or some ready-made equivalent and position it so that the circle is shown first in its entirety and then gradually tilted backwards, you see a series of ovals (or ellipses) getting narrower and narrower until the circle could be represented by a single line. Providing that the object being drawn is a perfect circle, the ellipses will be symmetrical (fig. 68).

Fig. 66. *Seated Nude* by Harry Baines.

Drawing curves demands a good deal of practice and control. It is extremely difficult to achieve the symmetry of the ellipses, and there is often a tendency to make them rather 'pointed'. Remember that you are drawing a view of a shape which is a continuous regular curve. It is necessary to spend a good deal of time working at drawing curves and there is a great possibility that because of the actual practical difficulty in drawing the ellipses, the problem of assessing the precise depth of them will be forgotten. Practise drawing ellipses of various widths and depths, and use any means you can think of (measuring, tracing, etc.) to achieve perfectly symmetrical shapes.

The next step is to make drawings of cylinders, the solid forms derived from circles. You can use cylindrical tin cans for objects and you should first compare a cylinder (standing on its end) with a rectilinear solid. From a viewpoint above the objects (fig. 69), they will both appear to have bases with a larger area than their tops. Often in teaching drawing these facts are told to students as rules, but the student never really grasps that this is not some rule of drawing but a clearly observable fact. It is most important that points such as this are actually seen and understood from your own direct observation and not just accepted as being facts.

Fig. 69.

Just as with rectangles, a cylindrical space frame is extremely useful in understanding circles and cylinders. Perfectly cylindrical glass objects are available (fig. 70), some in domestic and some

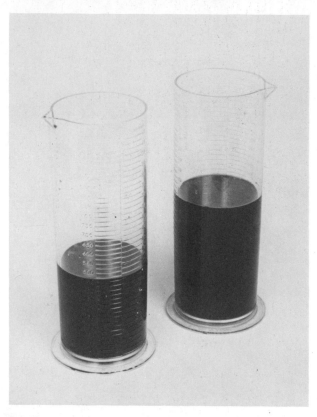

Fig. 70.

in laboratory use. A wire space frame can be constructed but it will involve using metal and is more difficult to make than the balsa-wood space frame in Chapter 3 (fig. 71).

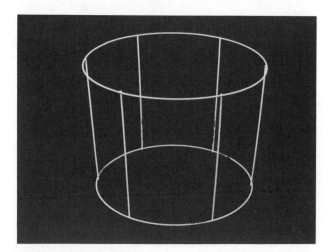

Fig. 71.

I have already touched on an important point in the translation of objects to drawing, but I wonder whether it has occurred to you. Your drawings so far have used line only and with the drawing of rectilinear objects these lines have been a translation of edges (remember you cannot

usually see lines when you look at the objects). In drawing cylinders, however, when you put vertical lines for the straight sides of the cylinders these lines are not describing edges; they are describing the point in space at which a constantly curving surface disappears from view. The sides of cylinders have no edges and this use of line to describe completely different visual appearances further underlines the translation aspect of drawing. Not only must you translate what you see, but you have limited means with which to work and sometimes a line describes a sharp change of direction and at other times a smooth gradual change. Whether it means one or the other in your drawing depends on the supporting information you are able to supply.

If you consider for a moment you will realize that so far we have only thought of simple translations from observation of edges or regular curves into line. But supposing you want to draw the arm of a figure, for instance, where, although basically a cylinder, it has particularly subtle variations in its form from one section to another. These subtleties can still be translated by line through the kind of linear variations shown in figs. 72–4. This descriptive ability comes largely from experience and practice but it makes use

Fig. 72. *Female Nude, Back View* by Gaudier-Brzeska (Tate Gallery, London).

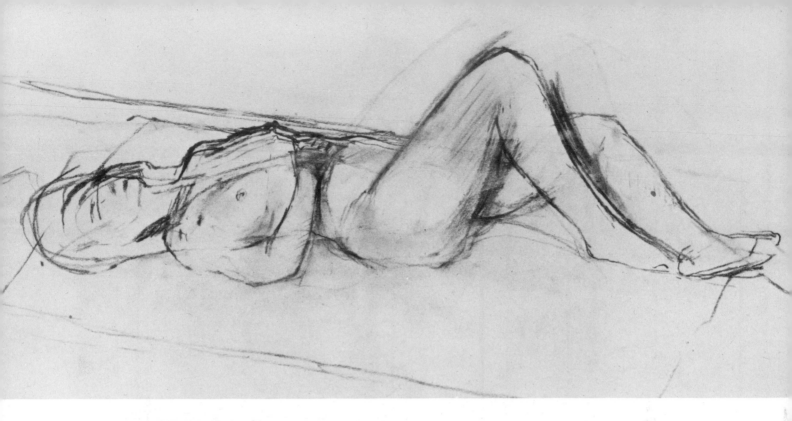

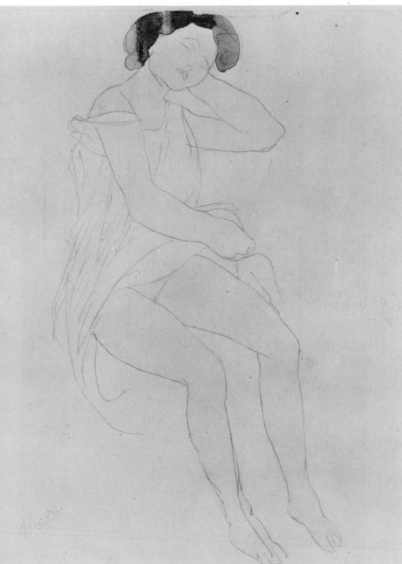

Fig. 73. *Reclining Nude* (I.S.).

Fig. 74. *Seated Woman* by Rodin (University of Glasgow, Hunterian Museum, McCallum Collection).

of the fundamental qualities of line you have been exploring up to this point. I will be returning to these qualities again in later chapters.

Ellipses are extremely difficult to draw and though you may have grasped the principle of the way in which the appearance of a circle changes from different viewpoints, it can be difficult to achieve the necessary control and critical observation of your drawing to produce the required symmetrically curved shape. It is possible to construct ellipses geometrically, but the application of this fact is more in the realms of technical or geometrical drawing than in drawing from direct observation. Some degree of construction, nevertheless, may be necessary and even when not actually used in making the drawing, the principles can still be borne in mind. Fig. 75 shows

Fig. 75.

Fig. 76.

a circle in a square and the way that the 'squaring-up' of this square and the view of the circle change from different viewpoints. Ellipses, unlike rectangles, always appear symmetrical (i.e. the

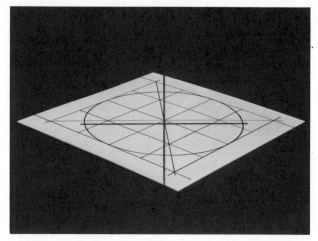

Fig. 77.

quarters are identical) (fig. 77). It is important that this visual phenomenon is observed and understood as, at first, it seems contradictory to what you have learned about squares and rectangles, where the quarters are very different. In practice, it can be helpful to turn the drawing upside down and reverse the ellipse, as the different view sometimes reveals errors that are not seen from the normal drawing position. The problem of not being able readily to recognize errors in your drawings is one that is always with you.

The shapes become familiar as you continue to look at them on the paper and it becomes more and more difficult to be critical. Artists often use a mirror to look at their drawings – thus getting a reversed image of their work, in effect, an unfamiliar view which makes it easier to identify errors. Making measurements on a strip of paper and transferring these from one side of the ellipse to the other can be a useful way of checking symmetry, but I would stress again that observation of the object is the most important factor in making the drawing and that all the construction and measuring possible will not create the correct illusion if, for instance, the right relationship of the width of the ellipse to its depth has not been realized.

Practice in achieving the relative width to depth can be usefully carried out, again, by making tracings through a piece of glass or similar transparent material (fig. 78). This can be particularly helpful

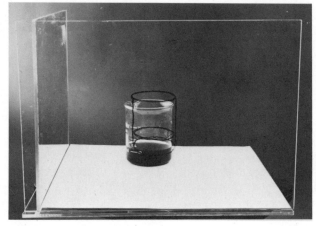

Fig. 78.

in gaining confidence in drawing continuous curves without recourse to all the constructional devices mentioned.

In simple geometric terms the drawing of cylinders leads on directly to the drawing of cones

Fig. 79.

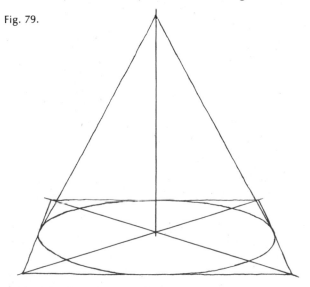

(fig. 79). The real problems in drawing cylindrical objects do not present themselves, however, until you consider cylinders not just standing on their ends, but also lying on their sides and turned away from the observer at various angles (fig.

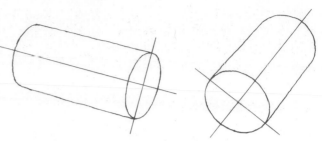

Fig. 82.

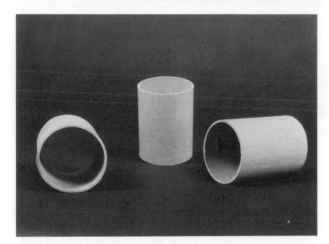

Fig. 80.

80). What happens should be observed and drawn from a group of your own including, ideally, either a cylindrical space frame or a transparent cylindrical object. The objects should be periodically moved so that they are grouped at different angles to you, and you should draw each resulting group.

Previously, the optical shrinking that took place when you looked at three-dimensional objects was in the form of a reduction of depth and an alteration of angles. Now you should recognize another phenomenon. You will find that the circular ends of cylinders appear to be ellipses tilting in a direction which is dependent on the angle

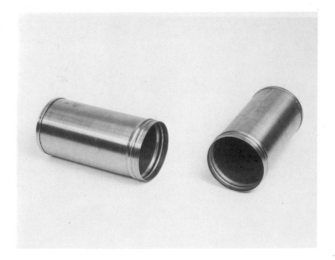

Fig. 81.

at which the cylinder is turned away from you (fig. 81). On analysing the tilt and the angle of the ellipses, you will discover that a line drawn through the centre of the cylinder along its length (giving the direction of the cylinder) is always

at right angles to a line drawn through the centre of the ellipse (fig. 82).

I would stress again that it is of the utmost importance to recognize this not as a 'rule of drawing' or part of a mystique that will guarantee 'good drawings' but as something that can be observed. What I am pointing out is the logic behind something you can observe. In carrying out the observation and drawing, all the constructional and observational devices mentioned previously should be used, particularly the device of tracing through a transparent screen. Looking at the illustrations in this book gives only an indication of the various visual situations and is no substitute for the realization that once observed these visual facts can be readily identified and understood.

The shapes and forms considered in this chapter have an enormous number of applications to everyday subject matter. I have already mentioned the usefulness of glass objects because the transparency allows the whole of the ellipse to be seen instead of just the section nearest the observer, as with opaque objects. Still-life groups can be constructed from tin cans, pans and other simple cylindrical forms. The first drawings should be made with the cylinders on their ends, and later attempts can be made at drawing them at an angle to the observer. Most cylindrical objects that are available (like jugs or cups, for example) are of a varying cylindrical section. Objects with wheels are now obvious choices and offer extensive study of this particular problem. Do not underestimate the difficulties of drawing these objects accurately. Try drawing a bicycle (basically, an object almost entirely composed of circles and cylinders) or even a wheel and you will find the test of observation, construction and control is phenomenal.

Perhaps toys or a wheelbarrow or trailer would be less difficult introductions to the problem but the subject matter is almost limitless, at any rate in the field of man-made objects (figs. 83–8). You have a limiting factor in making your drawings, however, in that to date you have used only linear means for translating your observations.

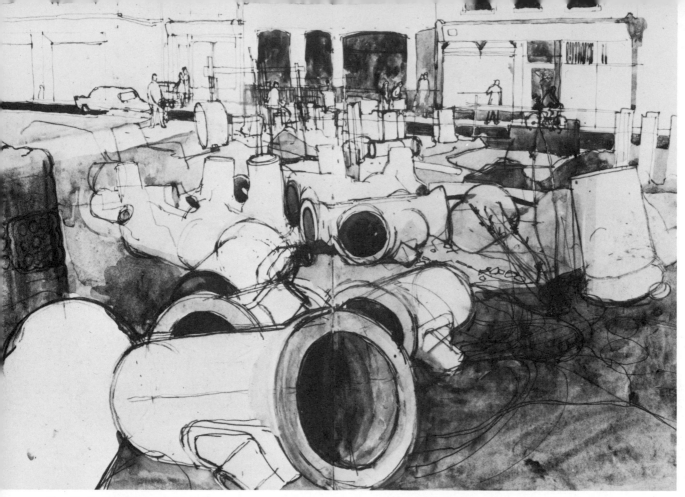

Fig. 83. *Drainage Pipes* (I.S.).

Fig. 84. *Rolls of Paper in a Factory* (I.S.).

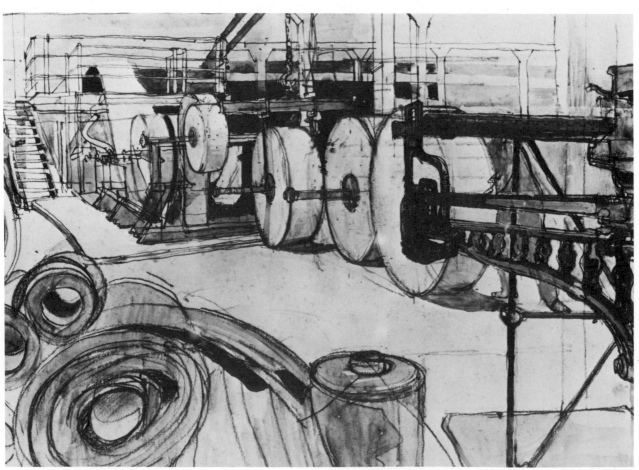

Fig. 85. *449 Strand* by Alfred Daniels.

Fig. 86. *The Castle at Trent* by Dürer (Trustees of the British Museum).

Fig. 87. *Objects on a Table* by John Titchell.

Fig. 88. *Docks, Sunderland* by H. W. Simpson.

Fig. 89. *Anatomical Drawings of a Horse* by Stubbs (Royal Academy of Arts, London).

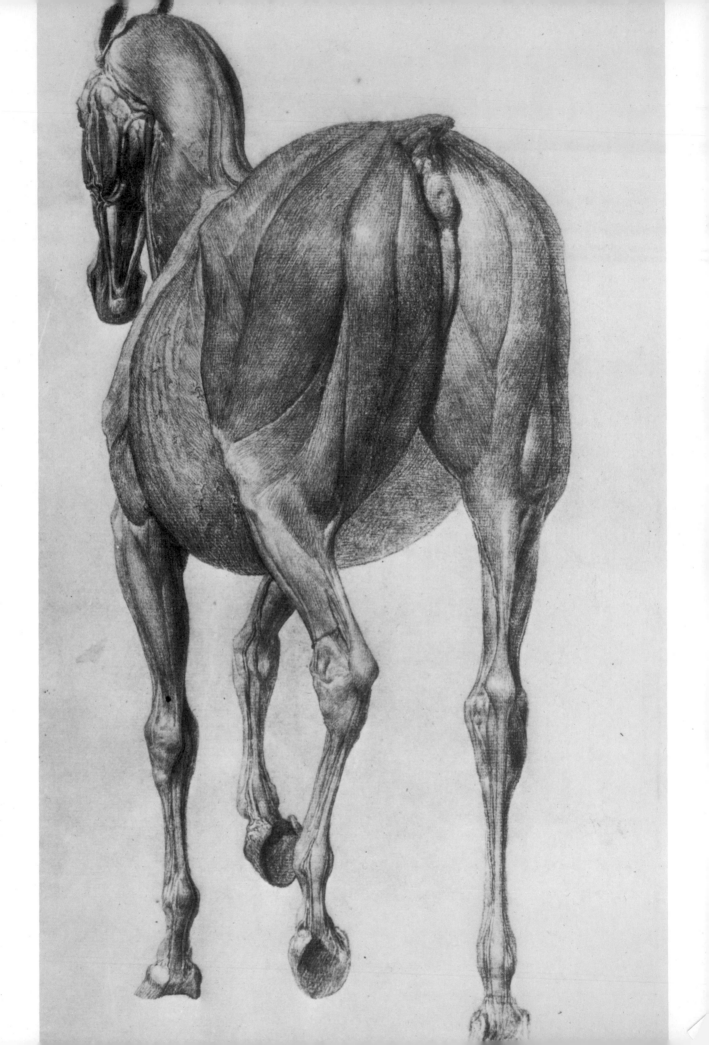

# 7 OBSERVATION AND PREVIOUS KNOWLEDGE

Fig. 90. Natural form study. Student drawing.

We have considered basically simple geometric forms and the problems involved in drawing man-made objects where the geometrical structure is apparent, but what of the objects in the visual world whose appearance seems irregular rather than regular? There are, obviously, regular elements in the structure of a tree – for example, the leaf shapes – but the view of a group of trees does not present the same simple geometrical problem as a group of houses. A botanist, for instance, would be able to point out the underlying geometry of the natural world, but is it necessary to understand to this degree the objects you draw? Need you know in detail about a motor car to be able to make a convincing drawing of it? It is easy to dismiss a question like this as not worth consideration. Cézanne made drawings of rock formations but there is no evidence that he had exceptional knowledge of geology. On the other hand, Leonardo's drawings and his scientific enquiry went hand in hand and the beautiful anatomical drawings of Stubbs were achieved primarily from the standpoint of a medical training (figs. 89-90). A really enquiring eye may be able to unravel and translate subject matter that is not really fully understood except by, for example, a scientist, but detailed knowledge of the object is not, on its own, enough. It is necessary, first and foremost, to have a knowledge of drawing and translation from observations and while an understanding of the objects being studied is useful it is not a prerequisite of producing a 'good drawing'.

I will enlarge on what I mean by 'good drawing' in a moment, but there has always been confusion on the subject of the relationship of fact, theory, knowledge, consciousness and intuition in the artist's make-up. Anatomy and perspective used to be compulsory subjects in art schools until comparatively recently. The first was intended to increase the student's knowledge of how the human figure is constructed and hence improve his observation; the second, to demonstrate how the third dimension could be translated and so improve his ability to record. Both these studies have now been largely discarded, and where they do exist they are frowned upon as decadent studies inevitably stifling, on the one hand, real observation (i.e. anatomy discourages 'looking' because you already 'know' what is there) and, on the other, intuitive and genuine creative expression (i.e. a 'how to do it' formula has been given which discourages the search for personal means of translation). There is an element of truth in both these criticisms. It is easy to end up drawing what you think (or think you know) is there rather than using your eyes, and it is easy to accept ready-made formulas for translation rather than to work out your own means. (Fears of this kind can lead to the complete denial that it is possible for anything to be taught in terms of observation and drawing – a not unknown situation in current art education.)

The short answer to how much you need to know about your subject matter is that it all depends on the kind of drawings you are trying to make, and this introduces the idea of selection and having an attitude towards the subject. So far, I have considered objectivity, detachment, fact for fact recording, but if you place a cup on the table and draw it, the fact that you choose one place rather than another to draw it from demonstrates from the first some rudimentary selection. The illustrations (figs. 91–8) show how the attitude of the artist can produce completely different results from the observation of similar subject matter. The amount of background knowledge required (in this case, botanical) depends

Fig. 91. *A Garden at St. Remy* by Van Gogh (Tate Gallery, London).

Fig. 92. Plant study. Student drawing.

Fig. 93. *Fir Trees at Hampstead* by Constable (Victoria and Albert Museum, Crown Copyright).

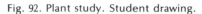

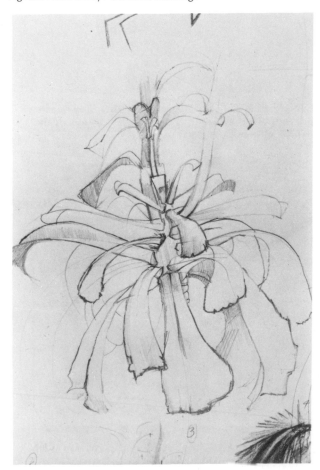

on the information that the artist is translating into his drawing. In each case, they give information about the branch structure of the tree but while one (fig. 93) makes a complete statement about these spatial relationships, the other drawings go on to add different information. If the drawing develops so as to give botanical detail

Fig. 94. Tree study. Student drawing.

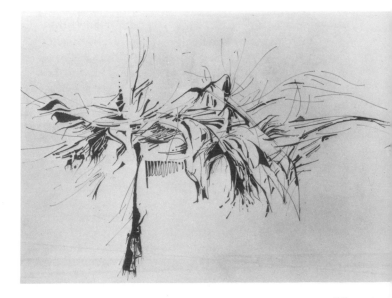

# 9 FORMS WITH NO FLAT SURFACES

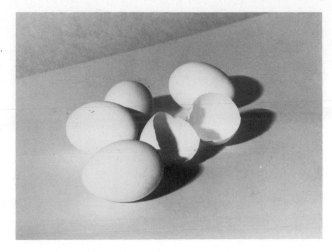

Fig. 108.

So far the visual problems I have set have involved objects where the three-dimensional form could be clearly revealed in a line drawing. That is, they were either objects with edges (like cubes) or if they had curved surfaces (like the cylinders) then they had a flat cross-section which clearly revealed the nature of the particular form. You may already have attempted, when making drawings of objects outside, a drawing problem where the translation could not be easily resolved in terms of line. The greatest problems occur in dealing with forms that do not have clearly defined edges nor reveal any obvious clue to their cross-section. An obvious example is the sphere, and an introduction to this particular problem can best

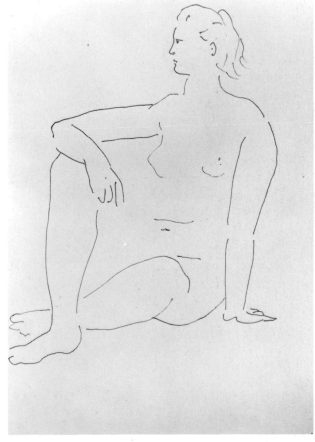

Fig. 109. *Seated Nude* by Picasso (Courtauld Institute Galleries, London).

be gained by looking at balls and eggs (figs. 107 and 108). It is not impossible to give an illusion of the form of objects even as complex as the human figure by the use of line only (fig. 109) but it demands an extremely sophisticated and experienced approach and the translation often involves a good deal of subtle distortion of what is seen in order to create the required form. Another way, however, which relies less on experience and dexterity, is by using tone as well as line to show that within the area enclosed by line there are points varying in the distance they

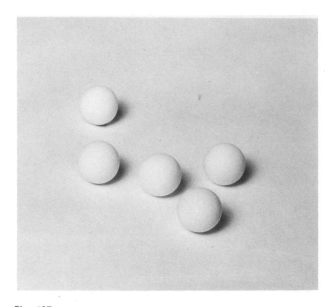

Fig. 107.

Fig. 106. *Standing Female Nude* by Seurat (Courtauld Institute Galleries, London).

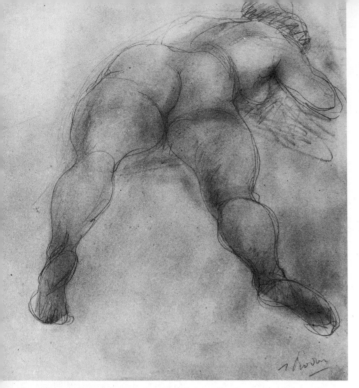

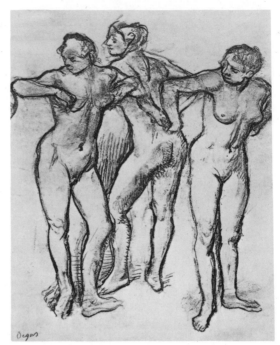

Fig. 110. *Reclining Female Figure* by Rodin (Whitworth Art Gallery, University of Manchester).

Fig. 112. *Nude Studies for a Group of Dancers* by Degas (Arts Council of Great Britain).

Fig. 111. *Reclining Nude* (I.S.).

Fig. 113. *Corn Stalks and Apple* by Harry Baines.

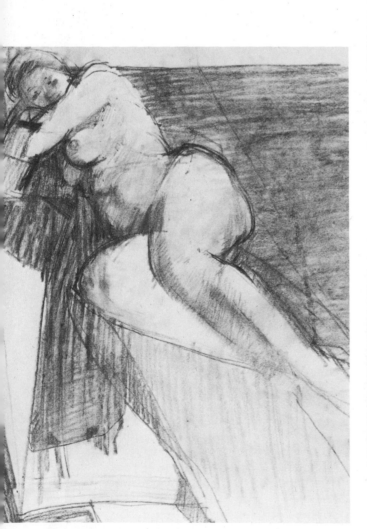

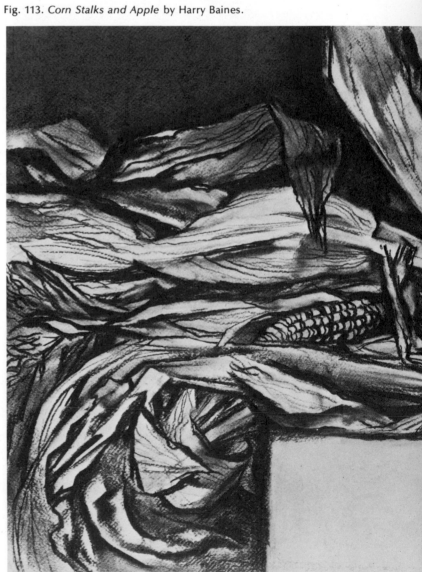

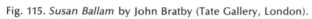

Fig. 114. *Still Life* by Tom Robb.

Fig. 115. *Susan Ballam* by John Bratby (Tate Gallery, London).

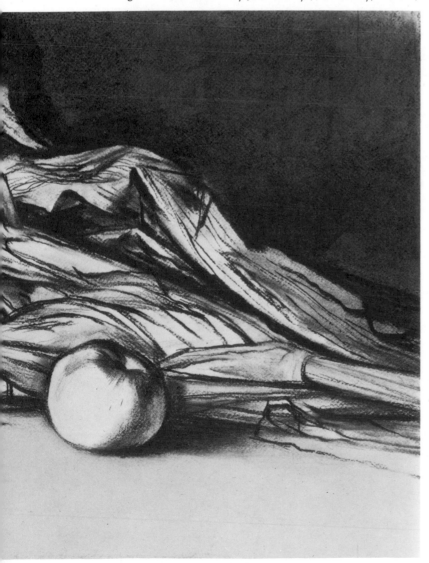

are from you in space. Figs. 110–15 show tone used with line to create a three-dimensional effect.

It would be as well to pause here for a moment to discuss tone and tonal values in some detail. In using the word 'tone' I am describing areas of shading (in any medium) used in drawing. So far in this chapter I have described only one use – that of helping to describe form – but there are others. For example, tone can describe colour. If you put a piece of yellow paper next to a piece of intense blue, apart from the colour differences the blue is darker than the yellow. This can be described as a difference of tone and it is possible to make a drawing in this way which incorporates the study of tonal differences. Drawings of this kind are often used as supporting studies for paintings (figs. 116–19). Tone can also be used to describe effects of light, the illumination of an object and the shadows cast by it as in figs. 119–21. An extension of this is the use of tone to describe atmosphere, the way in which the particular mood of a subject may depend on an overall dark tonal effect, for example figs. 122–5.

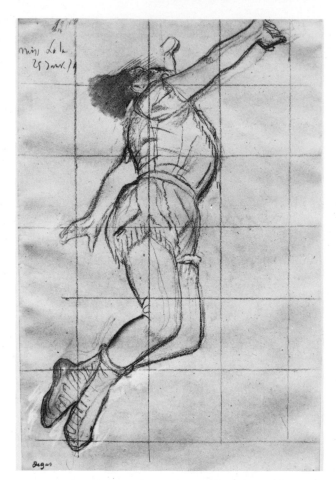

Fig. 117. *Miss Lola au Cirque Fernando* by Degas (The Barber Institute of Fine Arts, University of Birmingham).

Fig. 116. *Camden Road Station* (I.S.).

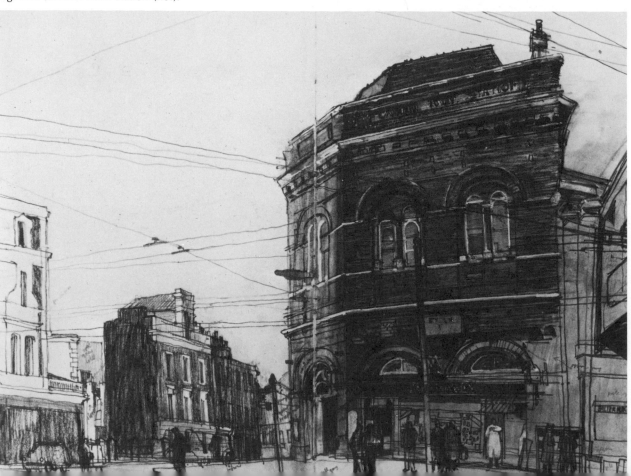

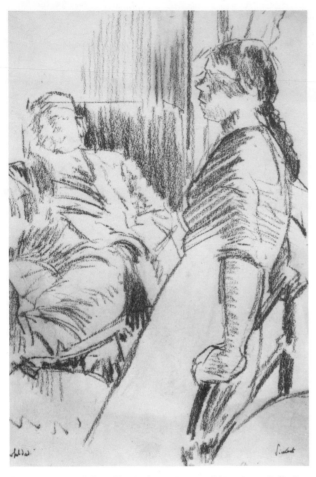

Fig. 118. *My Awful Dad* by Sickert (Courtauld Institute Galleries, London).

Fig. 119. *Portrait of a Young Man in Plumed Hat* by Rembrandt (Victoria & Albert Museum, Crown Copyright).

Fig. 120. *Study of Farm Buildings* by Giambattista Tiepolo (Trustees of the British Museum).

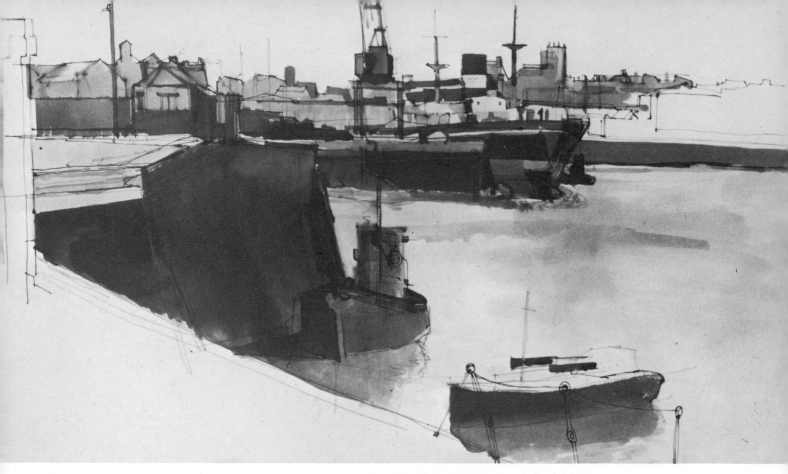

Fig. 121. *The North Dock, Sunderland* (I.S.).

Fig. 122. *Factory Interior* (I.S.).

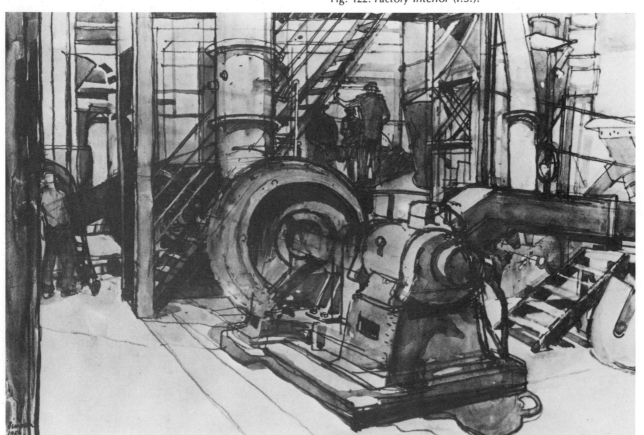

Fig. 123. *Band Stand, Peel Park* by Lowry (City of Salford Art Gallery).

Fig. 124. *View of the Stour, Dedham Church in Distance* by Constable (Victoria & Albert Museum, Crown Copyright).

Fig. 125. *The Sick Child* by Millet (Trustees of the British Museum).

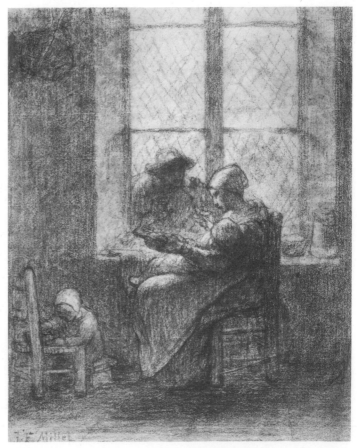

It is interesting to dwell on the problem of the translation of observation. When you look at objects, what you see is determined by the degree of light available. When you try to repeat these effects of light you are translating what you see into terms of (probably) dark marks on white paper. The widest tonal effects you can achieve, i.e. white paper on the one hand to jet black paint on the other, will not give the range that you can observe in reality. This point can only be proved from your own observations. Therefore, copying what is in front of you is impossible and everything depends on what you regard as important and what you are prepared to sacrifice. If a particularly brilliant light area is to be exploited, then the translation may mean that this can only be achieved by lowering the tone of practically everything else in the drawing. I made the point early on that translation into line was not in any way concerned with 'copying' as lines seldom occur in reality. There is, of course, a closer relationship between observing tonal relationships and transferring these into drawing, as you do actually see light and dark areas. A kind of translation similar to that demanded in line drawing must be preserved. This means that the limits of the medium should be recognized, and the medium should be used to translate what you select from your observations, not to attempt some kind of photographic copying.

The illustrations show different ways of recording tonal effects, and the laborious pencil effects known as shading are best avoided. There is nothing 'wrong' with pencil as a medium and nothing wrong with shading, but it can easily become a thing in itself. The laborious act of putting down on paper a series of lines to make an area of tone becomes more important than whether the area has the right degree of darkness.

In the first instance, I think it is best to use something which will produce areas of tone quickly and is also capable of being changed if events show that modification is required. The most useful first medium is either black water-colour paint or ink which can be diluted with water. Quite large areas can then be laid in with a brush and these areas can be made lighter, if necessary, by washing off some of the paint, or darker by applying more paint. It is possible to have white gouache paint or poster paint (paints which are opaque, not transparent like ordinary water-colours) to paint out completely areas which are incorrect. While I do not want to digress into an account of the techniques of water-colour and gouache painting, it is as well to know that if opaque white paint is mixed with the black transparent water-colour used for tone, an opaque mid-grey will be produced which may completely destroy an effect that is being built up through varying washes of transparent paint.

Any method of producing tone is right so long as it adequately describes the aspect of observation you have chosen to record. However, it is easy to become very mannered in dealing with tone. Students become aware that smudges made with a finger can create interesting effects, or that conté crayon used on its side and pulled over the paper can produce a flat area of tone reminiscent of some printing effects, and these become the predominant features of the drawing at the expense of the fundamental points of observation and translation that I have emphasized so much.

Anything that reveals the cross-section of a form

Fig. 126. *Girl Sleeping* (I.S.). Note, for example, the belt used to describe the form of the figure and the creases in the cover used to describe the form of the bed.

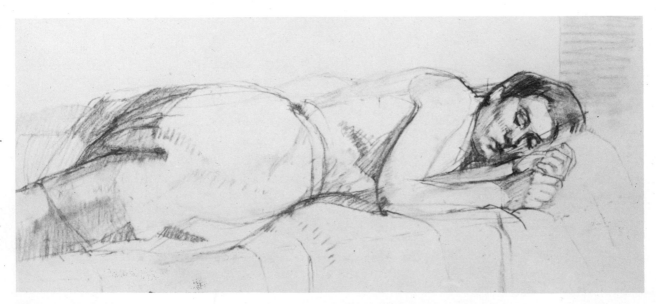

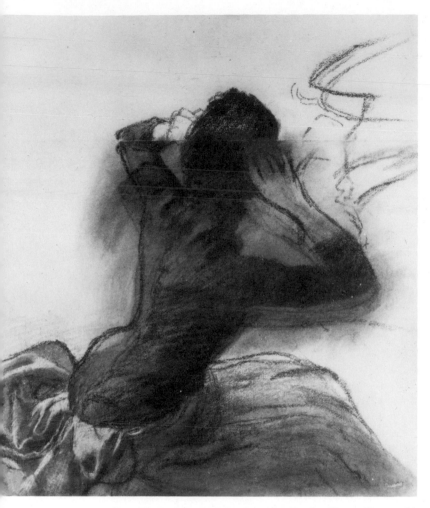

Fig. 127. *A Woman Adjusting Her Hat* by Degas (Courtauld Institute Galleries, London). Note the cross sections revealed by the skirt and the sleeves.

Fig. 128. *Zebra.* Student drawing.

is extremely useful in helping to describe it in drawing (figs. 126–7). Cross-sections are sometimes revealed by shadows or by patterns on objects (fig. 128). In the same way that light can reveal form, it can also camouflage it so that, again, one has to be really selective. The mere recording of lighting effects can lessen the effect of form, and a shadow which reveals a cross-section may prove useful while another shadow may have the effect of completely flattening an object. Once again, the whole drawing process becomes delicately balanced between fact, analysis and logic on the one hand, and trial and error and, above all, critical judgement on the other.

Before considering the use of tone in the translation of curved surfaces, look at the problems involved in making an objective study of a group of objects which have surfaces comprising clearly defined planes. Returning again to some of the geometric objects used earlier, consider now translating these in terms of tonal areas and eliminating completely the lines you have used previously. Start by drawing in faintly the shape of the object and its different surfaces. The problem then is to distinguish between the different amounts of light falling on each surface and to translate these differences into areas of tone in your drawing. First, you should find out which is the lightest and which the darkest area in the subject. It is often useful to record these first as they demonstrate the limits within which the other tones have to be arranged. The other areas of tone then have to be identified, compared and transferred to the drawing. The darkest areas can be drawn by using black straight from the tube (or jar). The addition of different amounts of water will give a variety of tone values getting progressively lighter until you reach the white of the paper itself. The mixing of just the right tone can be difficult at first. It is a good idea to try the paint you have mixed on a scrap of paper before applying it to the drawing. It is important, too, that the paint is mixed on a white surface (there are excellent white plastic mixing trays available or a white enamel plate is an alternative), otherwise it is virtually impossible to forecast what the paint will look like on white paper.

It can be useful in determining tonal values to look at the subject through half-closed eyes. This has the effect of diffusing the colour and can reveal quite clearly tonal differences not otherwise seen. An extension of the tonal study of geometric forms can be produced by crumpling a large sheet of paper (fig. 129). Some definite folds should be made and the paper then opened out to make a kind of white landscape. The tonal assessment procedure described previously can be repeated. The limits of light and dark should be set as references, and then the infinite subtle variations in tone assessed and recorded. In con-

Fig. 129.

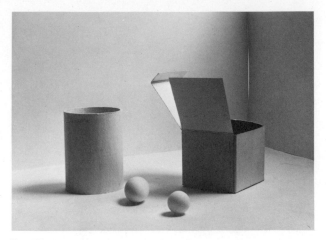

Fig. 131.

sidering further study of a similar kind of problem covering tone values you should bear in mind that both the geometric forms and the crumpled paper have been single colours (in this case, white). Further complications are involved when the subject matter contains several different colours.

I want you now to return to the balls and eggs (figs. 107 and 108) and discover how to approach the problem of creating an impression of their

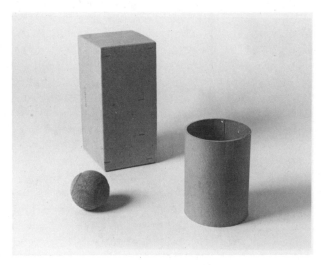

Fig. 130.

three-dimensional qualities on a flat piece of paper. You have seen that if you draw the amount of light falling on an object it can help to describe its solidity, and that a sharp edge (say, at the corner of a cube) produces a sharp change in tone but a rounded form produces a gradual one. Fig. 130 shows objects with sharply turning and gradually turning surfaces. They have been arranged so that the light is from one direction only. It illuminates to the greatest degree the surfaces turned towards it and, conversely, those turned away are darkest, but you should notice

that there are exceptions. Light can be reflected by objects and an area turned away from the light source can be illuminated by light reflected in this way.

The illustrations I have used have been carefully arranged with objects and background of the same colour so that colour changes have been avoided. Now arrange a similar group (it is probably easiest to use white objects) and examine the way the objects are illuminated and record the tonal effects. It may be necessary to make a 'corner' for the objects (fig. 131), and this could be two large pieces of cardboard at right angles to one another. This device can be useful for making an arrangement that cuts out unwanted sources of light. But the mere copying of areas of tone will not produce an accurate representation of reality. The procedures of analysis, selection, and trial and error have to be gone through until a translation is achieved which accurately conveys the particular three-dimensional qualities of the objects.

The use of tone to describe form has, so far, been considered only in relation to carefully prepared groups with a single light source and with the objects all the same colour. Unless specially prepared, however, these contrived conditions will never exist and if you want to draw a more usual group of objects or some outdoor subject, you will have to make a whole series of decisions about whether you are going to ignore the actual colour of the objects or whether you are going to show the intensity and direction of the light or, alternatively, only use it as a device for translating the form of the objects.

In demonstrating form, generally the key to the situation is that the objects should be considered as having a single light source even if there is in reality more than one. Colour should be disregarded. This involves a high degree of selection on the part of the draftsman and much of this is, of necessity, trial and error (fig. 132). If the main light source is taken as indicating the

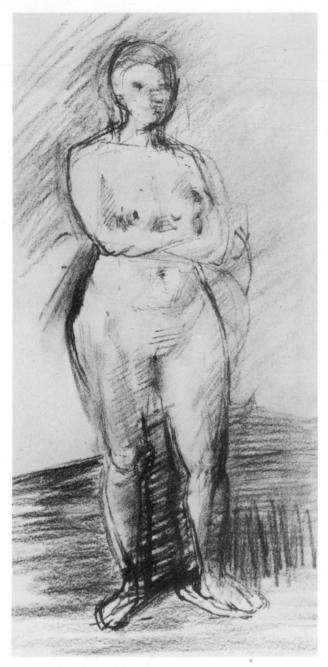

Fig. 132. *Standing Nude* (I.S.).

indicate the cross-sections of forms or help to locate an object on the ground. If the search is for 'pure' form, i.e. to translate only the three-dimensional qualities of the objects, then colour can be ignored completely and this is the way in which drawing is traditionally taught. The assumption is that drawing is a search for form, and that this should be completely removed from any context of colour or atmosphere. The best example of this purist attitude takes place in the life class where there is usually an insistence on the form of the model being considered without reference to the difference between the colour of her flesh and the colour of her hair or the colour of objects in the background. In a way, this purist approach has much to commend it. Drawings can easily descend into an attempt to convey so many kinds of information that nothing comes through with any clarity. On the other hand, while drawing is concerned primarily with the creation of an illusion of three dimensions on a two-dimensional surface, there is no reason why other aspects of a subject should not be conveyed. It is, in the end, a matter of choice. What is important must be determined and this may include colour, atmosphere or even an extreme emotional involvement with the subject. Again, I want to underline that although rational analysis is a factor and an important one, we have already looked at several drawings where an artist of the highest repute and with all the technical expertise possible at his command still did not know what he wanted in his drawing until he recognized it on the paper. Drawings, more than any other work done by an artist, show the preliminary stages in coming to grips with a problem. If you put down in words what seems a very good argument, there often comes the realization that there are flaws and perhaps omissions. Just the same happens in drawing objects. You look at them, and the way you look at them determines broad guide lines that start your drawing; but the operation proceeds partly from analysis and logic and partly from taking steps in the dark, and ultimately some of the logic may have to be modified and some of the steps in the dark may produce highly justifiable results. The key, however, to understanding how tone is used to assist in describing three-dimensional form is contained in the purist approach I have described. Basically, the three-dimensional illusion is achieved by indicating that parts of objects are either fully lit or at various angles to a single light source, and whatever other information is to be included in the drawing must not confuse the realization of form.

So far, I have advocated sketching in the position of the objects in line and then using tone exclusively to build up the drawing. This is more true to what one sees than the linear drawings

direction of light in the drawing and the subsidiary sources are omitted, this can be the starting point for a study but it cannot be followed as an unchallengeable truth. Both the group and your drawing have to be analysed in the light of your developing experience, and in the final analysis what works on the paper is more important than the observance of a rule. Nevertheless, a drawing of form using tone as the basis of translation must be developed from the idea of the different planes of the objects being illuminated by a source of light.

There is also the problem of shadows and of translating colour. As we have already seen, shadows can be useful – particularly when they

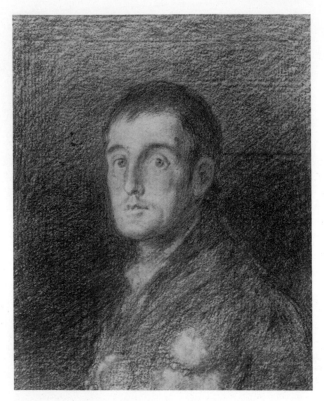

Fig. 133. *The Duke of Wellington* by Goya (Trustees of the British Museum).

Fig. 134. Study of trees. Student drawing.

Fig. 135. *Two Crouching Lionesses* by Rubens (Victoria & Albert Museum, Crown Copyright).

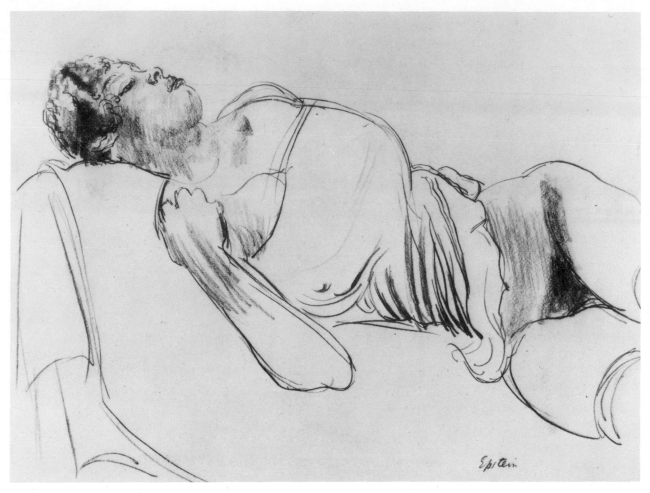

Fig. 136. *Recumbent Negress* by Epstein (Courtauld Institute Galleries, London).

of the earlier chapters. This approach is perfectly feasible (figs. 106 and 133), but it is more usual to use both line and tone and combine the qualities of both when translating the significant aspects of your observations (figs. 134–67). Again, it is possible to give general guidance but no rules. The line and tone must support each other, and the weight of line (its density) and the weight of tone should be closely related. If the tonal areas are close to black, the line used will, generally, be dark as well. There is no reason why traditional patterns of line and tone (e.g. ink and wash) should be followed. Any combination is possible, but the traditional approaches have not developed without reason and the balance that can easily be achieved by using a pen line and wash areas of the same ink diluted has still to be achieved if multi-media drawings are attempted. There is a lot to be said in favour of the latter. Apart from the fact that the different media have their own intrinsic qualities which can be exploited, drawing demands an inordinate degree of concentration and the use of the different media can add variety both to the actual execution (the change from pen, to brush, to crayon, for example) and also to the approach (a linear

medium dictating, to some degree, that contours are examined; a broader medium encouraging the scrutiny of, perhaps, lighting effects).

Drawing is often referred to as a discipline. The observation required, the analysis, selection and control have been traditionally believed to be not only the basis from which, of necessity, painting and sculpture are developed, but also the basis for design as well. This concept of the necessity of the discipline of drawing has been much questioned in colleges of art in the last decade and in many instances it has been reduced to teaching students a style of drawing which they could reproduce on demand but which relied little on anything other than the most superficial observation. However, drawing as one of the ways (and there are others) of developing visual awareness and sensitivity is as valid as ever it was, and the discipline it imposes, not only on observation but also on recording the subject, is in miniature what both the Fine Art and Design processes should contain – analysis of a situation, identification of the problems and their solution partly by logic and partly by sensitivity, experience and intuition controlled by critical awareness. It is important to note also that while the illustrations in this

Fig. 137. *Coastal Landscape 1972* (I.S.).

Fig. 138. *Study of Water* by Frederick Cuming.

Fig. 139. *Seated Nude* by Bill James.

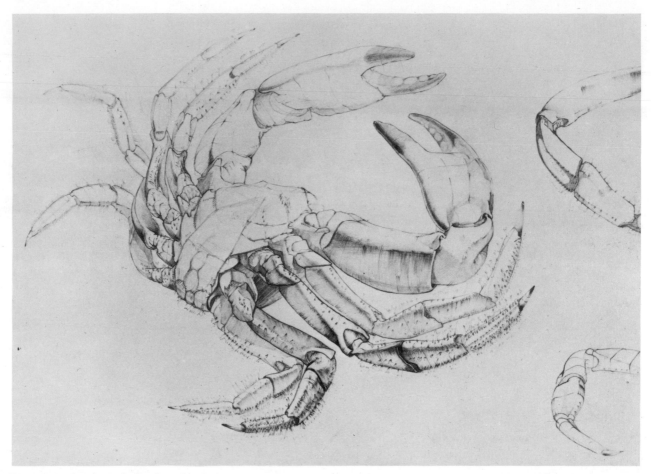

Fig. 140. Study of a crab. Student drawing.

book deal mainly with realistic representation, an objective drawing from direct observation need not necessarily be so (figs. 137–9). It all depends on which aspect of the visual world you wish to record.

Drawing is hard work and sometimes even tedious. Starting a drawing can be exciting. The final result can be rewarding or sometimes, seen some time afterwards, positively amazing in that it contains things you had not noticed during the actual execution. Sometimes you cannot quite understand how or why you did certain things. Between starting and finishing, however, you may have many misgivings and be easily sidetracked into giving up or starting another version. Sometimes this struggle can be alleviated by the use of several media in the drawings and, of course, if this is an aid to concentration on the aspects of drawing that I have repeatedly stressed, then it is a useful thing.

I do not want to give the impression that drawing is only to be considered as something on a monumental scale, where you confront the objects for hours on end and this gradually leads to a highly considered detailed study. Again, it all depends on what you want to do and the kind of subject matter you are using. If you want to catch a fleeting effect of light outdoors, for instance, the drawing must be quick; conversely, the study of a group of objects indoors may be pursued at a more leisurely pace and contain much deeper research and much more attention to detail. Both rapid and extended studies are valid. Try both. Either can produce something of significance and, equally, either can produce something merely trivial. However, I must admit that I am greatly in favour of perseverance and while perhaps not always completely true, in most cases, providing genuine observation and translation are being attempted, if you work on a drawing for long enough something of significance results in the end. How you determine 'the end' is another matter. In the case of drawing the fleeting effect of light, the change in the subject determines the end. You do what you can before the light changes. In the more consistent atmosphere of the studio the end is generally when, having ceased to make new statements about what you see, you are being repetitive or tidying up.

Line, in conjunction with tone, can be used to convey the most subtle visual information. Often the tone is used with the utmost economy. Rather than shading in the whole of an area turned from the light, for example, the shading is used only at the point where the actual change of direction of plane takes place (figs. 140–1). In the introduc-

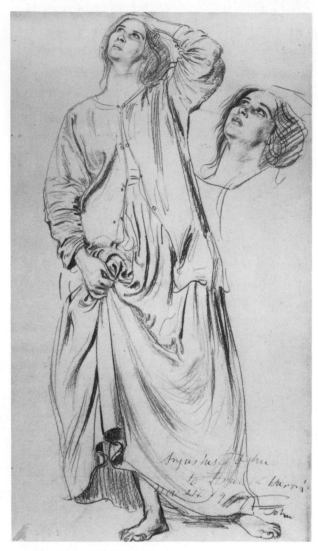

Fig. 141. *Study of Dorelia* by Augustus John (Collection of Thelma Cazalet-Keir).

Fig. 143. *Trees and Stretch of Water on the Stour* by Constable (Victoria & Albert Museum, Crown Copyright).

tion I pointed out that the eye and brain combined did not need much information to build up an image. Given a few clues they are eager to provide a visual solution and, in practice, a few marks and splashes of tone can sometimes transmit incredible detail and subtlety (figs. 142–3). The use of

Fig. 142. *River Scene* by Bonnard (Private Collection, Paris – © S.P.A.D.E.M. Paris 1973).

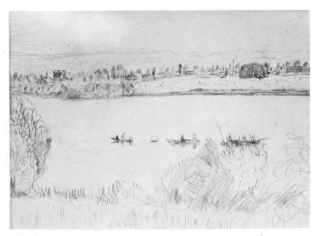

tone to hint at changes in plane rather than actually drawing them in their entirety is one way in which use is made of the observer's eye and brain to complete the picture. It is a form of 'drawing shorthand' but it can be particularly effective, and its quality of economy often makes it possible to include more information than in a more heavily worked drawing.

You have, so far, considered line as defining contours, but there are other subtle uses of line. Notice, for example, the way in which the varying thickness of a line can make the contour occupy a different position in space, and equally important, the way in which the contour can indicate changes in plane by breaks in the line and by having sections where the line overlaps and creates the illusion of one form fitting behind another (figs. 144–5). It is no coincidence that fig. 144 is of the nude. The nude is the most complex of natural forms and it requires every conceivable drawing effect to reproduce the changes of form

Fig. 144. *Nude, 1951* by Roger Grand (Tate Gallery, London).

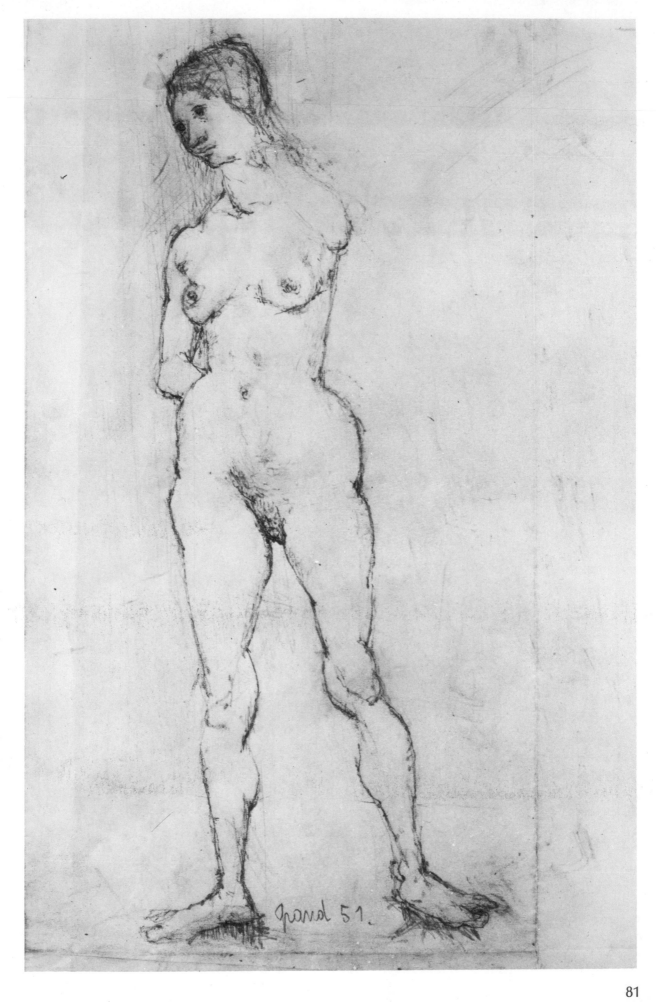

grand 51.

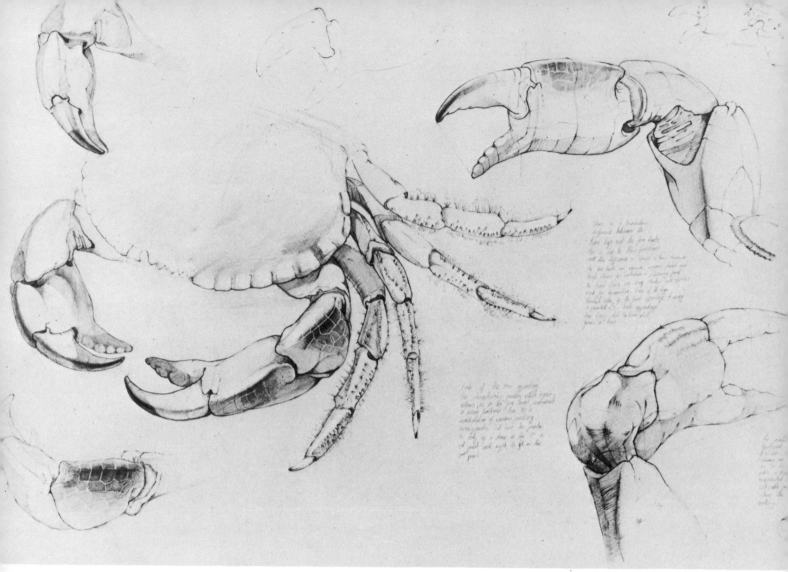

Fig. 145. Studies of crabs. Student drawing.

Fig. 146. *Standing Nude* (I.S.).

one experiences in studying the human figure. Basically, however, in this chapter we have covered the essence of portraying complex curved forms and this, together with the knowledge of more geometric forms in earlier chapters, should now allow the problems of the human figure to be attempted. I have already touched on anatomy in Chapter 7 and said that while knowledge of the underlying construction of the figure (or of any subject for that matter) is good, it is not in itself a substitute for acute observation and analysis. It is, nevertheless, of the utmost importance that in drawing the human figure, as with any other objects, the drawing is constructed so as to be really convincing, and rather than anatomical details the main tensions of the body have to be identified and recorded (figs. 146–7). I want to make absolutely clear that I am not saying that life drawing is some special branch of art which demands a different approach. But although tensions and construction are equally important in drawing, for example, plants or buildings, drawing the human figure sets a collection of problems that, in total, are more difficult than you generally find elsewhere. Perhaps this is because being

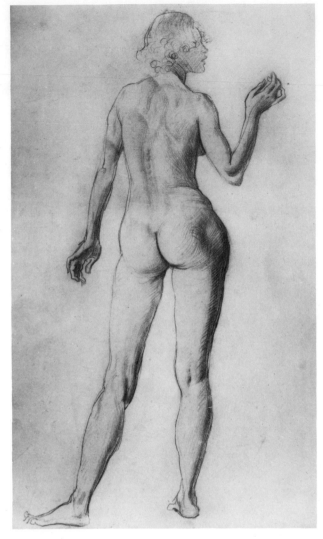

Fig. 147. *Nude Study* by Augustus John (Collection of Peter Harris).

3. Tone can also describe other visual appearances: lighting effects, atmosphere and colour, for example.
4. In practice, line and tone together are usually used to describe all kinds of combinations of form, light and colour, and drawings of 'pure form' are no longer regarded as an absolute necessity.
5. The human figure is probably the most complex form to attempt to draw. This chapter has dealt with all the basic problems involved in drawing a life figure but I have referred back to the earlier chapter which touched on anatomy and also emphasized awareness of tensions inside forms.

For your first study of tone and form, it is best to choose subject matter that does not pose colour problems. Figs. 107 and 108 have already shown excellent examples. Fig. 148 shows a study group of eggs with broken shells to give the problem of concave as opposed to convex forms. The group

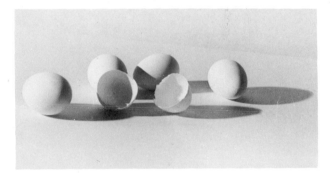

Fig. 148.

human ourselves, our attitude towards the figure is more questioning than with other objects.

Cézanne considered that the cube, the cone and the sphere were the basic forms underlying all objects and that mastery of these made it possible to draw anything. This is true, and this whole book is based, to a large extent, on the theory that mastery of the drawing of a few basic geometric forms enables any subject matter to be tackled. The human figure presents probably the most difficult arrangement of these forms and gives you the greatest problems in identifying them. Before going on to consider the human figure in greater detail let me briefly summarize this critical chapter and suggest subject matter for study before the figure is attempted.

1. Although line has properties (width and density) that enable it to describe form, tone is frequently required to describe forms, particularly spherical and other forms with curved cross-sections.
2. Tone can be used selectively to demonstrate how a single light source would illuminate the form.

is placed on a white ground and the eggs are as close in colour to the ground as possible so that the difference between ground and objects is almost entirely one of form and there is no major colour difference. A second study group (fig. 149) shows balls, some black and some white, and the ground is alternatively black and white.

Fig. 149.

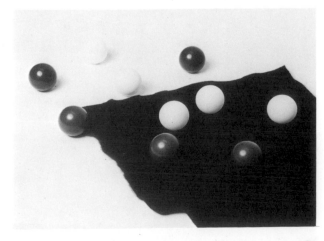

Geometric forms make an excellent drawing problem because they leave no room for deceiving yourself and imagining that what you are putting on paper is a translation of what is out there in front of you when it patently is not. The balls, therefore, make a perfect group for studying this problem. Alternatively, a group of white cups or other white pottery objects could be arranged on a white ground. Outdoors there are possibilities of finding this problem in large modern concrete buildings where the colour will be minimal. Industrial buildings, power stations, for example, might readily be available as convenient and appropriate subject matter.

Before moving on to the human figure, try making some drawings of heads. I hesitate to call them 'portrait' drawings as this seems to put the emphasis on the portraiture aspect. The undue emphasis on the creation of a likeness can easily cause the fundamental purpose of drawing, that of using line and tone to describe form, to be forgotten. Consider caricatures for a moment. They sometimes achieve an astounding likeness but they are not, generally, in any way concerned with the three-dimensional properties we have been considering (figs. 151–5). Their appeal is of a different kind altogether. In making a portrait

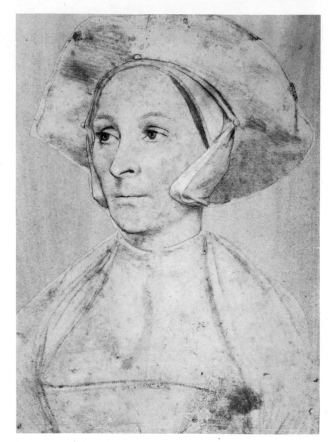

Fig. 152. *A Lady, perhaps Margaret Roper* by Holbein (Trustees of the British Museum).

Fig. 150. *Studies of Heads* (I.S.).

Fig. 151. *Study of a Girl* by John Titchell.

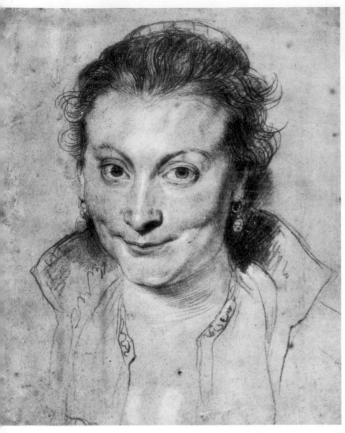

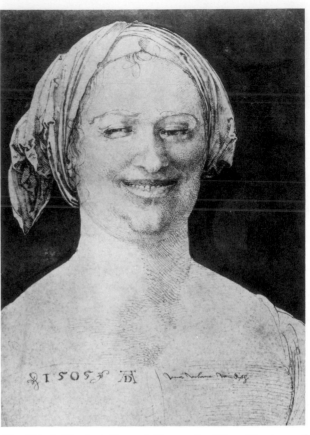

Fig. 153. *Elizabeth Brandt* by Rubens (Trustees of the British Museum).

Fig. 154. *A Windisch Peasant Woman* by Dürer (Trustees of the British Museum).

Fig. 155. *William Macbrearty* by Stanley Spencer (Tate Gallery, London).

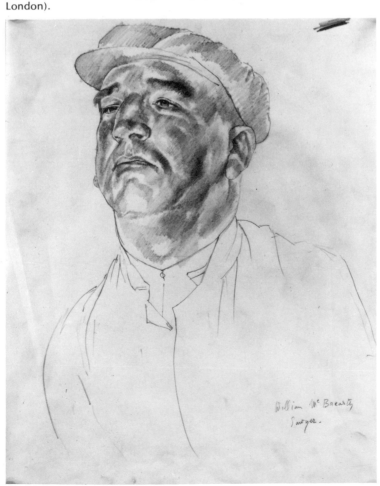

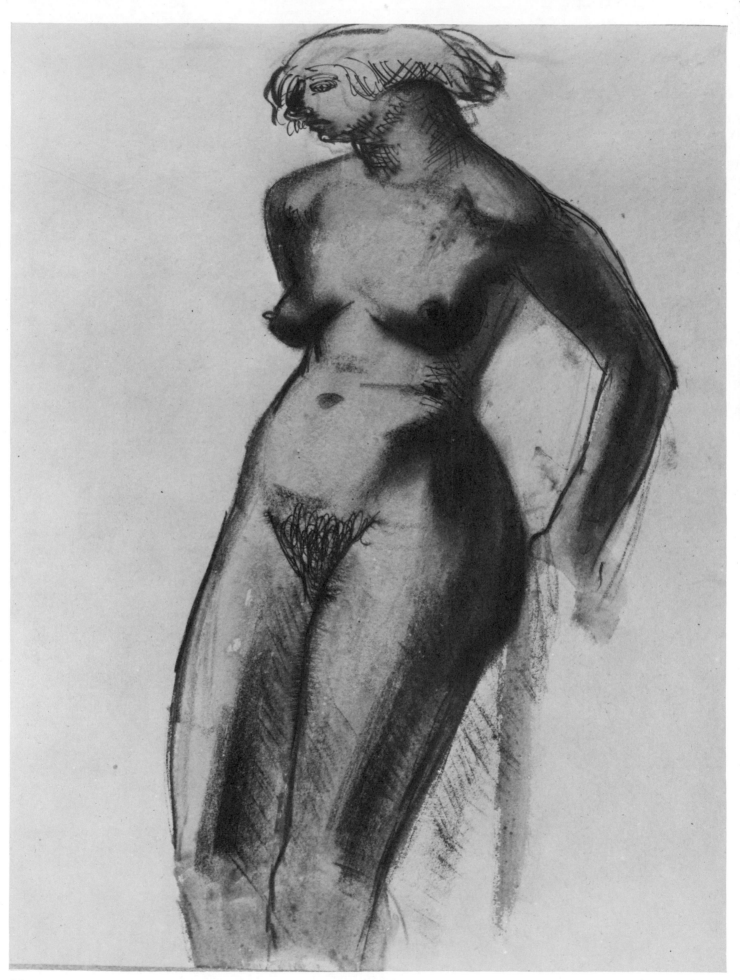

86

drawing remember that the figure is an 'art object' and so many drawings have been made of it that it is easy to fail to see it as a problem of observation and translation and try to reproduce what you think figure drawings should look like. In making these initial portrait drawings the head should be considered as a single three-dimensional form which is made up of a series of forms connected together. These forms and both their internal tensions and the tensions existing between them and the other forms of the head have to be observed, analysed and translated. The likeness that has to be aimed at is one of truth to observation – not a likeness produced by superficially emphasizing some feature of the head that may be instantly recognizable. The problems of drawing the head can be both fascinating and discouraging. Fascinating from the exploratory point of view, in that keen observation will continue to reveal all manner of visual facts about the head that will be both new and unusual, but discouraging because of the difficulty of recording them. The placing of the eyes in the eyesockets, the realization of the form of the nose, the drawing of the planes of the lips, all pose this kind of problem. Application and keen analysis of both the subject and the drawing are the main aids in this situation, but if the results are too discouraging, return to some of the earlier problems to gain more experience and confidence. Another difficulty that presents itself when you draw a head is that of the subject moving. The model can only pose for a limited period of time and it is not always easy to get the person back into the exact position they occupied previously. The drawing must be developed to allow for this, by fixing the largest forms and then gradually evolving the smaller ones. In this way, if constant reference is made to the relationship of the various forms, slight changes in the overall position of the figure can be unimportant.

A good illustration of this comes in the traditional teaching of life drawing. A rule in life class was that one should not draw the shapes between the arms and the body that would be evident, for example, in the pose for a drawing like fig. 156. The idea behind this rule was that these background shapes would change constantly even while the figure was posing, and that the relationship of the forms of the arms to the body and the way the arms fitted to the body at the shoulders should be considered, rather than drawing an arbitrary, ever-changing background shape. We saw back in Chapter 1 that with inanimate objects, the object to background relationship could be

important in determining size and precise shape, and in the initial 'blocking-in' of a figure drawing it can still be extremely useful. It can help establish the overall shape and proportions of the figure, but the construction, tension and relationship of forms must be considered in relation to each other and the figure as a whole. The figure in its entirety, not just one isolated section, has to be related to the background, but the object and background relationship is something that you should not dismiss. In the very first drawings, where the object and the background were considered as equals, you must have been aware of the interesting abstract qualities that were possible. These are important qualities that may eventually outweigh the drawing of forms when you make final decisions about how a particular drawing is going to be developed. Do not overlook the fact that even if the object you are drawing is inanimate, you are not, and you move constantly when drawing so that the problem of movement is present in any drawing situation. Note that in drawing the figure it is quite possible to use yourself as a model. The movement problem already discussed is the main problem in drawing a self-portrait as it necessitates perpetual movement of the head from pose to drawing and the position of the head may have varied a great deal before it has proved possible to fix the main forms in your drawing.

Once you have gained experience of drawing from a head, you should attempt drawings of the human figure. These may be drawings of the figure clothed or nude. Just as when considering the nude figure, the underlying structure has to be searched out and included in the drawing, so in drawing costume figures the clothes have to be understood as fabric draped in various ways over a human figure, whose structure needs to be investigated with the same thoroughness that informs a drawing of the nude. Look back over all the methods and devices, both observational and technical, that have been mentioned in the book, as they will all be required in these drawings. Also use as wide a variety of media as possible; and if you have not made much use of a plumb-line before, use it in drawing the figure as so much depends on getting the balance of the forms right and vertical relationships are of primary importance. In making drawings of the figure it is important to remember that even though you will be drawing from one position, your observations should be from every angle possible so that you have as much information as is available about the forms you are drawing.

Fig. 156. *Standing Female Nude* by Henry Moore (Tate Gallery, London).

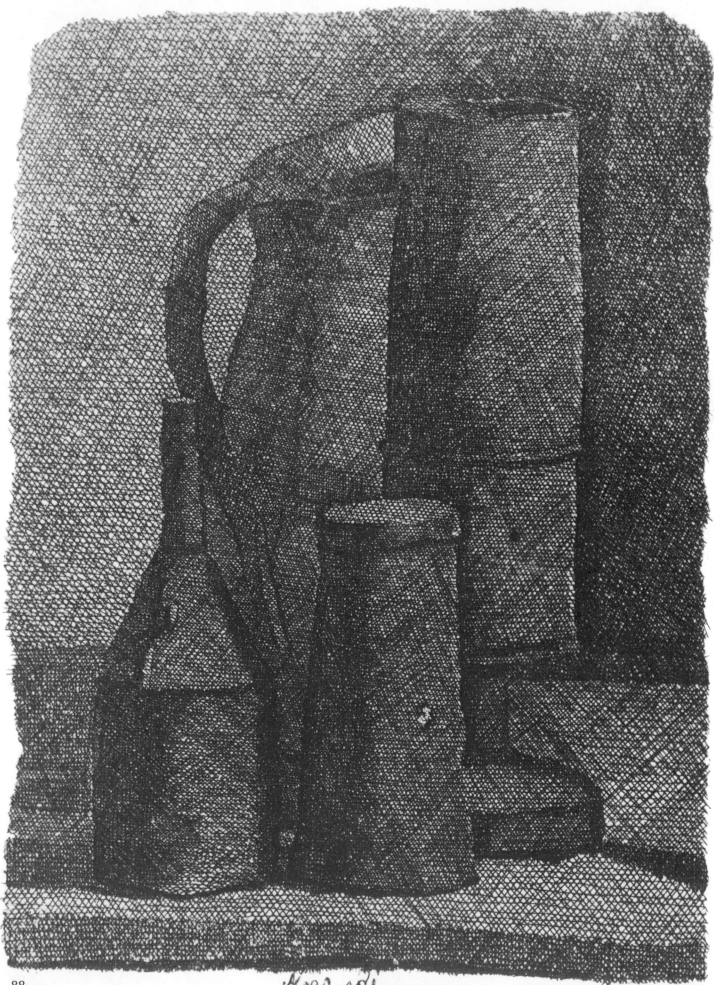

88                 *Morandi*

# 10 ANALYSIS AND SELECTION

At several points I have mentioned selection in relation to drawing and subject matter, and selection and analysis are linked. Selection without analysis would be arbitrary, but even so all selection is not carried out in a predetermined and analytical way. You have now reached a point in your study of visual appearances where your subject matter must inevitably become more personal. So far the suggested subject matter has been an object or a small group of objects and it has been chosen initially in order to examine a particular visual problem. Not all drawing is done in this way and the approaches to subject matter are nearly as varied as the number of artists involved. An artist like Morandi may become obsessed with a particular subject such as his still-lifes of a range of bottles and jugs (figs. 157–8), and he may be completely absorbed in taking from this subject relationships of shape, form and so on which he wishes to translate into drawings.

Once you have become visually aware and see the world as a series of complex inter-related forms, does it really matter what kind of subject you work from? There is a lot in support of this point of view but, nevertheless, there is an initial emotional involvement in some kinds of subject matter. This is not to say that the visual-problem type of approach I have encouraged so far is not legitimate, but in developing your drawing the main thing is just to look and to draw. Draw anything and everything. Students often approach a studio situation or some outdoor subject and report that they can find nothing that interests them, but the most trite and conventional subject contains some aspects waiting to be discovered

Fig. 157. *Still Life with Four Objects, 1947* by Morandi.

Fig. 158. *Large Still Life with Lamp on Right, 1928* by Morandi.

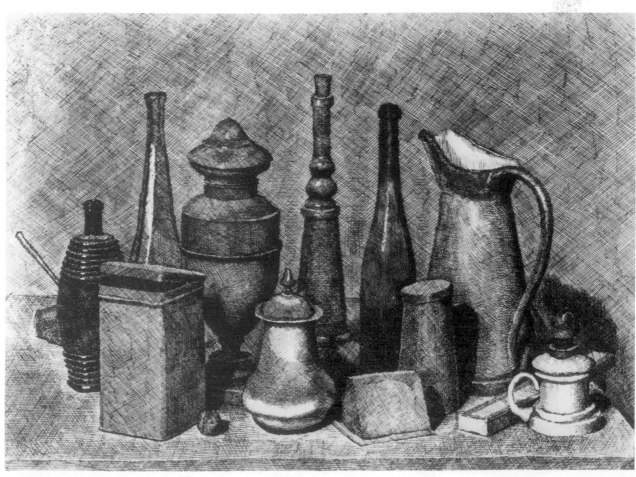

by those who are prepared to investigate.

Once you have probed and found a wide range of subjects and approaches, you can begin to narrow them down to what you find most suits your temperament. The point has now been reached where I want to encourage you to find widely different kinds of subject matter and use the information gained to date to make drawings. As well as looking at different subjects – houses, landscape, figures, rooms – you should attempt as wide a variety of actual drawing problems as possible. Large, spatial areas should be examined as well as a single isolated object that can be turned round in the hand. Now you will want to attempt more complex situations incorporating, possibly, several problems. Landscape, for example, or a combination of buildings and landscape like the Van Gogh drawing in fig. 159, can include examples of all the problems you have considered to date.

Although I have stressed that it is important to be selective in drawing, how can you eventually decide on what to draw and then on an attitude towards your chosen subject? I think of drawing primarily as a form of exploration so I do not put a high degree of emphasis on the composition as such, that is, on achieving a picture which is well organized in relation to the rectangle of the drawing surface. Once you start to draw, the scale and the size of the drawing (within certain limits) can be worked out on the paper. There can be problems in settling for a scale for the drawing, for example, in deciding how large the principal object should be. There is a tendency to want to draw objects the size you actually see them, that is, 'sight size', and it can be difficult, if not impossible, to draw them larger or smaller. When you begin to draw it can take some time before the drawing settles down to a particular scale. You may have to draw and redraw some sections until the problem of scale has been solved, and it may be necessary to add another section to the paper so as to include the information you discover you want. It is often helpful to 'block-in' the drawing in large simple areas (figs. 160–1) so that you can see just how much of the subject matter is likely to be included, although if at some stage you want to add to the drawing you should go ahead and do it.

Drawing is extremely fortunate in offering not only immediacy, as it is the quickest possible way of responding to a visual situation, but also flex-

Fig. 159. *View of a Tile Works* by Van Gogh (Courtauld Institute Galleries, London).

Fig. 160. *Animal Studies* (I.S.).

Fig. 161. *Studies of Brompton Oratory* (I.S.).

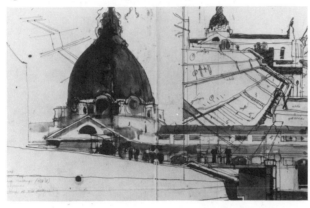

Fig. 163. *Head* by Alan Davie (Tate Gallery, London).

Fig. 162. Below. *Vulture II* by Gaudier-Brzeska (Tate Gallery, London).

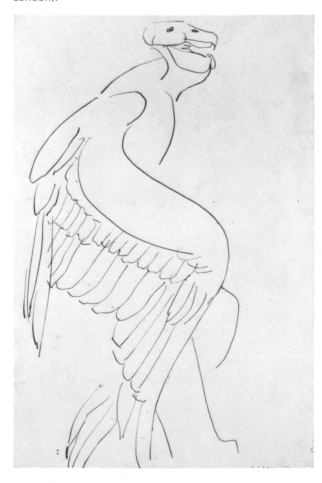

ibility. You can add to drawings easily or, alternatively, cut them down or isolate one particular part and develop it. It is very difficult to draw by completing a small section and adding a series of sections to it until the paper is covered. This is because drawing demands that you observe and relate the objects in front of you to each other, and this can generally only be done if you are constantly comparing all sections of the subject matter. To give an example, if you draw a figure and attempt to draw first the head, then the shoulders and so on down the figure, it almost always leads to difficulties. You fail to relate the different sections and just add together what are essentially a series of separate drawings. A general guide in drawing is that at any given time the drawing should be at the same stage of development all over. Continued working on the drawing should see the different sections developing more and more, but not in isolated pieces. To return to the example of drawing a figure, if you stopped after a few minutes' drawing it would be reasonable to expect that not only the shape and position of the figure would be established to some degree but also the relationship of figure to background.

I have referred to accuracy of both observation and translation. It is possible, however, to be faithful to a 'feeling' for a particular subject and this may compel distortions that deny, to some extent, observation: a fidelity to the inner truth rather than the outer one (figs. 162–3). Drawing

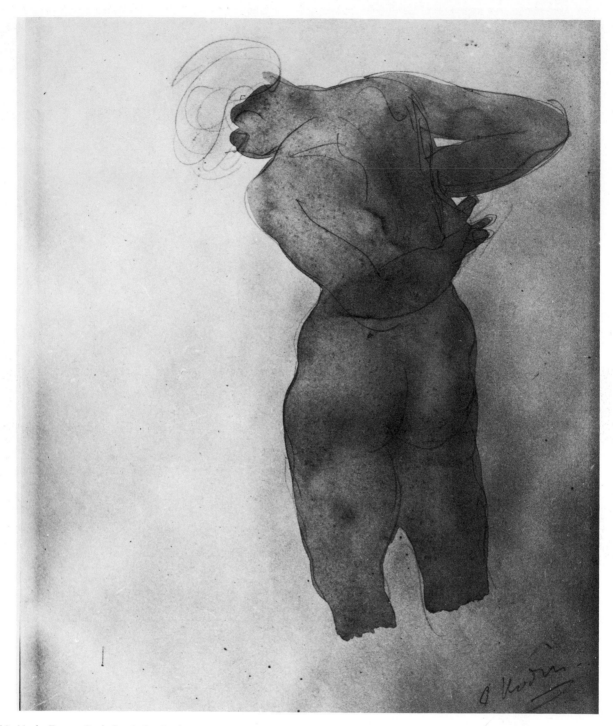

Fig. 164. *Nude Torso, Back Study* by Rodin (Whitworth Art Gallery, University of Manchester).

is sometimes concerned less with direct observation and analysis and more with the subjective responses gained from looking at a particular subject. The artist may need something external as a starting point, but from there he superimposes attitudes already developed or exaggerates elements he observes in the subject (figs. 164–7). He may not be concerned with whether his proportions are accurate, or whether the object he is drawing is necessarily located in the correct position in space.

The approach I have been encouraging has been 'objective', with the emphasis heavily on analysis and truth of observation. I am not denying, however, that the subjective approach has produced significant work. In general terms and in relation to visual education and the development of one's visual awareness, a leaning towards objectivity is much more healthy than a leaning to subjectivity. I stress 'leaning', as ultimately no work can be wholly objective or subjective. These are extremes and all drawings contain something of each. The subjective approach can be dangerous to students, as it encourages the use of precon-

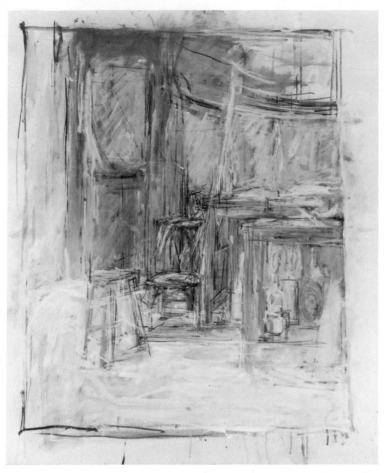

Fig. 165. *Interior* by Giacometti (Tate Gallery, London. Rights reserved A.D.A.G.P., Paris 1972).

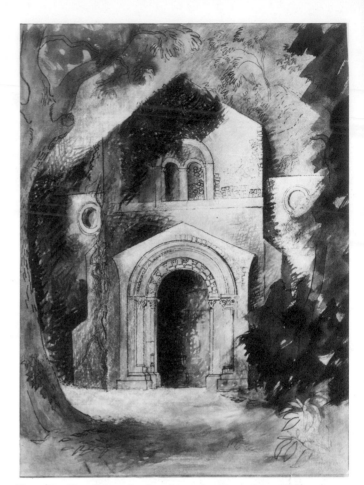

Fig. 167. *The Dairy, Fawley Court* by Piper (Tate Gallery, London).

ceived notions and often produces work in which the same mannerisms appear over and over again. It can also lead you into thinking that something which you recognize as inaccurate is all right, as it is what you 'feel' rather than 'see'. It encourages lazy observation and general inaccuracy and it discourages a critical approach. In the end, though, subjective or objective is a matter of degree. This book deals with drawing with a strong bias towards the objective, but it would be wrong to confuse this with so-called academic drawing or naturalistic drawing. It is possible for an objective drawing to be selective in such a way that the source of the information recorded is not immediately apparent. Abstraction does not necessarily mean that the work must be done completely from imagination. It can be the product of the observation and analysis of visual material and the selection of certain abstract qualities from it (figs. 168-75).

As well as emphasizing an objective approach I have stressed the importance of logic in drawing. Certain visual facts can be worked out by anyone and there are many problems that occur in drawing that can be solved by reason rather than

Fig. 166. *Female Figure* by Bonnard (Rights reserved A.D.A.G.P., Paris 1973).

93

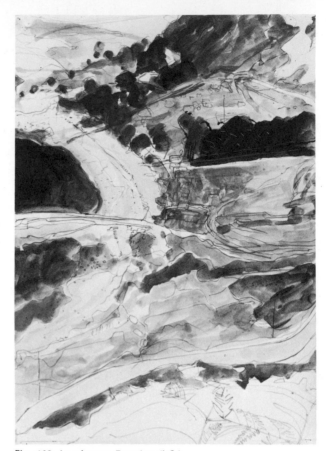

Fig. 168. Studies through a Microscope. Student drawing.

Fig. 169. *Landscape Drawing* (I.S.).

Fig. 170. *Porthmeor Beach, St. Ives* by Pasmore (Tate Gallery, London).

Fig. 171. Grass study. Student drawing.

Fig. 172. Skull. Student drawing.

Fig. 173. Natural form studies. Student drawing.

Fig. 174. Studies of mushroom. Student drawing.

Fig. 175. *Water Patterns*. Student drawing.

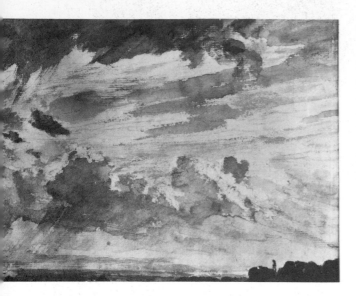

Fig. 176. *Study of Clouds above a Wide Landscape* by Constable (Victoria & Albert Museum, Crown Copyright).

intuition. This, however, is not to deny intuition a useful place in your repertoire. Many things have to be done by trial and error, and drawing, because of its immediacy and use of relatively uncomplicated media, is a very good area in which to experiment. Different approaches to a particular subject can be tried in quick succession where the equivalent, say, in painting would be slow and tedious. Traditionally, the drawing media have been seen as a basic training ground and experimental area for both artists and designers.

In discussing objectivity and accuracy I have been considering a visual world of clearly defined shapes and forms, but there are occasions when the most significant visual phenomenon is a particular atmosphere, and this is emphasized if it is an effect of light or weather (figs. 176–81).

Often in the teaching of drawing an opposite standpoint is taken to the one I have adopted and the argument put forward that above all the individual artist's self-expressive powers must be emphasized. It is pointed out that all the technical know-how possible means nothing unless the artist has something to say. Furthermore, that providing he has something to say, the ability to communicate the information is secondary. It is possible for drawings to be crude, but where the artist has keenly observed something of interest and in spite of his limitations something of his vision has come through into the drawing; but to see this as a basis on which learning to draw can be developed is misleading. Unless everything is to be left entirely to chance and you accept that the process of drawing is almost completely intuitive, so that without help some people will

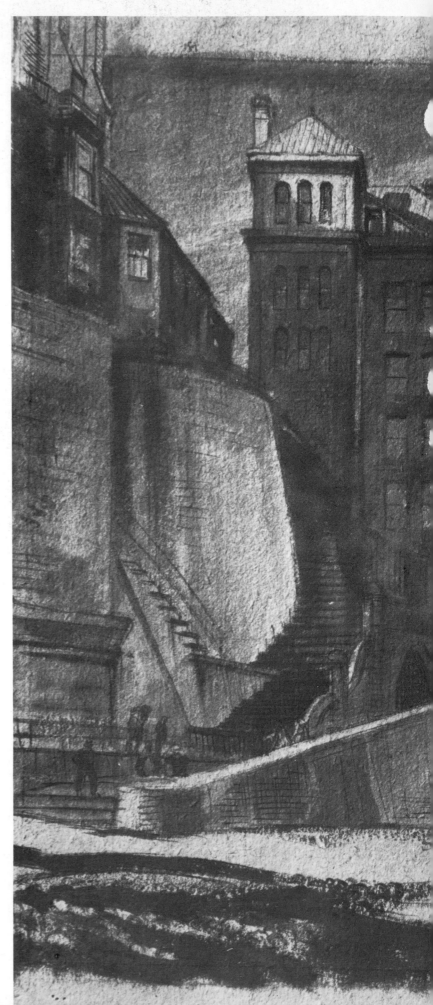

Fig. 177. *Cromer Hotels* by Francis Unwin (Tate Gallery, London).

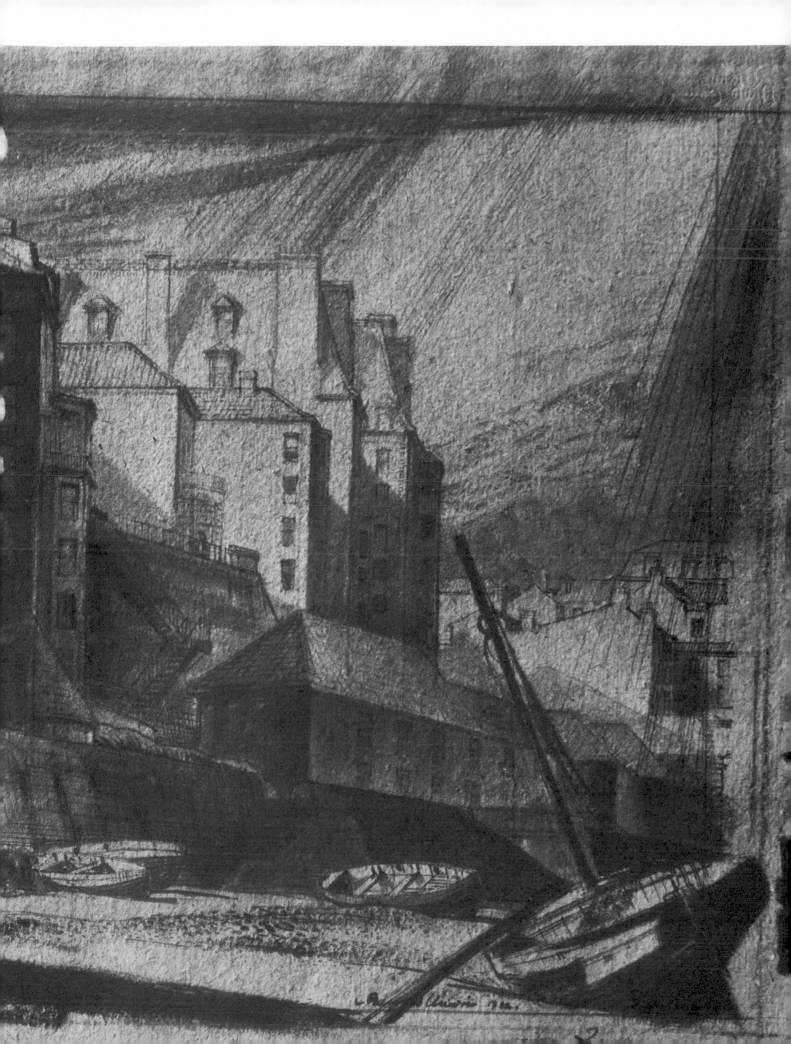

Fig. 178. *Nuage sur la Mer* by Bonnard (Private Collection, Paris. Rights reserved A.D.A.G.P., Paris 1973).

Fig. 179. *The Falls of Schaffhausen* by Turner (Tate Gallery, London).

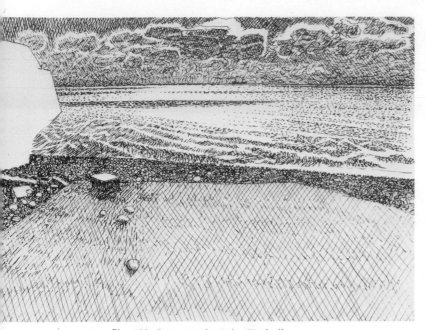

Fig. 180. *Seascape* by John Titchell.

Fig. 181. *Landscape* by Tom Robb.

be able to articulate their ideas and others will not, then a less subjective approach is required towards learning to draw. Historically, the great draftsmen have usually had a very rigorous training. True, this has been in some cases self-imposed (figs. 182–4), but it has usually been con-

Fig. 182. *Young Peasant with a Sickle* by Van Gogh (Kröller-Müller Stichting).

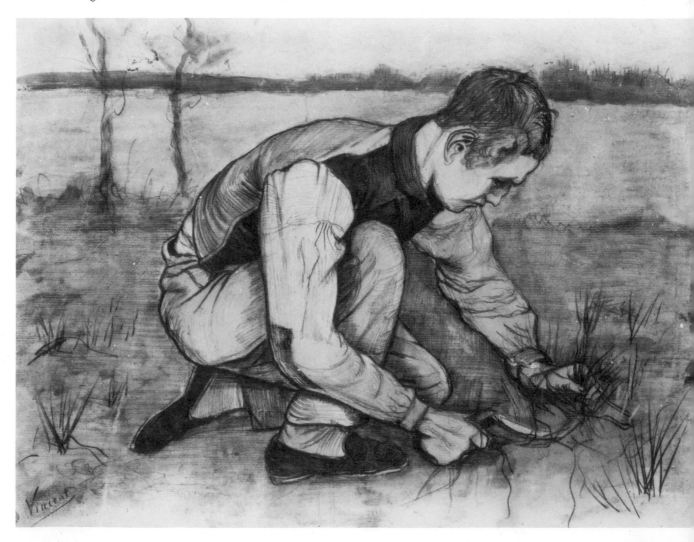

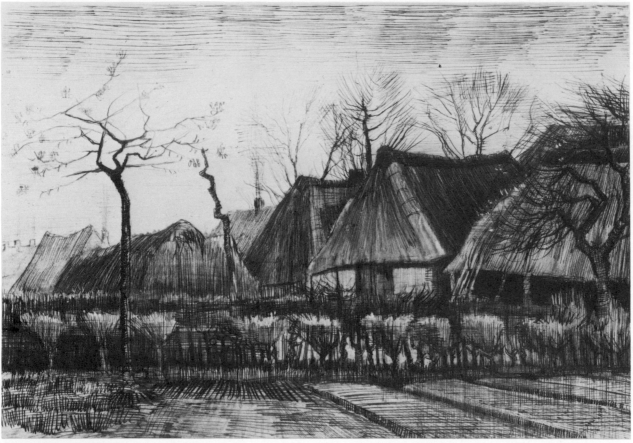

Fig. 183. *Thatched Roofs* by Van Gogh (Tate Gallery, London).

Fig. 184. *The Crau, seen from Montmajour* by Van Gogh (Collection: National Museum Vincent Van Gogh, Amsterdam).

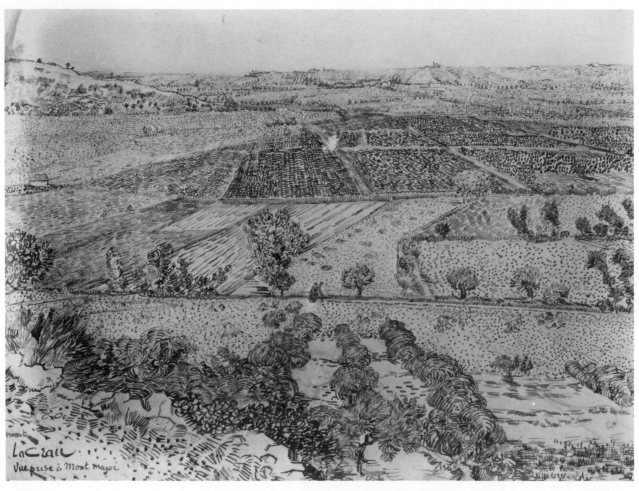

cerned with the emphasis I have advocated, that of analytical observation and the translation of this into graphic terms.

I have not, so far, touched on the development of the visual language that particular artists have used. Although, no doubt, when Pisanello and Dürer looked at animals or birds (figs. 185–7) they saw much the same as Picasso, the means of expressing observation had been developed between the fifteenth and twentieth centuries. Visual clues given to us now by artists, which we can readily fit together to represent various shapes or three-dimensional forms, differ from some of the devices that have been used in the past. And not only is it possible to find something new and unique in an analysis of observation, but it is also possible to change, extend and personalize the means by which this observation is translated. In literature, in just the same way, different writers arrange words so that their work is distinct from that of other writers, though they may be working in much the same area of subject matter.

I have continually encouraged an interest in the 'abstract' qualities of drawing, and advocated an involvement in intervals of space, the position-

ing of various forms in space or in the directions of planes rather than an interest in a particular subject, like drawing churches, trees or the figure. In suggesting areas where these abstract qualities can be found I have always seen the subject matter as incidental. The relationship between an artist and his subject is a topic that requires more extended study than is possible here, but it is worth posing some questions. Is the subject of any importance at all? (And here I am only posing this question in relation to artists who actually work from external subject matter.) Is it of importance that the artist is familiar with his subject? Does he have to find it interesting in itself or only interesting in that it offers visual problems? Does an artist look for a subject that provides a certain kind of material or does the subject inspire the drawing? There are no simple answers. There are, undeniably, artists who have been obsessed with a particular subject, and reveal this love in their drawings. But I am thinking of mature artists and rather moving away from the basic intention of this book which is to demonstrate that anyone can learn to see and translate information into drawing.

At a certain point you will have to continue

Fig. 185. *Study of Rabbits* by Dürer (Trustees of the British Museum).

Fig. 186. *Deer* by Pisanello (Radio Times Hulton Picture Library).

Fig. 187. Illustration to Buffon's *Natural History* by Picasso (Courtauld Institute Galleries, London).

on your own – this book is only a starting point – and eventually you will have to determine the way you wish to proceed. The most I can do is to point out some of the possible dangers of the different approaches and to justify my own instructional approach. In learning to see and draw subject matter is not important, but there are certain preconceptions and misconceptions which can be misleading. There is the desire to draw only pretty girls or beautiful buildings, presumably based on the belief that a pretty girl must produce a pretty drawing. Or the feeling that there are hierarchical layers of subject matter with the nude figure as the highest and most significant. There can be enormous mental blockages in trying to find subject matter for drawings. There is the assertion that if you select and position objects, you have thereby exhausted your interest in them and there is nothing more to do, and the belief that subjects must be found in a more or less natural state. Then there is the problem that often faces students when responsibility for the choice of subject matter is passed to them. They find that with everything to choose from, nothing is sufficiently interesting and absorbing and they cannot discover anything they want to draw.

The emphasis on the abstract qualities in drawing leads students away from some of these problems. Knowing about objects has been dealt with in Chapter 7 and my approach is that, generally, the more you know about a subject the more clearly you will observe it and be able to draw it. To give an illustration, if you were going to

make a panoramic drawing of a town that you had not visited before, it would be difficult unless you had spent some time walking around the streets so that you had some knowledge of where the buildings were placed in relation to each other. In the same way, in the life room, it is important to view the figure from as many points as possible even though the drawing is made from only one point. The various groups of objects that I have suggested for drawing demand that the same sort of information is acquired in the setting up process. This chapter is concerned with the move from directed subject matter to personally chosen subjects. At this point you need to consider your position and to decide whether you are going to remain with the abstract problem approach or become more involved in the subject matter for its own sake. If you have a strong desire to explore a particular subject, go ahead and do so. If, however, you are happy to continue in the way that has been suggested so far, then I suggest you go on in this way. It is easy to get yourself in the unhappy position of searching for subjects that you feel are going to inspire you, and eventually arrive at the conclusion that there is nothing you really want to draw. The all-important thing is to maintain the principles of observation and translation. It is easy to be seduced into virtually ignoring the study of shape, space and form and to end up trying either to reproduce drawings you have seen of a similar subject or else becoming so involved in some area of the subject that it is not seen in relation to anything else.

Fig. 188. *Coastal Landscape* (I.S.).

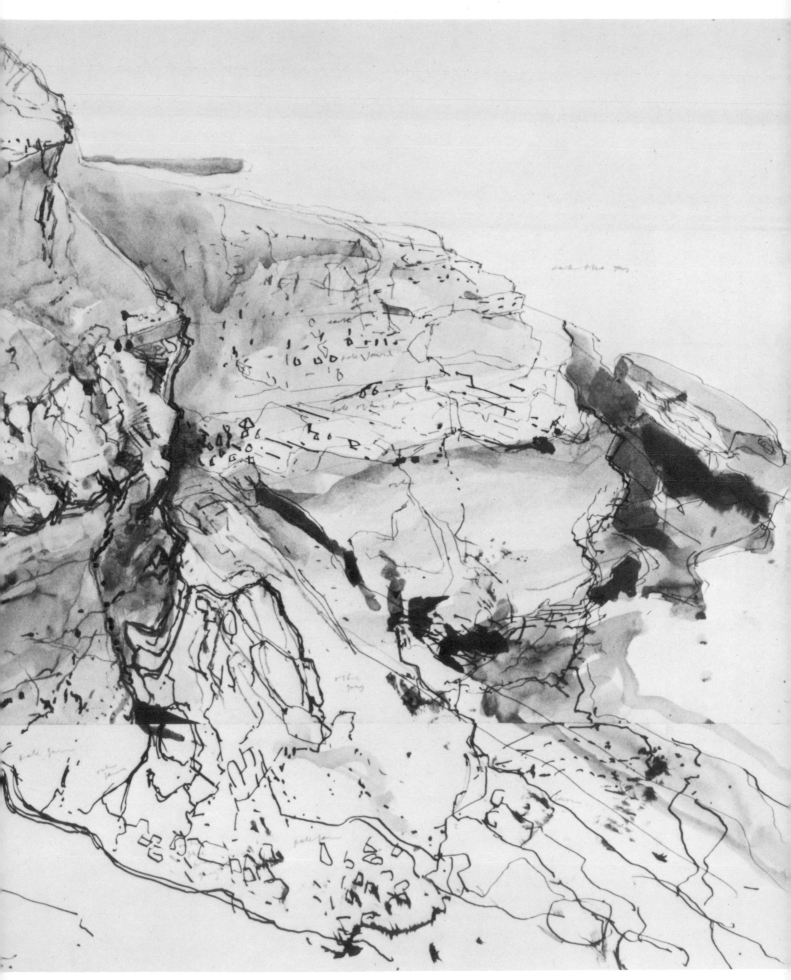

# 11 PERSPECTIVE

that the images of the objects as they would have appeared on such a screen could be drawn without recourse to 'tracing'. The system is based on two rules: firstly, that lines actually parallel in the visual world appear, if extended, to meet at a point (i.e. the 'vanishing point') on the horizon (i.e. the level of the spectator's eyes or the 'eye level'); secondly, that all lines actually parallel to one another appear to meet at the same vanishing point (fig. 190).

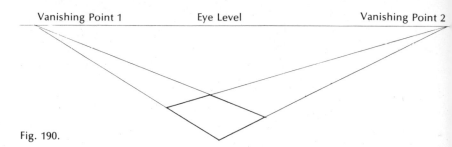

Fig. 190.

Perspective is an aspect of drawing which is often thought of as a means by which, once its mysteries are understood, work of great accuracy and quality will automatically be produced. Perspective can be learned by anyone and there are a number of books devoted to explaining the theory behind it and demonstrating how it can be used. In the history of art, perspective is a comparatively recent discovery. It is basically a device for establishing the scale of objects at different positions in space and you have already, in earlier chapters, observed from direct observation the principles involved. The system is mathematically based and was developed from an early fifteenth-century system usually attributed to the Italian architect Brunelleschi. Perspective was improved by other artists including Piero della Francesca, Uccello and Leonardo. Fig.

If you refer back to Chapter 3 you will see that the first rule, at least, is something you have already observed as a fact. You know that a rectangle has two pairs of parallel sides but that if you observe a rectangle placed in a horizontal position at least one pair of sides appears to be getting closer together. Clearly if the sides are extended they will eventually meet, and you have already observed, perhaps without realizing its significance, that where these extended lines meet

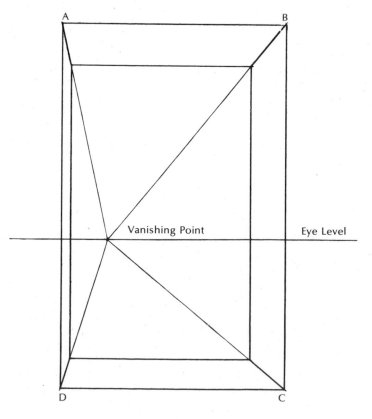

Fig. 191. A view of a rectangular space frame. The lines from A, B, C, and D drawn to the vanishing point are in reality parallel.

Fig. 189

189 is based on a diagram from a Leonardo sketchbook and illustrates how an object would appear if it were traced on a flat screen placed between the eye and the subject matter. The drawings on glass suggested in Chapter 6 were, in fact, carrying out exactly what Leonardo illustrated. A whole geometrical system was, however, developed, so

depends on the position of the observer. In fig. 191 two of the sides of each rectangle are not drawn as getting closer together. These two sides are parallel to the drawing surface (the 'picture plane') and they are represented as either horizontal or vertical lines. Initially, all pictures using perspective were drawn in this form. They had one plane of rectilinear objects drawn parallel to the picture plane and the other planes described by lines going away to a single vanishing point. This form of representation is known as parallel perspective. Drawings produced in this way give a perfectly good illusion of depth, but objects included in them can only be drawn 'flat-on'. The development of angular perspective was necessary (fig. 190) before a satisfactory sys-

Try drawings from different heights (i.e. drawings with different eye levels) and, again, compare observation and perspective methods. Try looking at the rectangles from different distances. Do you find that the closer you get to the objects the more the observational and perspective drawings differ? The distance you draw from is important in producing a convincing representation of reality, and if the rectangles are very large and you look at them from only a very short distance away you will produce distorted shapes from accurate observation and these will not follow the rules of parallel perspective at all. I will return to the question of distance from the object and your angle of vision again later.

Repeat the whole drawing process with the rectangles observed corner-on. This, of course,

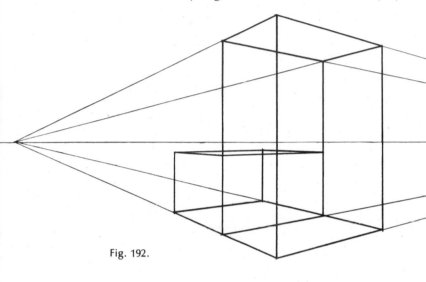

Fig. 192.

tem was available for making drawings which included 'corner-on' viewpoints (fig. 192).

You should now try out these systems by making some drawings of rectangles as in Chapter 3 but using a combination of observation and perspective method to produce them. Put the rectangles that you are using as objects (sheets of paper as before) on a flat surface (preferably a table). Position the rectangles with one side flat-on to the observer for the first drawings. These will involve parallel perspective. Remembering that the eye level is an imaginary horizontal plane projected from your eyes to infinity, work out where the eye level occurs in relation to the rectangle you are going to draw. Indicate the eye level in your drawing. Assess the angles at the corner by eye and when you have drawn the rectangles from observation only, check as to whether the receding sides of the rectangle, if extended, would meet at a vanishing point on the eye level you have included in the drawing. Be absolutely honest in your observations, and remember this can be carried out extremely accurately, as you can visually measure the angles by using a plumb-line. It is important to analyse discrepancies between your observation and the rules of perspective.

uses angular perspective and this time involves two vanishing points. You must organize this so that you can get both vanishing points on the paper and it will necessitate a large sheet of paper and small rectangles (e.g. postcards) as objects. Again, compare the drawings from observation with what should happen according to perspective rules. As well as making drawings from different distances, position the objects at the extreme edges of your vision. Keep your head still and have someone arrange the objects so that they can just be seen at both your left-hand and right-hand sides.

A description of these operations can seem very tedious, but I cannot overstate the importance of seeing these points for yourself. You may be able to grasp a particular point from my description and from the supporting illustrations but this is no substitute for seeing for yourself and making your own drawing. There are also limitations as to what can be explained in a book, and the only way in which these can be minimized is by your carrying out all the practical work yourself. After the drawings of rectangles, you should continue with rectilinear forms. Use a space frame again and a solid box, and refer back to Chapter 5 and inclined planes. What happens when you position one of the forms so that it is not on a horizontal plane? Try positioning the objects as in fig. 193.

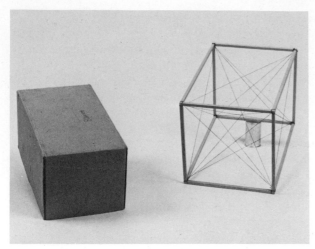

Fig. 193.

There are limitless extensions of this particular problem that can be arranged by moving a few simple objects around and positioning them at various angles to the horizontal surface (fig. 194).

Fig. 194.

These few paragraphs on perspective have contained a number of statements that need further illustration and justification. They also include several words that need explanation as they are terms that I have so far avoided. Let me establish first why perspective, which is as I have described it a mathematical system, appears in a book on observation. There have been in the past decade many students who have studied drawing but have never been taught anything about perspective. Perspective, as we have seen from the illustration of tracing on glass, is based on observation, and you will eventually see how a knowledge of perspective recreates a reproduction of the information that our eyes receive. It can also make it possible, provided you are supplied with sufficient information, to produce a drawing of an object without your actually seeing it in a three-dimensional form. This is how architects, for example, produce drawings of views of buildings before the buildings exist. These drawings are construc-

tions based on the information obtained from plan and elevational diagrams.

You must understand these two words, 'plan' and 'elevation'. A plan is like a map, it describes the horizontal features of an object or group of objects. An elevation is a view taken at right angles to a plan and gives information on vertical features. If you look at fig. 195, a plan of the rectilinear

Fig. 195. Plan and elevation diagram.

solid would be the actual features of surface 'A' and an elevation the features of surface 'B'. Because it is perfectly regular, these two diagrams tell you everything about the object. From them you know every dimension and have the details of every surface. If, however, this were a house rather than a rectilinear solid you would require much more information. The equivalent of 'A' would be only a ground plan and you would need plans of each floor and the roof. Likewise, you would require elevations of the front as well as the side, before you had reasonable knowledge of the object.

Fig. 196 shows a model which can be used to demonstrate plan and elevation and, in addition, shows what happens when you look at objects and trace their images on a picture plane. When you draw directly from observation you are carrying out an exercise exactly like the one demonstrated in figs. 197–9 but with some slight (but important) differences. Firstly, your drawing surface (the paper on your drawing board) is the picture plane. In the majority of cases you have no actual plan or elevation of the subject, but you will remember I have insisted that you should have the maximum possible knowledge of your subject and when I said that in the life room it was important to view the figure from every

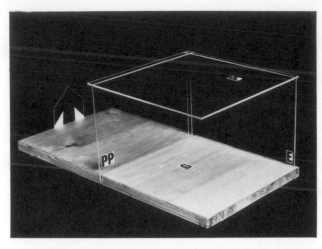

Fig. 196. The arrow points to the viewing position. PP=picture plane; P=plan; E=elevation; G=ground.

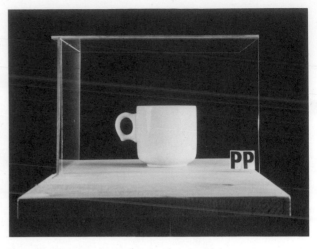

Fig. 198. The view from the viewing position.

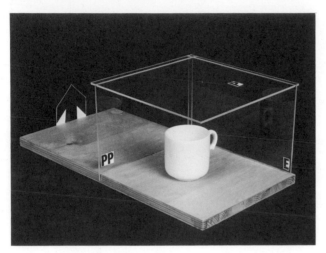

Fig. 197. The model with an object in position.

Fig. 199.

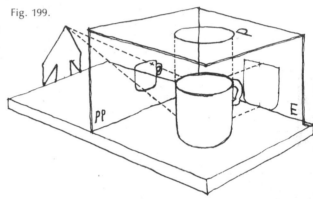

The dotted lines represent the infinite number of visual rays radiating from the viewing position to the object. Where the P.P. cuts these rays, determines the size and shape of the object in the drawing.

Figs. 199 and 200. The plan and elevation of the cup can be obtained by transferring the *actual* measurements of the object onto the appropriate surfaces. The image on the picture plane is *projected*.

possible angle, it was in order to compel you to have plan and elevational views available in your mind when you drew from your single viewpoint. Another important difference between reality and viewing an object using the model in fig. 196 is that in reality your eyes are not fixed to a single viewpoint and you do not keep your head in the same position throughout making a drawing. If you look now at fig. 200 you can see how it is possible to construct a drawing geometrically without having to have a transparent screen. The complete operation can be worked out on paper and the images that would appear on picture planes positioned at various points can all be reproduced. The example illustrated is a particular one; it is like the flat-on rectangles in parallel perspective we have drawn already. There are additional problems when you go on to consider corner-on views of rectangles.

The practical work required earlier in the chapter involved comparing drawings from observation and drawings constructed according to the rules of perspective. Now I am showing you how to use perspective to construct what would appear

on an imaginary transparent screen (the picture plane). You are getting so involved with theory and fact that it is important to examine the crucial question, 'Is a perspective drawing a record of what you actually see?' If you were prepared to surmount the difficulties involved in using transparent sheets of some suitable material for making your studies, and then to transfer the results to paper, would this be the same as making accurate drawings directly from observation? The drawings, if traced absolutely accurately, should be the same as perspective drawings, and as they are carried out from observation it would appear that they should be what you have actually seen. Does perspective reconstruct what you see? Does a drawing carried out using the rules of perspective turn out to be exactly like an extremely accurate drawing made directly from observation? The answer to the first question is a qualified 'yes' but, paradoxically, to the second is 'no'. It is strange

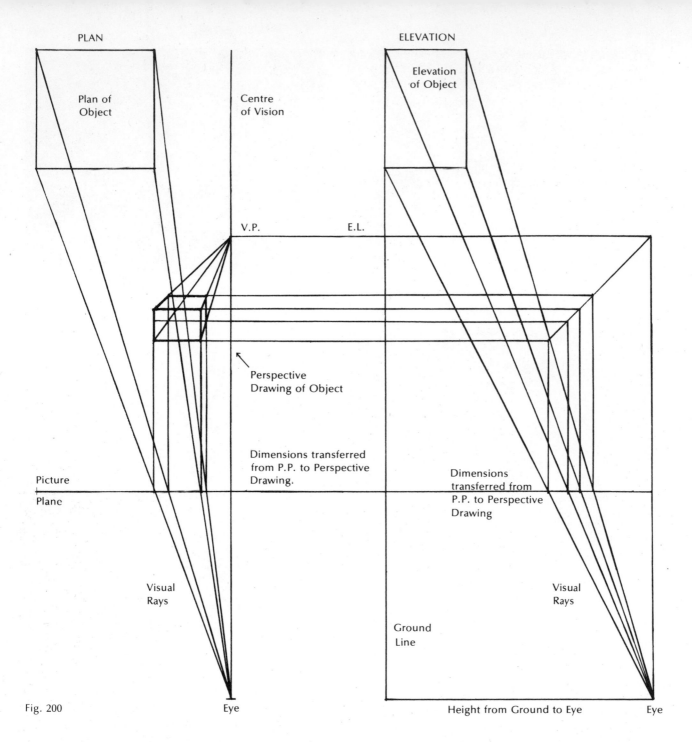

PLAN

Plan of
Object

Centre
of Vision

ELEVATION

Elevation
of Object

V.P.          E.L.

Perspective
Drawing of Object

Dimensions transferred
from P.P. to Perspective
Drawing.

Dimensions
transferred from
P.P. to Perspective
Drawing

Picture
Plane

Visual
Rays

Visual
Rays

Ground
Line

Fig. 200          Eye

Height from Ground to Eye          Eye

that perspective was not really developed until the Italian Renaissance, because for anyone who cared to look, it has always existed. Parallel lines do appear to recede in the visual world and you know by now that the relationship of the level of your eyes to the ground makes a great deal of difference to the view you have of objects. Even so, when you draw using geometrical perspective, you do not draw what you see. You make a reproduction of the information appearing on the retina of your eye and you will remember from my description of the process of observation in the introduction that the retinal image and what you 'see' (i.e. what your brain decodes) are two different things. What you 'see' is different

because it is affected by size constancy. This is a term for the way in which you tend to scale up the size of distant objects. Even though something observed in the distance appears on the retina as a tiny object, your brain automatically enlarges it. A very good instance of this is often clearly illustrated in holiday snapshots. When you look at a particular architectural subject, for example, you may be impressed by the relationship of foreground to background buildings, only to find when you eventually see the photographic record that the background buildings are much smaller and less significant than you remembered them.

Broadly speaking, perspective is what we should

'see' but it eliminates the all-important constancy factor. It produces results related to photographs and in photographs distant objects usually seem to be too small. It would be easy, therefore, to say that perspective is unimportant as an aid to drawing from observation, and it is true that it has recently been almost eliminated from students' studies except for inclusion in technical drawing courses for design students. It is interesting to note that our ability to scale up distant objects seems to be much better when we are observing on a horizontal rather than on an inclined plane. Photographs of buildings taken with the camera pointing upwards result in very unstable results, the buildings usually looking as if they are about to collapse, and architects have designed buildings which take into consideration the fact that our visual compensation for distance is not nearly so efficient when looking upwards.

Unless, however, we can find another way of giving visual clues to indicate distance in our drawings, perspective is necessary. Without perspective (which is only a means of determining the

Fig. 201. Natural form study. Student drawing.

Fig. 202. *The Table 1916* by Gris (Philadelphia Museum of Art: The A. E. Gallatin Collection 52-61-37).

Fig. 203. Illustration to story of *The Marriage of Nala and Damayanti* (Indian) (Victoria & Albert Museum, Crown Copyright).

Fig. 204. *The Different Processes in the Making of Colour Prints.* Utagawa Kunisada (Victoria & Albert Museum, Crown Copyright).

relative sizes of objects) although it is possible to create an illusion of depth (figs. 201–4) this illusion will not be like the visual world. The artist is, in this case, creating a new kind of space which although you can identify with it, as it includes elements of your visual experience, is a personal creation not a record of an external situation.

It is interesting to speculate on why, if a perspective drawing is really like the visual world, our brain does not scale up the distant objects in the drawing. The reason is that this constancy factor only operates when we are looking at actual depth and not at an illusion. A drawing has really only two dimensions and the depth is evoked

110

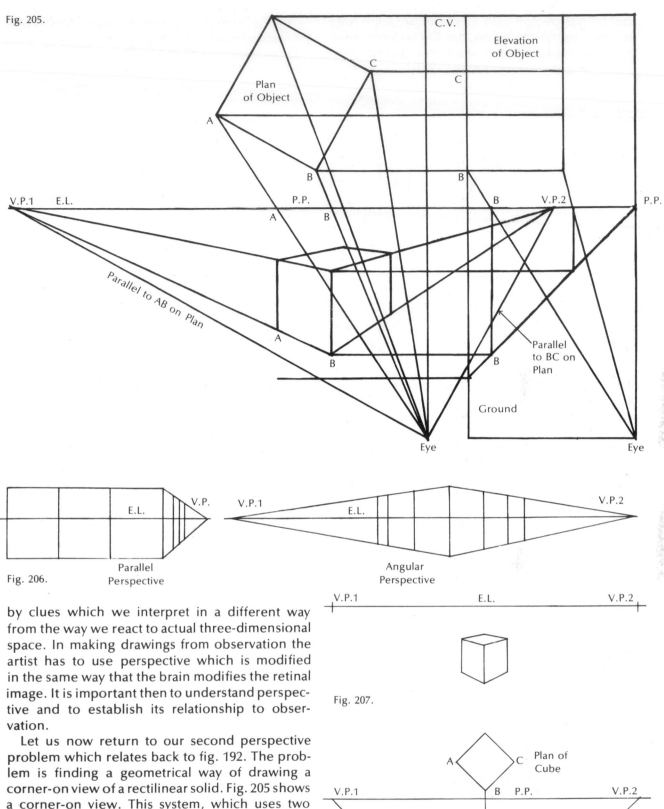

Fig. 205.

Plan of Object

Elevation of Object

C.V.

Ground

V.P.1　E.L.　P.P.

Parallel to AB on Plan

V.P.2

P.P.

Parallel to BC on Plan

Eye　Eye

Fig. 206.　Parallel Perspective

V.P.

E.L.

V.P.1　E.L.　V.P.2

Angular Perspective

V.P.1　E.L.　V.P.2

Fig. 207.

V.P.1　E.L.　V.P.2

Plan of Cube

Parallel to AB

Parallel to BC

Centre of Vision

P.P.

Fig. 208.　Eye

by clues which we interpret in a different way from the way we react to actual three-dimensional space. In making drawings from observation the artist has to use perspective which is modified in the same way that the brain modifies the retinal image. It is important then to understand perspective and to establish its relationship to observation.

Let us now return to our second perspective problem which relates back to fig. 192. The problem is finding a geometrical way of drawing a corner-on view of a rectilinear solid. Fig. 205 shows a corner-on view. This system, which uses two vanishing points rather than one, is called angular perspective. It obviously allows for a much greater degree of realism as it does not restrict the artist to the limited range of views that parallel perspective allows. A system which allows corner-on views of rectilinear solids must employ two vanishing points because no surfaces of the object are parallel to the picture plane. Fig. 206 shows the difference between the parallel and angular perspective. The illustration (fig. 207) demonstrates

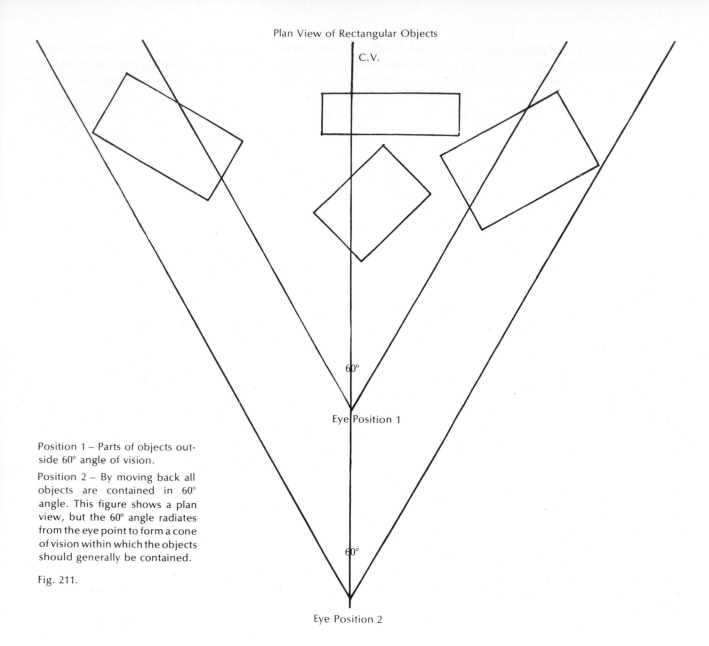

C.V.

60°

Eye Position 1

Position 1 – Parts of objects outside 60° angle of vision.

Position 2 – By moving back all objects are contained in 60° angle. This figure shows a plan view, but the 60° angle radiates from the eye point to form a cone of vision within which the objects should generally be contained.

Fig. 211.

60°

60°

Eye Position 2

example where 'truth to observation' is very difficult to reconcile with drawing. You can look at objects and draw a translation of exactly what you see in front of you, but because you are using what are really a series of different viewpoints the result will convey a completely different impression. The drawing, in a sense, is true to your observation, but when you look at a drawing your eyes do not travel over it in the way they do over the subject. Unless the drawing (or picture, as this applies to all two-dimensional artifacts) is so large that it cannot be taken in at one glance, you almost always assume a single viewpoint. Many drawings that I have made have been drawn taking in a view from top to bottom of the drawing that is impossible without moving the head. In some cases the angle must far exceed 90°. I would maintain that these drawings are accurate to my observation (figs. 188 and 212), but the use of a whole series of different eye levels has the result of reducing the illusion of depth in the drawing and the foreground becomes flat-

tened. If you start a drawing at your feet and continue looking and drawing upwards to the horizon, a rectangle at your feet would be represented by a straightforward plan view while at the horizon a rectangle would be just a straight line.

You can see from this that perspective is helpful, but it is not a system that once learned and applied to all your drawings will readily provide an accurate basic structure for them. You cannot avoid modified perspective when you make drawings from observation, as the illusion of depth that is the fundamental problem is achieved by directions and scale relationships which are also the systems used in perspective. The decision you are faced with constantly is to what degree you are going to modify or even ignore perspective. When I mention ignoring perspective, it must occur to you that perhaps it is unnecessary to worry about these geometrical problems at all, and it is quite true that drawings can be produced from observation without any knowledge of per-

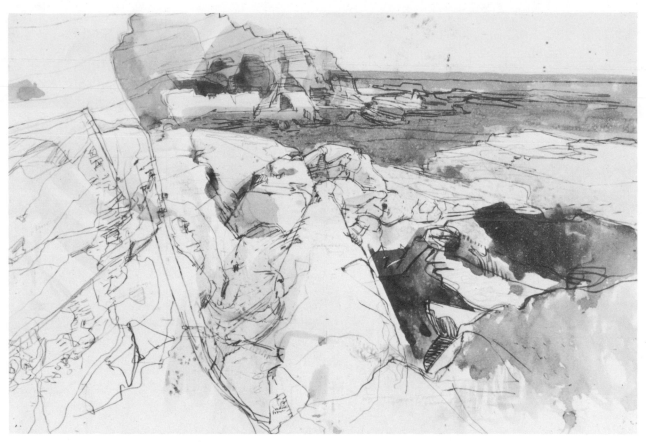

Fig. 212. *Coastal Landscape* (I.S.).

spective. Assuming no previous knowledge of perspective in the reader, then all your drawings prior to this chapter have been produced from observation alone and you will now be able to assess for yourself whether this additional information now enables you to relate directions, for instance, in a way that had not previously occurred to you. For a few, perspective may get in the way of observation. They may, given some definite rules (in contrast to the previous instruction which has emphasized guide lines only and not provided any hard and fast drawing laws), seize gladly on perspective as offering a security that they feel they require. This is really avoiding the main issue of observation, translation and drawing. The delicate balance between all the possibilities is one that must be preserved or the result will be limited to an exercise in the application of a geometrical formula which is far from being the aim of drawing.

Fig. 213.

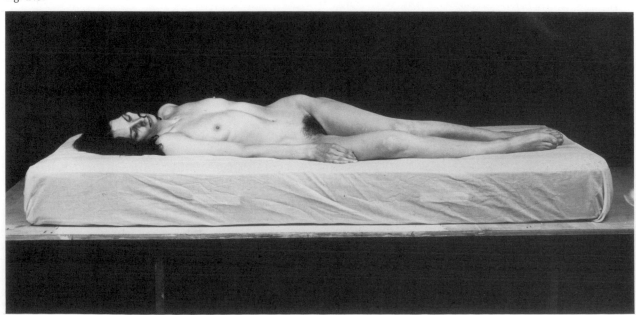

It is worth spotlighting one kind of problem that occurs when drawing, and the confusion that can arise when the rules of perspective are applied in order to solve it. Fig. 213 shows a typical life-room situation with a model lying on a rectangular mattress. If you take a viewpoint close to the model you can have a position where you cannot

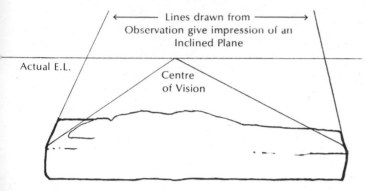

Fig. 214.

see the two ends of the mattress simultaneously, but have to turn your head, a state of affairs that I have already illustrated in this chapter. If you carefully assess the angles at either end of the mattress you get a shape as in fig. 214, but it does not give you the illusion of being a rectangle receding on a horizontal plane. From your knowledge of perspective you know that if you check your eye level and see that the two sides of the mattress, when projected, meet on it, you should have the required shape. If you do this, though, you will produce a shape which would be the equivalent of the view of the mattress that you would obtain only if you were to move your observation point further back in the studio. If you do not, then it is as if you were working on two different drawings and obviously the correct relationship between figure and mattress cannot be established. The problem obviously evident in the drawing of the mattress is also there less obviously

Fig. 215.

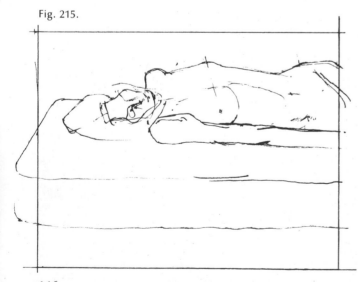

in the figure. The lines that could be drawn through the shoulders, breasts, hips, knees and ankles will be unrelated in the same way as the lines describing the ends of the mattress. A choice is available. You can draw from the close viewpoint and accept the distortions, or the viewing position can be moved back to allow the whole subject to be in the field of vision, or from the close viewing position you can narrow down the section of the subject drawn so that it is within the field of vision (fig. 215).

I have been concerned in this chapter with perspective as an aid to drawing from observation, and I have shown its limitations in this field. Where perspective is indispensable is when there is no subject to observe; where (as in the case of an architect's drawings) there are only designs, usually in the form of plans and elevations, and one is required to project from this information an idea of what the eventual object will be like in its completed three-dimensional form. It is possible to carry out drawings in measured perspective so that the views are an accurate description (in the perspective sense of accuracy) of the objects depicted (fig. 216).

There are occasions when some degree of measurement may be required in drawing from observation. It can also be very useful on occasions to make a sketch plan of the subject when (or before) drawing. This might be used in conjunction with some of the perspective principles I have discussed. It might also be used just as a means of clarifying your mind and establishing exactly where each object is in space so that this can be established in the drawing.

It is worth mentioning that there are drawing systems other than the perspective we have studied which give spatial information. The system that I have described so far in this chapter is called linear perspective. There is another system, aerial perspective, which creates an illusion of space. This system is not so much concerned with the precise shapes of objects and the way they appear to reduce in size as they get further and further away; rather it deals with the tonal changes and colour changes that can be observed as objects recede in space from the observer. You know that distant mountains always look blue because the atmosphere intervenes between the observer and far away objects and they become more and more muted in colour the further away they are. The colour also becomes relatively more blue the further away it is. Receding objects also become less distinct in both shape and form and their tonal values change. Drawings can be made which make use of this out-of-focus effect, and also the effects of tonal changes (fig. 217). The darkness (or lightness) of tone used can create very positive spatial illusions, and this is true whether the means used are tonal variations of

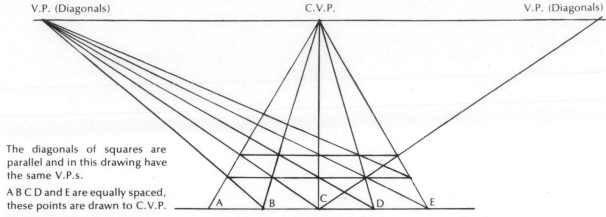

The diagonals of squares are parallel and in this drawing have the same V.P.s.

A B C D and E are equally spaced, these points are drawn to C.V.P.

The diagonals are then drawn and they mark off the lines to C.V.P. so that horizontals can be drawn to produce a grid of squares.

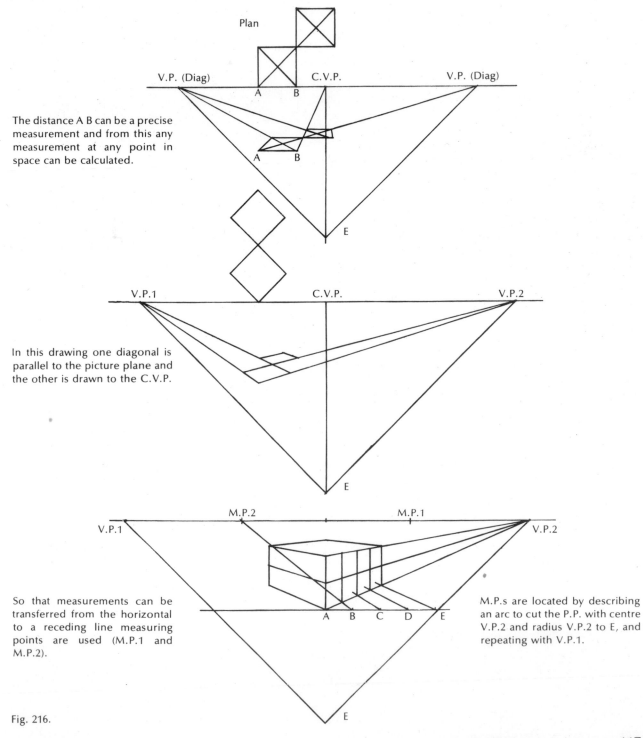

The distance A B can be a precise measurement and from this any measurement at any point in space can be calculated.

In this drawing one diagonal is parallel to the picture plane and the other is drawn to the C.V.P.

So that measurements can be transferred from the horizontal to a receding line measuring points are used (M.P.1 and M.P.2).

M.P.s are located by describing an arc to cut the P.P. with centre V.P.2 and radius V.P.2 to E, and repeating with V.P.1.

Fig. 216.

117

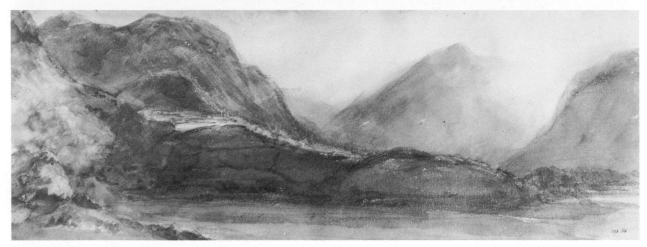

Fig. 217. *Studies of Landscape* by Constable (Victoria & Albert Museum, Crown Copyright).

area or line. If you draw a series of vertical lines (of equal length) making some very dark and others light in tone, there are immediate indications of space. The same is true of areas of tone and generally the dark lines or dark tonal areas appear to be nearer than the light ones. This to some extent depends, however, on the size and relationship of the areas. A light area can appear

Fig. 218. *Coastal Landscape* (I.S.).

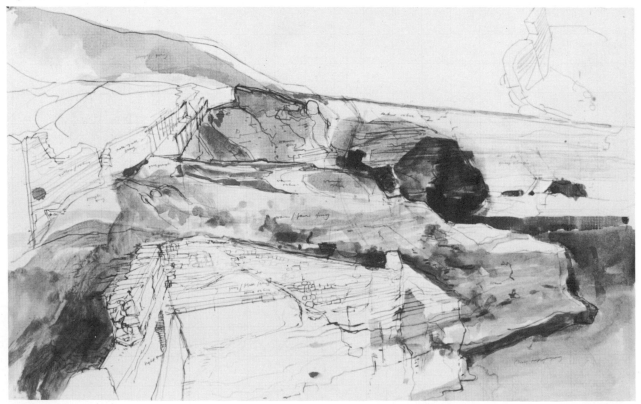

to advance from a dark area if the shapes are so organized that the appropriate degree of contrast is produced (fig. 218). Some of these points have been covered in a slightly different form in earlier chapters. For example, in Chapter 9, in discussing the way that three-dimensional form could be described by line, I showed how space could be created by overlapping forms and also by adjusting the strength (i.e. the darkness and width) of lines so that one section seemed to be positioned nearer in space than another.

The relationship of object to background has also been touched on and there are factors that you will have discovered in your own drawings that have a significant bearing on this. There are no rules. You cannot adopt a policy of making foreground tones darkest and foreground lines darkest to create a spatial effect. What can be said is that tonal areas and darkness of lines are factors that can be used to create a sense of space, but they must be used in a critical way to translate observation into drawing. It can be very useful to experiment with these effects in isolation. By this I mean that you can make drawings that are not actually translating observation but are an examination (an exercise, if you like) of how these tonal marks can be used. A start can be made in organizing dots, then lines, then areas of tone, and after this, various combinations of all these. You can then move on to using actual visual situations that have a particular quality that will allow the exploitation of one or other of these tonal devices. There is, for example, a close relationship

between an exercise using vertical lines and a study of a group of trees as in fig. 220. Horizontal lines might be used in considering various aspects of landscape or seascape.

Drawings made from subjects with an absence of strong lighting are very suitable for demonstrating the way that diffuse lighting reduces the clarity of the shape of objects. These drawings would, of necessity, be concerned with examining a considerable degree of depth. A drawing of a large

Fig. 219. *Sun Trying to Penetrate Fog* (Radio Times Hulton Picture Library).

room is a possibility, but an outdoor subject in bad light would be ideal. Fog creates this kind of visual effect as well (fig. 219), and there are several ways in which the effect can be created artificially by something being interposed

Fig. 220. *A Study of Trees* by Tom Robb.

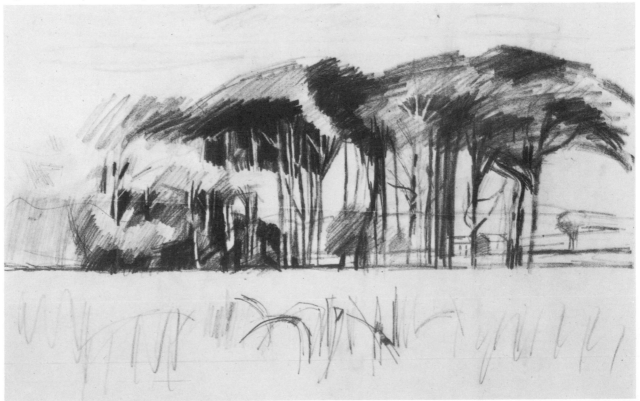

Fig. 221. *Quayside Whitstable* (I.S.).

between the observer and the subject. Examine a view through a window which has fine net curtains in front of it, for example, or views through different kinds of semi-opaque glass. These have the effect, again, of blurring images, making them less distinct, and the use of light and dark areas of tone in conjunction with different weights and widths of line can be a useful means of describing this visual phenomenon.

In the section on aerial perspective I referred to subjects like landscape and views of buildings which can involve a considerable degree of actual depth. On the other hand, the sections on linear perspective dealt only with the most simple geometric shapes. It is now necessary to examine subjects which will extend your use of linear perspective by drawing variations on the rectilinear solids drawn earlier. These can be found in subjects like townscape, markets, or in situations you could set up indoors using books and boxes, for example. Of course all the points that have been made about the construction of rectangles in linear perspective are true of other regular and irregular shapes. Circles will diminish in space on the same scale as squares and so will freely contoured shapes. And though there may be few straight lines in trees or the human figure, they are subjected to the same general rules as basic geometric shapes. In drawing more complex subjects, the two vanishing points for an object that occur in angular perspective are not always going to be positioned on the paper. You will have

to rely on your developing experience to indicate whether lines going to vanishing points off the paper are correct. The emphasis in these drawings should be based on the observation and translation of earlier chapters with the acquired background of basic perspective used to measure and, if appropriate, modify your results. Continued study of aerial perspective depends to a great extent on selecting subjects with sufficient actual depth for you to observe the fading of images that occurs when objects are a long way off. You should consolidate the study of the drawing systems detailed in this chapter by drawing some complex subjects involving geometric and freely shaped objects in a situation offering considerable depth and where atmospheric tonal changes can be observed. Warehouses and docks could offer some absorbing possibilities – the cranes, like the space frames used in your subject groups, and the simple buildings offering variations on the geometric objects considered earlier. The drawing (fig. 221) is an example of these problems studied in a particular subject.

Fig. 222. *Black Vulture*. Student drawing.

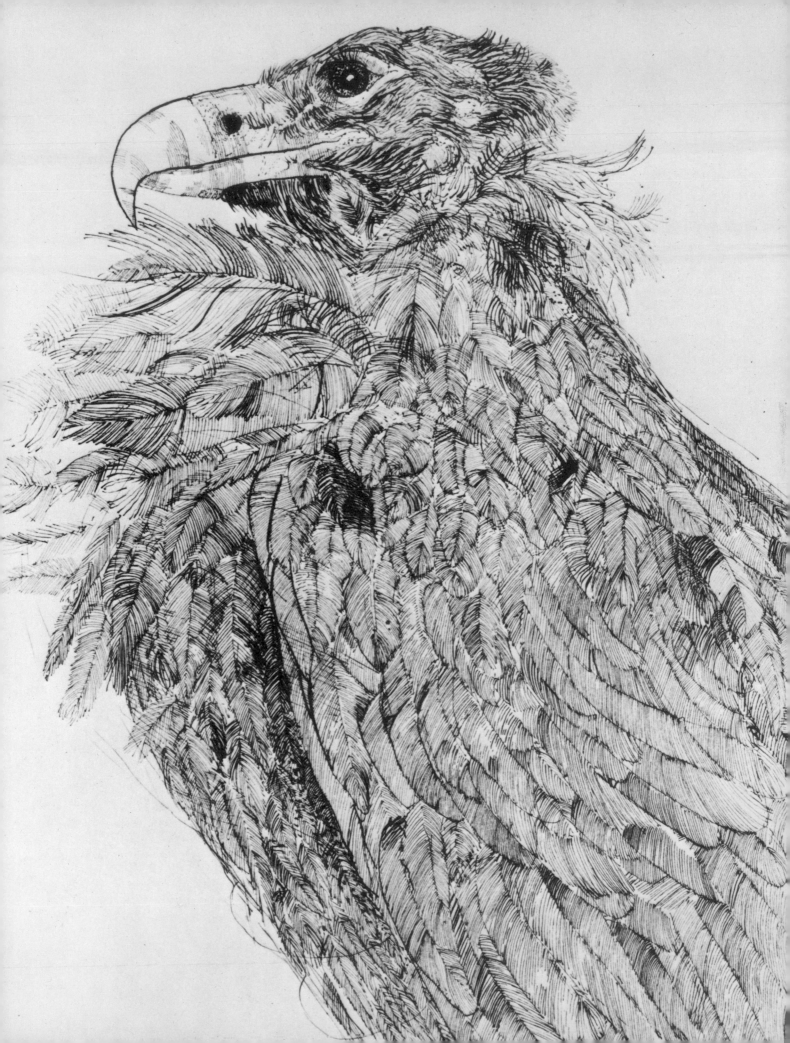

# 12 TEXTURE

In the previous chapters the surface quality of objects has been ignored. There has been no concern as to whether a surface was brick, for example, or an area of grass, yet these two surfaces give us two very different textures. Areas of brickwork generally offer a surface regularly broken by the lines of mortar between the rows of bricks, and grass has, in contrast, a soft irregular texture. Texture can be a very useful means of revealing the form of an object and the drawing of texture can be another way of creating a sense of depth in a drawing. Fig. 223 shows a view along the

Fig. 223.

surface of a wall. The brick texture, made up of the diminishing size of the bricks as they get further away in space, gives a very clear indication of the distance this wall extends away from the observer. Drawing this texture would obviously create the same kind of spatial effect shown in the photograph. If you think of the drawings you have done to date as showing the main shapes of objects, the drawing of texture is a way of breaking down these main shapes into their

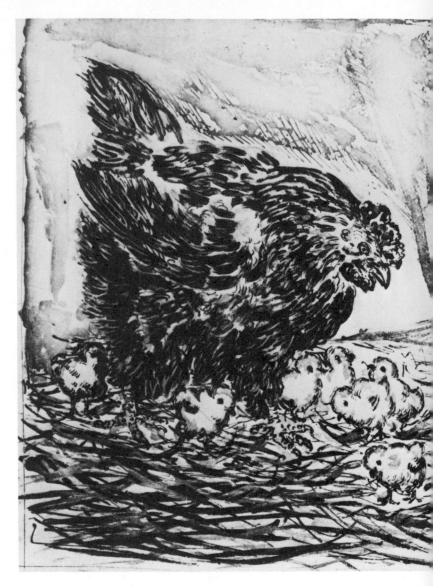

Fig. 224. Illustration to Buffon's *Natural History* by Picasso (Courtauld Institute Galleries, London).

smaller components. Each main shape can be analysed for the purpose of discovering its best space-descriptive properties in the same way that the main shapes have been considered in relation to the complete subject.

Just as you can see textures in the objects you draw, your drawings contain textures produced by the intrinsic qualities of the materials you use. A scribbled area of pencil has a distinct quality which is different from the effect created by shading with conté or the smooth tones that can be achieved by wash. Linear media have different qualities too. The hesitant grey line that can be produced by pencil contrasts with the definite hard line that can be produced by a pen. These devices have to be used sensitively and in a critical way and, equally important, in an experimental way as well. Sometimes a description of texture may indicate in a drawing the contrast of two or more actual substances. The consideration of using its ability to describe form and space may

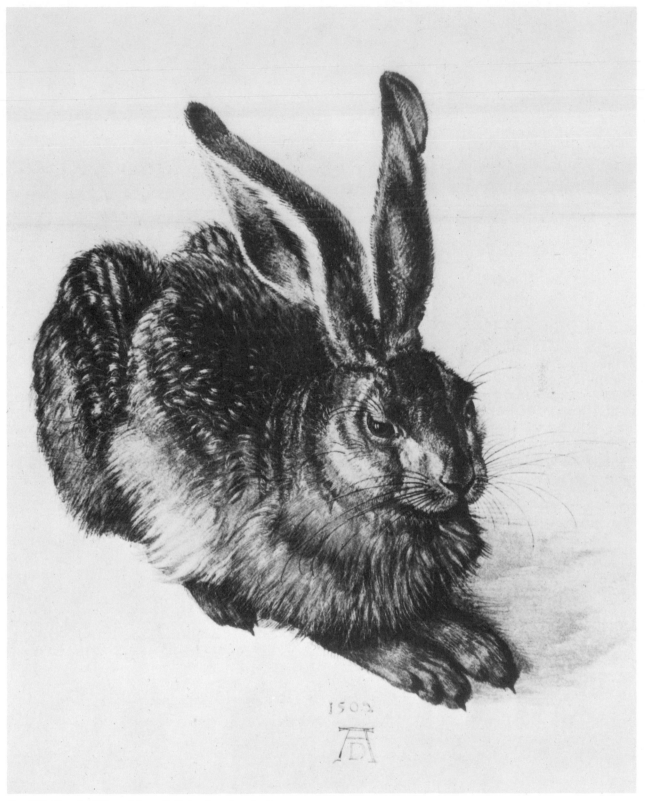

Fig. 225. *Hare* by Dürer (Mansell Collection, London).

then be secondary. The Picasso lithograph (fig. 224) (a drawing process carried out on a stone or plate that allows a series of prints to be made), effectively contrasts the different textures of the hen's feathers and scaly feet, those of the soft chicks and the hard long strands of straw. He has, however, used these textural descriptions in such a way that they indicate the three-dimen-sional form of the hen and chicks. Fig. 225, a drawing of a hare by Dürer, shows the drawing of texture organized in a selective way so that it describes the light falling on the animal and the details of minute changes of form (like the waves in the fur). It preserves, however, the sim-ple relationships of the main forms of the head, body and hind legs of the hare.

Fig. 226.

In the section on aerial perspective in the last chapter, you saw that the drawing media allowed you to create an abstract space, a space that was not describing a direct visual experience. Texture can create similar effects. Fig. 226, showing dots distributed close together at the top of the drawing and wider apart at the bottom, gives the illusion of a ground plane receding in space. You should experiment with textural devices and observe how these abstract spatial effects can be created. Follow this by trying to use these effects in relation to an actual observed experience (figs. 227–9).

Fig. 227. *Stubble Field* by Charles Keene (Ashmolean Museum, Oxford).

Fig. 228. Snake. Student drawing.

Fig. 229. *Beach* by John Titchell.

Fig. 230. *Foxes* by Pisanello (Radio Times Hulton Picture Library).

Fields, roofs, roads, pavements and any large areas which are relatively unbroken and apparently featureless, offer interesting subject matter. Try making a drawing looking over the surface of an unpatterned carpet or a lawn, for instance. The most important thing is to move from the abstract effects to the examination of objects. This must be genuine analysis, not merely getting an idea of a texture and then superimposing it on the drawing as a preconceived device. You will usually need to get close to the surface of an object to be able to analyse its texture properly and it is important to find the particular quality that a surface possesses and not just to decorate areas of your drawing with some general statement of texture.

It is not necessary to include references to texture in drawing. The main aim in drawing from observation is that of describing space and form in a selective way and it may well be that the

fact that one form is hard and shiny and another soft and of a completely different texture is irrelevant. It is easy to be led astray by concern for texture and to apply to surfaces in your drawing a mere decoration which in no way enhances the illusion of space and form. Texture must be observed as keenly, analytically and selectively as any other part of the subject, but it must help to define space and to give a feeling for form as well. If you look through this book at the illustrations, you will see little evidence of concern for texture on the part of the artists. There are occasions, as in the drawings of animals or birds in figs. 222 and 230 when it is difficult to avoid coming to terms with it. The form of the animal is soft and cannot have a really firmly defined outline. You then have to decide how important the texture is, and if it is to be included you must find a means of translating it into drawing.

Again, I would like to remind you of multi-media drawings. Some media are much better than others at describing the textural effects you may wish to achieve and it is important to choose the most appropriate tool for the job. There is

Fig. 231.

always a temptation that you must strongly resist to include textures to give your drawing a kind of additional interest. Unless the objects are observed analytically and recorded in a convincing manner, all the decoration in the world will fail to improve the drawing. Even though, to some extent, I have been discouraging about drawing texture, you should try some more drawing involving this. A good way of continuing the study of texture would be to collect a group of smallish

objects that can be put on a table. These should offer as wide a range of textures as possible (fig. 231). Continue making drawings of textural contrasts and extend this to working from outdoor subjects. Some drawings requiring very detailed treatment of single objects should be attempted. These should be both hard textural subjects like a piece of stone or a rough brick and soft objects such as fur or an animal or bird. Museums often offer natural history possibilities which are eminently suitable for this study and there are numbers of natural forms with a variety of contrasting problems. The hard spiky forms of teazles or the more angular texture of geological specimens would be particularly useful.

Many things can be implied in drawing without their actually being stated. The silhouettes of objects, for example, can suggest their texture. A firm precise shape and, in contrast, a shape with blurred edges can both suggest an overall texture for an object without it actually being drawn. If the object is recognizable in your drawing then, to some extent, the texture is implied as well, as the brain is adept at producing a complex series of images from a few visual clues. In making studies of texture, however, it is best to avoid objects with a very distinctive and familiar texture and to attempt some that demand consideration of the particular surface quality in some detail. It is appropriate to underline again at this moment the fact that drawing is primarily a means of research. It should compel you to examine something in a way that no amount of looking, on its own, can do. Thus in order to translate the observation into drawing, a degree of analysis has to take place which is hardly possible if the drawing step is not undertaken. There is a danger, though, in all forms of visual research that the research aspect will be sacrificed to 'picture making'. That is, that instead of retaining the approach of observation, analysis and translation into drawing, the observation and analysis are put aside and the drawing begins to be concerned only with the inclusion of elements that add purely pictorial interest. These elements may produce a more impressive picture but they do not give more information about what you have observed or your use of visual language. Drawing the surface qualities of objects can be a decisive way of describing both space and form, but it has serious overtones of picture making and has to be considered as a means but not an end in itself. Once you have covered the suggested drawings in this chapter, the possibilities of textural qualities should be one of the features which you will certainly consider and use when making drawings but it should not predominate, unless it is really intrinsic to the particular study and not just a kind of visual padding which extends your drawing to no real purpose.

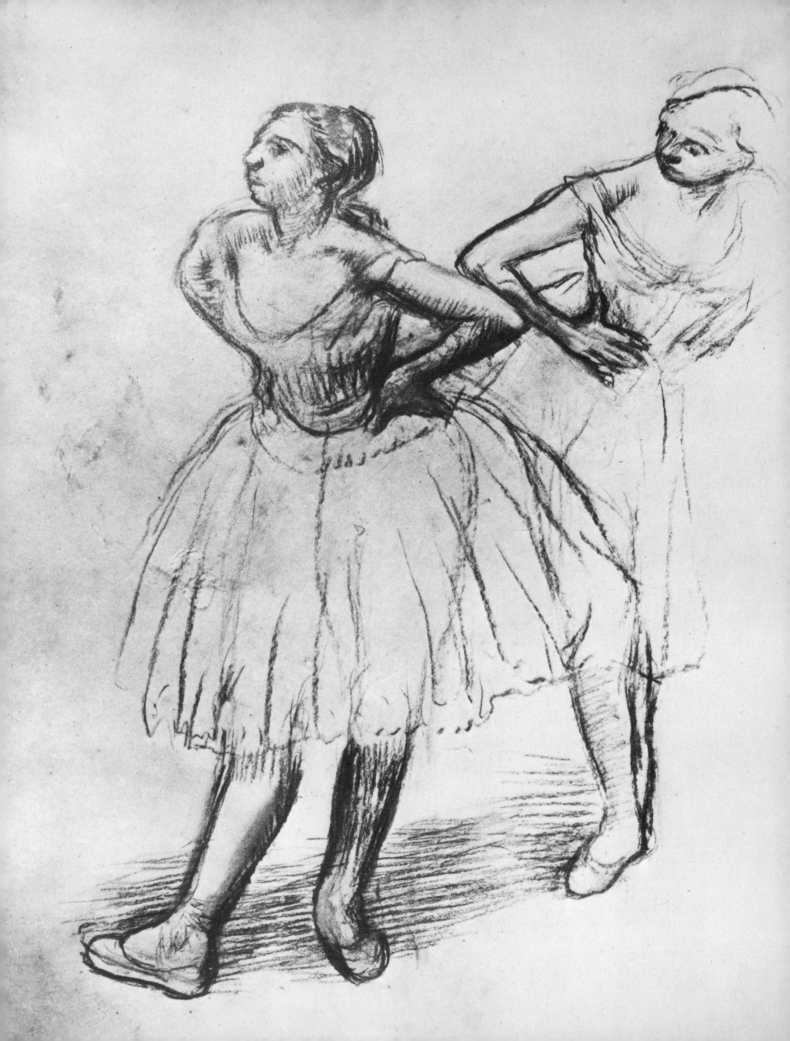

# 13 LIGHT SHADOWS AND REFLECTIONS

In order to see anything, there must be a source of illumination, but apart from demonstrating in Chapter 9 that selectively recording the way objects would be lit by a single light source was an important element in describing form, I have largely ignored light so far. Light, however, as well as revealing space and form, creates a whole range of visual phenomena that you must consider when you draw. First, think of light in the most simple and obvious ways. You have, so far, thought of it as coming from a single source and striking objects on one side so that they are neatly broken up into light and shade which will conveniently form the basis of an illusionary three-dimensional drawing. In practice, though, this state of affairs can be difficult to find. If you have groups of objects indoors there is often more than one natural light source – two windows, for instance; added to this, many surfaces reflect light and these effectively produce additional light sources. Natural light changes in intensity constantly and the light source changes as well, according to the position of the sun. This poses problems with indoor situations which is why artists' studios conveniently have north lights (i.e. their windows face north), so that they are not subjected to brilliant sunlight moving round the room during the day and altering the lighting conditions. Outdoors the problems are greater. If you make a drawing of a complex subject which demands working on one spot for most of the day, objects which could be revealed in detail by brilliant lighting from the front would, later on, be simple, dark silhouettes against the light. In addition to reflecting surfaces causing confusion, some materials slow down the passage

of light and create additional visual phenomena. This slowing down of light, or refraction, is the basis on which lenses form images and prisms bend light. You can see examples of the kind of phenomena I mean if you put a straight rod in water and observe the way it apparently bends, or if you look at an object through a window of reeded glass and see how the varying thickness of the glass creates unexpected distortions.

Light casts shadows and these can be used very effectively in drawing, though used indiscriminately they can easily be a source of confusion. Drawing teachers have often ruled that shadows should not be drawn as they are too concerned with photographic copying (which could be described as a form of drawing using light on a special, sensitive, two-dimensional surface) and are not really to do with translating form which is the real concern of drawing. It is wrong, in my opinion, to ignore the possibilities of anything that can be useful, although you must be wide awake to the dangers of the indiscriminate use of shadows. The result can easily be, at worst, a very laborious photographic study.

How effectively shadows can be used depends on the artist and the subject (fig. 233). Shadows can be used to show the way in which one part of an object projects from another (figs. 234 and

Fig. 233. *Drawing* by John Minton.

237). They can also be used to relate objects to a ground plane (figs. 232 and 236) and, as I pointed out in Chapter 9, they can be effective in giving a clue to the cross-section of a particular form. As an extension of this aspect, the shadow of an object can, for example, reveal the uneven surface of the ground.

Fig. 232. *Study of Two Dancers* by Degas (Arts Council of Great Britain).

Fig. 234. Over: *Study of Hands, also Torso and Legs* by Ingres (Trustees of the British Museum).

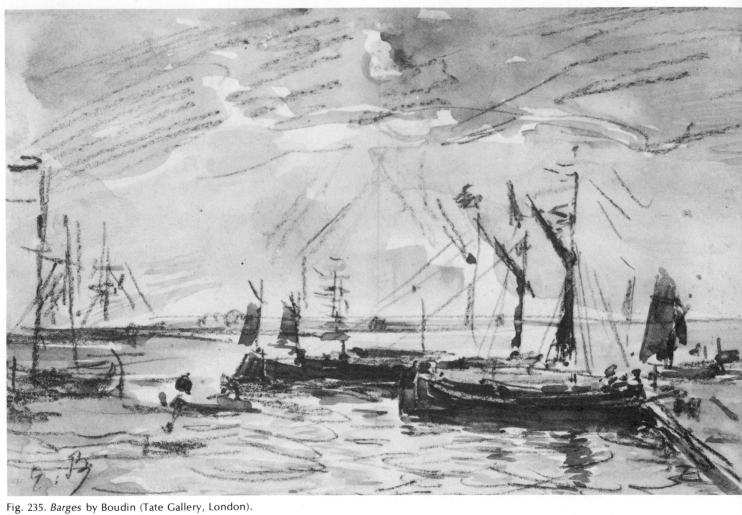

Fig. 235. *Barges* by Boudin (Tate Gallery, London).

Fig. 236. *Study of a Man* by Rembrandt (Victoria & Albert Museum, Crown Copyright).

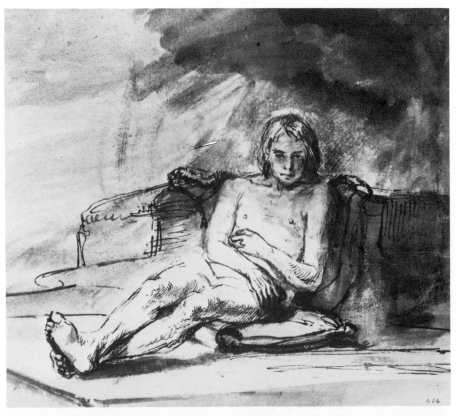

132

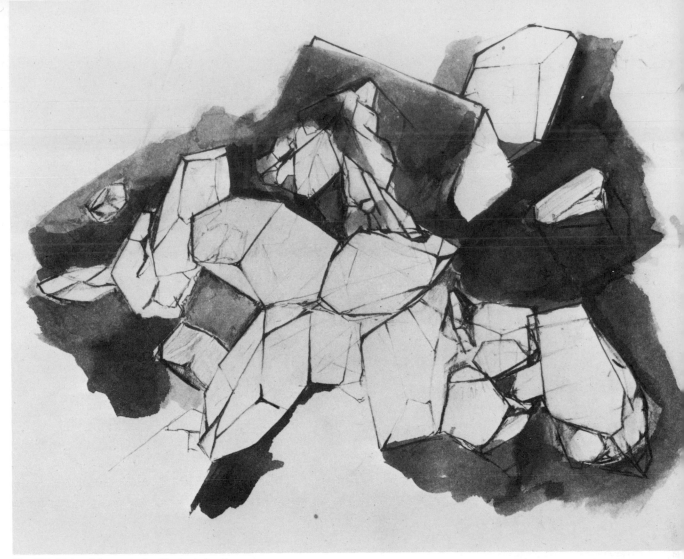

Fig. 237. Natural form study. Student drawing.

Reflecting surfaces and refracting materials tend to be confusing rather than revealing. This is not to deny their possibilities, particularly in producing unusual and unexpected visual effects. To be able to translate clearly a reflective surface may be of primary importance if you are interested in the contrast of the texture of water and landscape (figs. 235 and 238) but you must not lose sight of the primary objective of creating the illusion of space and form, and reflections and distortions caused by refracted light should be used mainly to enhance the three-dimensional qualities of the drawing. In pressing home the point of not being lured into a too literal use of shadows and reflections, I should mention the atmosphere or drama that light creates and which you may want to include in your drawing. I have, so far, talked of shapes, forms and space mainly in the rather purist way of creating on paper a world of clear, distinctly defined forms, precisely positioned in space. It has been a somewhat clinical approach. The observation of light can involve you in a special kind of atmosphere that surrounds many objects, and you may want to include this atmosphere in your drawing. Parts of the objects

may be immersed in dark shadows. Forms may be reflected in unsuspected ways. Shadows may conceal form rather than describe it and you may want to exploit the spatial ambiguities rather than the clear exposition of precise reference points.

All this, again, highlights the fact that as you continue to examine objects and situations step by step, and to discuss the ways in which their particular qualities can be translated into drawing, it is reasonable to anticipate that parallel with this you will be continually developing different interests and attitudes towards your subject matter. These may not simply reflect a preference for some objects over others but, more hopefully, the development of an attitude concerned with the abstract qualities of drawing. At any rate, you now have more and more to decide on. Initially, when you drew cubes for instance, it was just a question of linear accuracy, but now a whole host of decisions have to be made. Let me emphasize again that the decisions I am referring to may not be of a kind where you sit and consciously work out a response. Drawing is infinitely variable and flexible and it is in the act of drawing itself that some of the problems are unconsciously

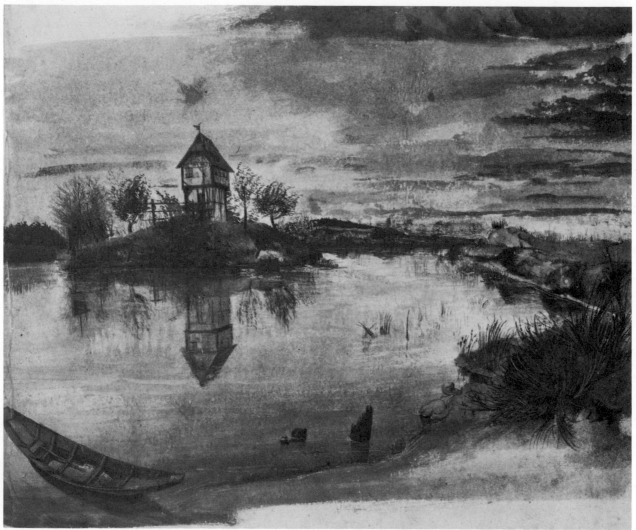

Fig. 238. *A Weirhaus* by Dürer (Trustees of the British Museum).

tackled and, to a large extent, intuitively solved. There are two pieces of practical advice that may prove useful. The first concerns the general problem of how to determine what to draw. Sometimes it can be useful to have a piece of cardboard with a small rectangular hole cut in it which you can look through to try to isolate a section of the visual world which might make an appropriate subject. A hole 1.5 in. by 2.2 in. will have a view which is in the same proportion as a 15 in. by 22 in. sheet of paper. An alternative is to make a series of small studies as a means of examining possible subjects, but the peep-hole method is often an excellent way of providing a starting point for your drawing. The second piece of advice is concerned with making studies of outdoor lighting effects. I am thinking particularly of the problem of drawing shadows and patterns of light and shade when the lighting is changing rapidly. Often by the time you have wrestled with the problem of getting an accurate statement about some of the major features in the subject, the light has

changed completely and if you are building the drawing up piece by piece, you can arrive at a nonsensical final result. The best plan here is to make a quick study of the lighting conditions and constantly refer to this as the more studied (and probably more accurate) drawing progresses. The Impressionists, who were very much concerned with the effect of light on colour, often painted a particular subject for only a short period of time and then returned to it at the same time the following day in order that they had, as far as possible, a constant light, but for many people this is impracticable and, anyway, it demands a climate with fairly predictable weather conditions.

A start can be made on this problem by setting up a small group of objects and lighting them artificially so as to see and study the effects I have mentioned. You should, at first, organize the light so as to enhance form, then light the group so that the objects seem flatter and the sense of space is diminished. Try the light from above and below the group as well as from left,

134

right and the front. Create dramatic lighting effects as well as ones which clearly reveal the objects. Make a series of studies from this group in an appropriate medium. The best approach would be one of experimentation. Try different media in different drawings, but paint and the broader linear media such as charcoal or conté will obviously produce tonal areas more easily than a pencil or pen will do. In recording these lighting effects there is a major problem of translation touched on previously. When you observe situations like these, the range of tones that can be seen from the lightest point to the darkest point is much wider than can be achieved by the use of paints or other drawing media. The same is also true of translating coloured light into coloured pigment. It is essential to admit this limitation right from the start and show by careful selection what you wish to exploit in the light to dark range that the drawing media puts at your disposal. It is useful to fix at an early stage the lightest and the darkest section in the subject, and to bear in mind that the lightest will probably be the white paper and the darkest will be the blackest mark you can make with your medium. The other tones can then be related to these and simplified into a range that can be graded between these two extremes. In drawing groups of objects lit in this

way it is useful to go back to the geometric forms I have used for demonstration purposes throughout. Fig. 239 shows a cube and a cylinder lit from a single direction and I particularly want you to examine the shadows and the relationship

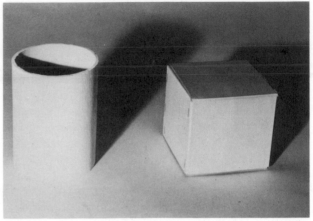

Fig. 239.

they have to the objects. Analysed in terms of perspective, you have to think of the light source (like the sun) radiating rays of light which produce a shadow (fig. 240).

Fig. 240.

The sun is in front of the viewer and to the right. The V.P. for shadows is directly below the sun and on the E.L. The shape of the shadows is indicated by the points of intersection of the lines drawn from the sun through A B C D E and those drawn from V.P. (shadows) through F G H I J.

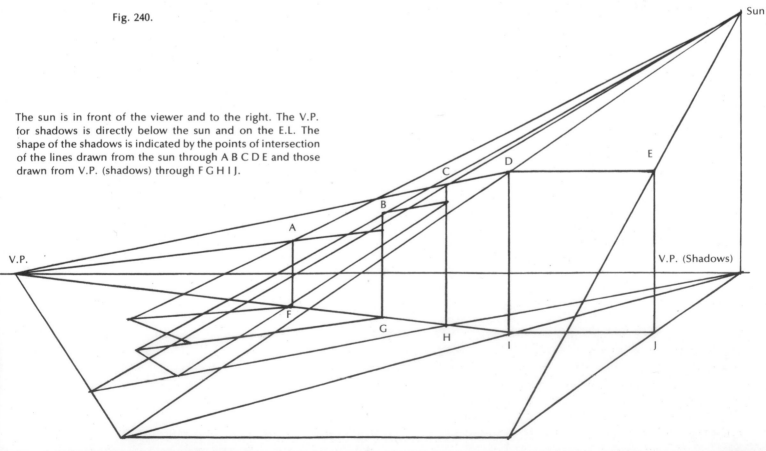

The other large subject area that must be considered in dealing with light and reflections is that of reflective and absorbent materials. Mirrors and similar reflective surfaces produce a world which reads spatially as the reverse of the objects it is reflecting. At some time you must have gone into a room and been surprised by the reflection of the room in a mirror, as often this mirror image has the look of a curious world removed from reality. This unreal world is made much use of by surrealist artists. In some public buildings a whole wall is covered with a mirror which has the effect of transforming the proportions of this particular part of the building. A mirror gives a different view of objects from the one you get when you are looking towards a mirror and the objects are in front of it. The mirror shows the part of the objects that you cannot see.

Water is a notable natural mirror and, again, produces views of parts of objects you cannot see (like the undersides of boats) and also reflects objects some considerable distance away. If you can imagine any object standing on a mirror which is placed on a horizontal plane you will understand the principle of the behaviour of reflections. Fig. 241 shows objects on a reflecting surface. If you place something between the object and this surface, it effectively cuts off part of the reflection and also, of course, it has its own reflection as well. If the reflective surface is not flat the reflection is a distorted view of the object. Note the way these reflections tie up with the knowledge you have gained in the chapter on perspective. It is possible to construct reflections in just the same way as perspective allows you to construct objects. I am not suggesting that you should go to these lengths, but I am demonstrating that if you become involved in reflections in drawing, there is a logic in the reflections and it is important to assess the relationship of object to reflection and to observe how the reflection can be used to enhance the feeling of space in the drawing and also to describe the particular character of the reflecting surface. In connection with light-absorbing materials, I have already mentioned the particular qualities of semi-opaque glass. Water, of course, not only acts as a mirror but if it is clear and you can draw objects projecting into it, its light-absorbing properties cause refraction (and odd distortions) just as reeded glass, for example, would do.

You should make a series of drawings involving reflections and distortions through refraction. There can, of course, be distortions if the reflecting surface is not flat. Different curved, angular and faceted reflective surfaces can be made from thin sheet tin or metal foil. Indoors, it is easiest to examine a variety of objects by placing a mirror or other reflective surface in different positions relative to the group. Outdoors, you should make drawings using rivers or ponds, and the large reflective surfaces of shop windows or the windows of large buildings give interesting possibilities for study.

Fig. 241.

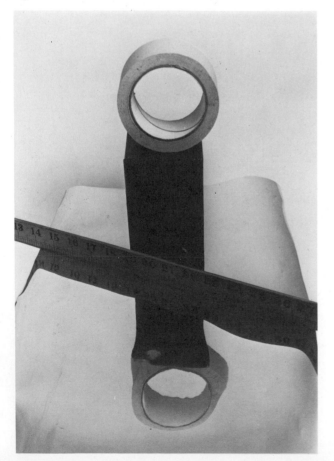

# 14 SOME DIFFERENT APPROACHES TO OBSERVATION

By now I have covered, in outline, the main visual elements that you will come in contact with and I have suggested ways in which what you see can be translated into symbols that someone else can understand. How well can the drawings you have made be understood? How precise is the information in your drawings? It is as well at this point to take stock and try a different approach to observation and a slightly different way of taking a critical look at your work. The constant appraisal of your work is important. Even when things are going well it is easy to settle for a stereotyped way of working, whereas the ideal in drawing from observation would be to approach each subject in an absolutely objective way and work out the appropriate means for translating what you have analysed as being significant. I stress that this is the ideal, and it is sometimes necessary to compel yourself to take a new approach. This can be achieved by new subject matter, new media or perhaps by a check on what your drawing contains. I have constantly stressed accuracy, not the soulless illustrative description of a subject but fidelity to an idea extracted from the subject after detailed observation and analysis. Supposing you try to make a drawing of an object and then to reconstruct the object from your drawing. It may be easy if you take a simple geometric form. You can actually measure the object and make plan and elevation drawings for your reconstruction, but try and model with clay or plasticine a stone or an animal or a portrait head from a series of drawings made from observation and see just how much information (or how little, as the case may be) your drawing really contains. The idea of using the drawing as a basis for a reconstruction of the object is one which can be very helpful in assessing for yourself exactly how great an understanding of

form your drawings contain. Drawings of mechanical objects can be very revealing. Try starting with something fairly simple but which has an easily distinguishable function – a pair of scissors, for example. In order to make a convincing drawing of them you will have to analyse their function, to see exactly how the blades come together and precisely how the handles and blades have been machined from the same piece of metal. Draw the object from several different points of view. Analyse whether the function of the scissors has been realized in the drawings. Could the blades be turned to meet in the same way as they do on the actual object? Are the blades pivoted in the same way as on the object? You could make a series of drawings from the same viewpoint with the scissors positioned with the blades coming closer and closer together. This analysis of the object is important to all drawing, but the problem of analysis is best revealed in objects with a clear function where it is possible to see whether one part does fit in another or whether some other function could be carried out by the object as realized on the paper. Quite simple tools can be used as objects and also things that can be easily taken apart. An electric light plug is an example where the parts can be separated and a drawing made in which the primary consideration is whether these parts can be fitted together in the terms of the drawing. This study can be extended into more complex objects such as bicycles, motors or spare parts and all kinds of industrial and technological subjects.

Another way of approaching drawing is by trying to analyse the form of the drawing not by eye but by touch. This, I suppose, can hardly be called drawing from observation but it is, nevertheless, an important study in considering both the analysis and the visual appearance of form. Obviously it can only be attempted with relatively small objects, but you can put a stone, for example, in a bag made of some thin opaque material and, by putting one hand on the object and using the other hand for drawing, you can translate what you actually feel the object to be into a three-dimensional representation on the paper. This can be checked against observation once the drawing is as complete as you can make it. Natural forms are best for this kind of exercise and they must be relatively hard to the touch.

Drawing from memory compels a degree of analysis which is worth mentioning here. As I have said previously all drawing is, to some extent, memory drawing, but if you deliberately observe something for a limited period of perhaps five to ten minutes with a view to producing a drawing without reference to the object, you not only have to retain a number of images in your mind but to sort them out into categories of relative importance. When the drawing is carried out the

absence of objects removes the possibility of arbitrary copying of areas of light and shade, for example, but it makes for great problems in setting up the tonal aspects of the study. Drawing from memory is a skill that can be taught and which has been used as an observational discipline in the curriculum of art schools in the past. Until comparatively recently it was considered an essential part of an art student's education. Providing that the study is carried out with the definite aim of disciplining your observation into some order, so that the information can be stored and then drawn on at a later date, it can only assist in developing your drawing ability. The danger, however, and one reason why memory drawing is no longer generally taught, is that there is a tendency to base the drawing on general rather than specific memories. A student can often readily develop an ability to produce a convincing-looking picture that has little or no resemblance to the particular visual situation it is supposed to be describing, and while there are occasions when the ability to produce this kind of picture can be useful (for example, in the production of an illustration or in the realization of an architectural scheme), it has little to do with observation of the particular kind that I am concerned with in this book. Nevertheless, as with perspective, providing the aim is understood and the exercise is concerned with the development of your ability to analyse and translate your direct observation, this is another study worth pursuing.

I have several times touched on the problem of concentrating on what you see rather than on producing a picture which bears little relation to the particular subject being studied. I regard drawing as the primary visual research tool, and I have presented it in a context of enquiry not in one of picture-making or of the production of any other end product. The developing of visual awareness (possibly through other means in addition to drawing) is as important to the designer as to the artist, and it is equally important whether the artist creates end products which are figurative or abstract. It is, perhaps, stating the obvious to say that the artist and the designer, like everyone, have to learn to see as children, but they continue to develop the ability to see and analyse their observations far beyond the point where most people stop. This is no revolutionary statement; it is only like saying that everyone has to learn to walk and run but the person who plays games to a high level develops his running, balance and general physical fitness to a point far exceeding that of the average person. In developing your ability to see and understand various visual situations you produce a storehouse of ideas that can be used in countless different ways, and essential to the seeing is a recording process, a way of documenting in some form what

you have observed. The most direct and flexible system is by using the drawing media.

To return to the point about drawing the particular rather than the general, this is not only a danger if you work from memory or if you are putting into operation a space-creating system like perspective. The danger is always there, and as the concentration demanded for real analytical observation is great, it is not difficult for casualness to take over and an easy result to be aimed at. What is required is the combination of visual analysis, checking and rechecking of the drawing, and the use of trial and error as well as intuition that I have described. Sometimes, the generalizations that appear in drawings can be quite alarming and there are particular instances (drawing from the human figure is one) where students seem incapable of working from their own observation but persistently take images from second-hand sources. It is usually a process of subconsciously recalling other artists' drawings and extracting from these certain elements that they admire. As you discover more about other artists' work it is likely that you will pick up from them certain features that will then appear in your own work, and it can indeed be very instructive to copy drawings to discover how a particular part has been carried out. It is important to make these features, taken from various sources, of service to your vision and ideas and not to use them merely as mannerisms.

This chapter has been concerned mainly with indicating subjects and approaches that will make it possible to check your progress accurately, or at least as far as observational accuracy is concerned. There are several ways in which the tendency to make generalizations can be overcome: firstly, by tackling particular drawing problems; secondly, by drawing from objects placed in unusual contexts; and thirdly, by finding completely new subjects. I have dealt so far with particular drawing problems and this limiting factor has been, in part, intended to focus your attention on the particular rather than the general. The difficulty with this is that there is a tendency for students to want to shake off restrictions, and I have indicated developments of these basic drawing problems where the same study can be extended to subjects with a greater possibility of student involvement than in some of the simple (but vital) basic drawing exercises. The placing of objects in unusual situations (fig. 242) is very good for stimulating observational interest. When you look across the group of objects you are not certain what to expect next, and you can discover unusual relationships between the objects. This provokes a keenness that can become dulled by continually making drawings where the objects seem entirely predictable. If you want proof of how you are compelled to observe with a new

awareness an object presented in an unfamiliar way, try making a drawing of a very commonplace object turned upside down. Try with a chair or a stool, for example, and you will find almost invariably that it is very different from drawing it in a conventional position with the legs projecting down to the floor. Upside down it is supported in a different way. It has a completely different appearance and when you try to draw it, it seems very different from the chair you could have drawn in a conventional position. You may decide that an object can be presented in an unfamiliar way by camouflaging it with the form of illumination used, or you may, perhaps, change the colours

Generally this means drawing either subjects not associated with art (although this becomes increasingly difficult) or bringing together objects not usually related. Some interesting effects can be observed in plastic materials (fig. 243), and still-life groups can be made in exactly the same way as one might set up apples and jugs by using, for example, boxes and strips of plastic tape (fig. 244). Often groups of this kind are arrived at accidentally, as are many of the best still-life groups. Setting up groups of objects for study can be a frustrating business. You can arrange and re-arrange a series of objects over and over again without arriving at an interesting arrange-

Fig. 242. Large posters used to create an unusual studio situation.

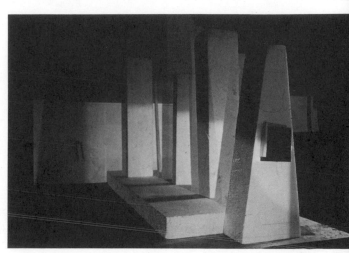

Fig. 243. A study group using large pieces of expanded polystyrene.

of the individual objects in a group to a single colour. This alters one of the ways of differentiating between objects – leaving only the individual forms and their relationships in space as definite aspects that can be observed. You could produce a subject without colour differences by setting up a group and spraying it a single colour with an aerosol can of paint. An alternative would be to paint a group of objects and a setting separately and then assemble them. It is surprising how your approach can change when even a slight variation is made in the appearance of a familiar object – bottles normally seen as shiny and reflective with matt paint.

If you can find new subject matter, this should enable you to approach it without preconceived ideas as to what a drawing of it should look like.

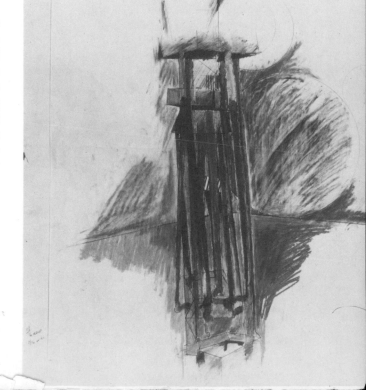

Fig. 244. *Boxes and tapes.* Student drawing.

Fig. 245.

Fig. 246.

ment and then find an absorbing problem created by some objects which have been accidentally thrown down in a corner. The group in the study illustrated started from an interest in the stripes that could be obtained by using rolls of tape. Then various ways of suspending the tapes were explored and the resulting forms drawn. There are innumerable examples of new subject matter that you can use, for instance, fig. 246 shows plastic bags filled with coloured liquid. The suspended forms make a new kind of three-dimensional object and the transparency of them provides an additional problem. These liquid-filled bags can give a wide range of different problems if they are placed on different kinds of surfaces. Fig. 245 shows the bags on a crinkled metal foil surface. The metal foil gives a number of small, highly reflective surfaces and the plastic bags have completely different forms when resting on a surface from those produced when they are suspended.

This chapter has dealt with the ways in which you can check accuracy in your drawing and the ways in which you can stimulate an interest in subject matter which is, to some extent, removed from the associations of other drawings. There are, however, different ways in which the sense of an object can be conveyed. The drawing may

be based on observation but not be, strictly speaking, realistic. In the introduction I said that maps, for example, were drawings which gave a great deal of precise information about a landscape. This information is gained mainly by measurement which, inevitably, involves observation, but is not a view from one point nor illusionary like most of the drawings you have considered. There are drawings, however, that have an illusionary quality and are based on observation but are not really realistic. Caricatures are a good example of this kind of drawing. They give, at best, an instantly recognizable symbol for a person but do not look like portraits (figs. 247–9). The illusion of reality is there and the head gives the impression of having a third dimension. It has not, however, been achieved by a disciplined study of the figure but by assembling a number of significant, perhaps obvious, features and by presenting these in an exaggerated way. Drawings of this kind are generally made from memory, but they are based on observation and their main feature is the way they distort what is observed in order to make their point. Caricatures are outside the scope of this book as they are only marginally concerned with space and form. They attempt to produce an instantly recognizable image and to this end the formal qualities of draw-

Fig. 247. *The Kaiser Wilhelm II* (photograph) (Radio Times Hulton Picture Library).

Fig. 248. *The Kaiser Wilhelm II* by Max Koner (Radio Times Hulton Picture Library).

JANUARY: I LAND AT DOVER.

Fig. 249. *The Kaiser Wilhelm II* – cartoon – January: I land at Dover (Radio Times Hulton Picture Library).

ing are sacrificed. The ingredients of distortion and simplification which they contain are elements which can help to convey the sense of an object because distortion, if used carefully, can be an adept way of emphasizing something, and simplification can become diagrammatic and explanatory and enable you to understand another aspect of the object (figs. 250–1). Distortion is also mentioned in Chapter 9 where I explained the way contours can be distorted to give an illusion of the particular forms they contained. In the same way, relative sizes of things can be distorted and special features may be accentuated because you consider them significant. Drawing is a language which you can use as a basis for recording all kinds of visual phenomena, but this language can be adapted in various ways and a degree of distortion and simplification is quite permissible. Diagrammatic representation (figs. 252–3) exists in various forms and the dividing line between it and straightforward diagrams can be difficult to place. An explanatory element in drawing is not unusual, but it is possible to push this to a degree which produces a result which does not allow the brain to compose a realistic image but explains the image in semi-mechanical terms. Probably this feature is most prevalent in sculptors' drawings, where the drawing is often seen as a step towards a further piece of work to be made in a three-dimensional material. In a sense this approach involves both distortion as well as explanation. It can become, at worst, mannered, so that the forms are based on preconceived ideas which are reproduced over and over again without reference to observation. Distortion, diagrams and simplification can lead to developing a type of shorthand for drawing that can be useful in recording information. There will be occasions when you need to produce rapidly notes which can perhaps be made use of again when the object is no longer accessible, or you may wish to record some changing circumstance that is to feature eventually in a more extended drawing.

The latter half of this chapter is concerned with developments in drawing that are arrived at more by practice and experience than by conscious effort. It would be wrong to try to force some personal development of visual language, but it could be useful to attempt diagrammatic representations and to try distorting elements in your drawings. A starting point for diagrammatic drawings would be to take a rounded form – the human figure would be a complex example but an apple or similar form would be equally appropriate – and translate this into a drawing which simplified the curving forms into a series of clearly defined planes. As far as distortions are concerned, the attempts would be on a trial and error basis, but you could take a particular subject which could

142

Fig. 250. Natural forms study. Student drawing.

Fig. 251. Natural forms study. Student drawing.

be used for a whole series of drawings and then make comparative studies which emphasized and otherwise distorted carefully chosen elements. I would suggest here that you refer back to Chapter 9, where curved forms were used as subject matter, and that a subject like the group of eggs used there might make an appropriate starting

Fig. 252. Grass study. Student drawing.

point for these experimental drawings. In discussing distortion I have implied that the means used would essentially be linear. I have mentioned distorting contours, but tonal emphasis could be used to translate any observation that expresses a particular aspect of the subject.

Fig. 253. Plant study. Student drawing.

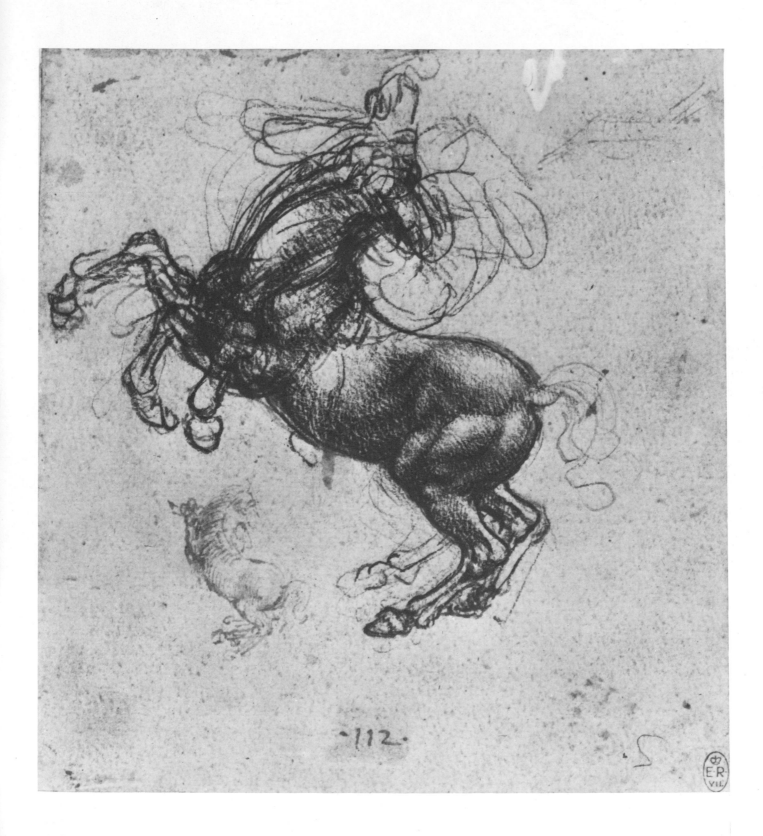

144

# 15 MOVEMENT

Fig. 255. *Dancing Figure* by Allen Jones (Victoria & Albert Museum, Crown Copyright).

Perhaps the most significant feature of the visual world is that it is not static. We ourselves move our eyes and bodies constantly and the world is full of natural and man-made objects that move all the time. I have mentioned the effects of changing light in Chapter 13 and as well as the movement of people and vehicles, for example, there are movements of elements like water and sky to be considered. Drawing, however, is not a particularly suitable medium for recording movement. It is arguable that it has advantages over painting and sculpture but the history of art shows only two occasions when the expression of movement has been of the greatest significance, during the period 1900-1915 by the Futurists and in the 1960s by kinetic and pop artists.

There have always been drawings made from moving objects but the aim has been to make a static record of them rather than one showing them in motion. It has generally been accepted that the illusion of movement that can be achieved in drawing is slight and the emphasis has been on isolating and recording a moment in time. In many cases this has proved extremely difficult, as the eye is unable to seize and preserve one point in an extremely complex movement and much of the development and interest in this area has taken place since the invention of photography when it became possible for aspects of movement to be identified and isolated. In this century much of the study of movement has been with the help of photography. The famous picture *Nude Descending a Staircase* by Duchamp is based on photographs, and it is difficult to say with any degree of certainty how much drawings of

Fig. 254. *Rearing Horse* by Leonardo da Vinci. (Reproduced by Gracious Permission of H.M. Queen Elizabeth II).

this century, at any rate those concerning movement, have been influenced by, if not directly based on, photographs rather than direct observation. In spite of the limitations of drawing artists have produced effective translations and illusions of movement (figs. 254–5) and this chapter considers ways in which drawings from direct observation of movement can be made. You will be aware by now that lines, dots, in fact every mark you make on the paper has a kind of visual energy, and it is not difficult to see that the means of producing limited illusions of movement of various kinds is freely available. The eye readily follows strong linear directions and this can give the line the attribute of movement. The pursuit of movement in drawing is, therefore, basically going to employ a linear system of recording, and it is necessary to take into consideration the actual speed of recording as well as the speed of movement of the subject. The gestures made by the artist's hand as it describes the movement and tries to come to grips with the moving image are important in producing lines or other marks which are attempts to capture the elusive quality of a moving object.

I have indicated that while the subject matter might be examined from several different points of view, this would lead to a drawing from a single observation point although I discussed in Chapter 11 drawing with some movement of the head and, thus, slight changes in viewpoint. Generally, though, the assumption has been that you would be positioned in one place and draw from direct observation an object or number of objects that were stationary. The only aspect of movement that has been considered is that of the light source (Chapter 13).

Now, firstly, I want you to consider the moving spectator rather than the moving object. It is poss-

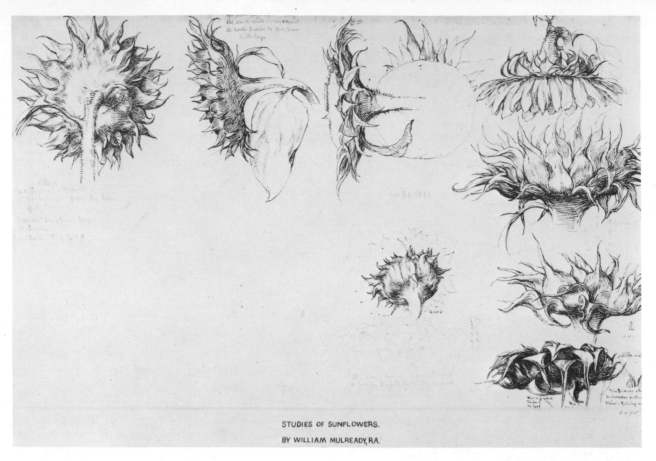

STUDIES OF SUNFLOWERS.
BY WILLIAM MULREADY, R.A.

Fig. 256. *Sunflowers* by William Mulready (Victoria & Albert Museum, Crown Copyright).

Fig. 257. *Dora Maar Seated* by Picasso (Tate Gallery, London © by S.P.A.D.E.M., Paris 1972).

ible to make a series of drawings of objects from different viewpoints as in fig. 256 and, put alongside each other, they give an accumulative experience of the object. It is also possible to give two completely different viewpoints in the same drawing (fig. 257), although this approach has to be limited to specific forms with clear distinguishing features in order to make its effect. As a first approach to the subject of movement consider the static object and the moving spectator and see if you can find ways in which to convey several views of the object in either a series of separate drawings or in a single assembly of drawings.

The problem becomes more complex when the observer is still and the object moves because the main problem is that the movement is outside the observer's control. When you make a series of drawings of the same object you are only making several still drawings and you can refer back to any position at any time. When the object moves, although the movement might be to some extent repetitive, you are unable to refer back to a previous movement and have to rely on your memory. Equally, you have to be able to analyse the movement, which can be extremely difficult (fig. 258), and determine the significant aspects which will enable you to convey an illusion of motion. Here you reach another problem. Supposing you can identify the way a particular object moves, how can this be translated into drawing?

146

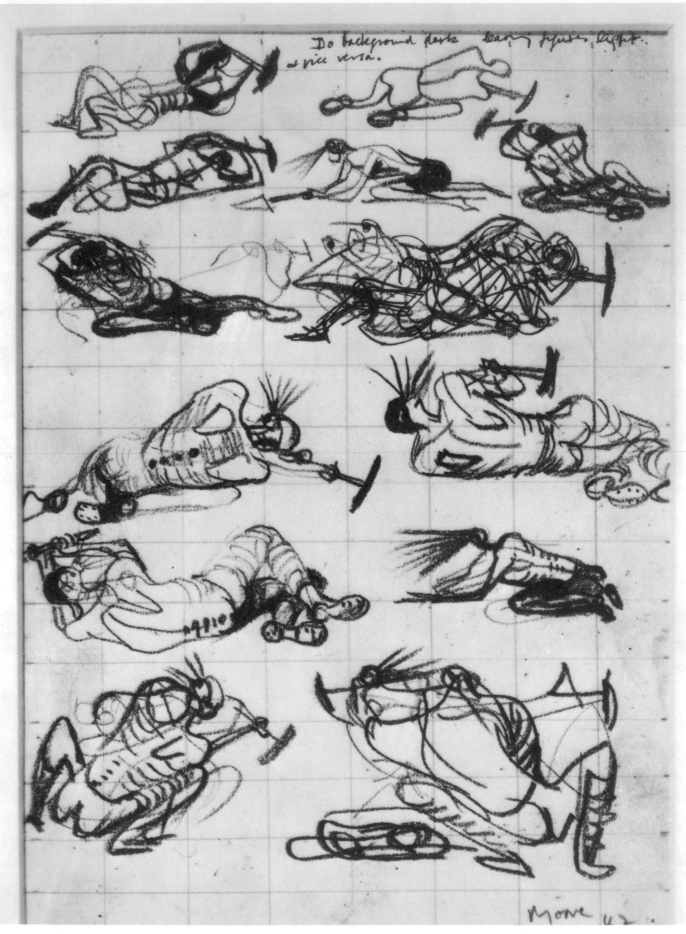

Fig. 258. *Miners at Coal Face* by Henry Moore (Victoria & Albert Museum, Crown Copyright).

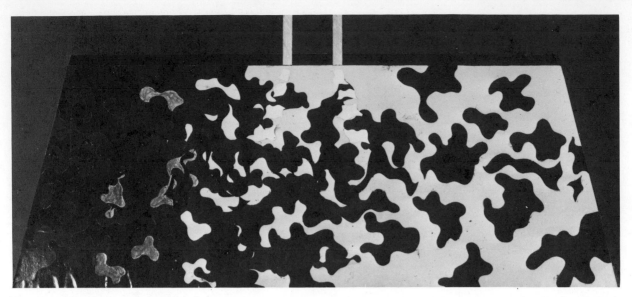

Fig. 260. Water studies. Student drawing.

Fig. 259. *Swimming Pool*. Student drawing.

Drawing is certainly capable of blurred images, but is movement an indistinct image, or a series of superimposed distinct images, or can the illusion be considered in some completely different way? The camera is a very useful instrument for recording arrested movement. The moving object is seen clearly at a split second in time and the background is often blurred where the camera has been moved to follow the movement of the object. Drawing offers more flexible solutions to the problem of translating movement, but it leaves the observer with the tremendous difficulty of observing and analysing a precise moment in time.

Examine, first of all, the problem of observing movement and then go on to consider how you can translate this experience into drawing. There are basically two different kinds of movement that you will have to analyse: firstly, the obvious large physical movements of an object or, more usually, an animal or human being; and secondly, movement or tensions contained in what are essentially static forms. There is, of course, a vast range of such subjects in the visual world, ranging from moving vehicles and figures to the movement of clouds and water. A good place to start in trying to identify physical movement is to take a situation like an area of water with considerable movement, perhaps a busy stretch of river or a section of coastline with the sea breaking over an obstacle of some kind. Alternatively, a running tap is a possibility. Try to analyse and translate the movement of the water into drawing. These subjects all have the advantage of offering a particular movement repeated over and over again in a similar, if not precisely identical, way and they are thus easier to observe than something passing and disappearing from sight. You can then try to freeze a particularly typical movement (figs. 259–60) or try to draw a whole series of different

Fig. 261. Student studies.

Fig. 262. *Fall* by Bridget Riley (Tate Gallery, London).

movements in the same study. Drawing can achieve an illusion of movement which is largely the result of spatial ambiguity (figs. 261–2). These kinetic effects compel a person looking at the drawing to change continually his idea of where a particular point is in space, and this can create an effect similar to that made by observing an object in motion. The same difficulty in saying precisely where something is at any one time is there in both instances.

There have been various attempts to create the effect of movement in drawings. The imagery of a strip cartoon drawing is one example (not, of course, drawings from direct observation) (fig. 263), where movement lines imply that the object has moved from a previous position to its present one. There are also devices like the disjointed images of the Futurists (figs. 264–6) and kinetic effects created by cutting a picture into strips and then separating them, which creates a lateral rather than a spatial movement. The movement of the eye across the spaces between the sections of the picture creates an illusion of movement across the picture surface. This device is related to the effect created by flicking through a series of pictures each showing the subject in a slightly different position (fig. 265).

I have referred to multi-line drawings in which, in the search for the object's contours, a number of lines are drawn near to each other, and I advocated that all attempts at defining the contours should be left and not erased. It is interesting to note (fig. 268) that in a drawing of this kind, while a perfectly acceptable illusion may be conveyed of the precise form of a leg, for example, it is impossible to define which line produces the contour. Elimination on any of the lines appears to destroy the illusion and somehow precision is created by the very vagueness of the

Fig. 263. Drawing from *Varoomshka* by John Kent.

Fig. 264. *Dynamism of a Horse* by Boccioni (Private Collection, Italy).

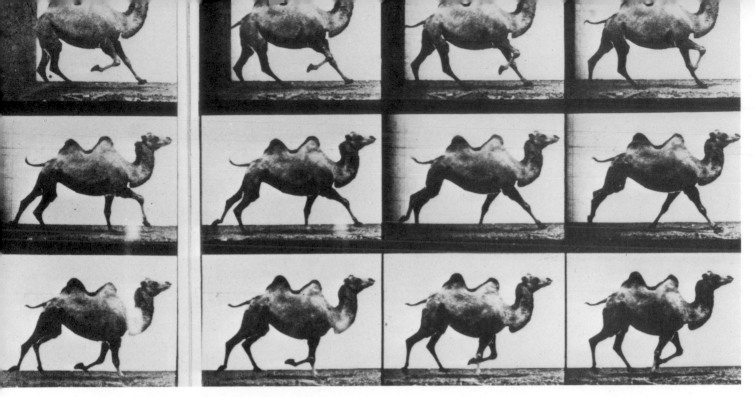

Fig. 265. Pictures from Muybridge's *Animals in Motion*.

Fig. 266. *Suburban Train Arriving at Paris* by Severini (Tate Gallery, London. Rights reserved A.D.A.G.P., Paris 1972).

Fig. 267. *Reclining Nude* (I.S.).

Fig. 268. *Whippet* by Augustus John (Cooper Art Gallery, Barnsley).

drawing. Your eye decides on a contour which is not described by any one line in the drawing and in doing so it also seems to imply that the form is subject to movement – that the artist moved slightly, that the subject moved too, and that these statements are a series of attempts at fixing something which is never static.

This leads to a consideration of the movements and tensions which are contained in forms, particularly natural forms. I mentioned tensions in Chapter 9 and the movement and tensions existing in forms can be clearly seen by comparing, say, an animal preserved in a natural history museum and the same animal, no matter how still it is standing, in a zoo. A living creature has a kind of inner vitality which implies movement and strength and the forms which go to make up an animal or human figure have to be considered and analysed in such a way that these tensions can be expressed. This can be achieved by the precise positioning of points of articulation and the contrasting and stressing of taut and relaxed forms (figs. 267–70). Movements and tensions can be analysed into rhythms. These are particular relationships of both contours and forms which, when you are looking at the subject, are features that lead your eyes round and across the subject and make it more than just a static object. These rhythms can be used in drawing not only to give an impression of the strength and vitality that an individial form possesses, but also the rhythms generated by forms in movement can be used in drawing to convey a total sense of movement. Fig. 271 shows how the swirling motions of these figures have, by carefully selected flowing rhythms, been translated into a drawing which gives a remarkable illusion of dynamic forces. As

well as the dramatic movements of figures in conflict or at work, there are in plants, trees, rocks and other natural forms equally dramatic qualities of movement and rhythm which are all important (figs. 272–4).

As far as 'capturing a split second in time' is concerned, the camera has a great advantage over the artist and the introduction of photography

Fig. 269. *Reclining Nude* (I.S.).

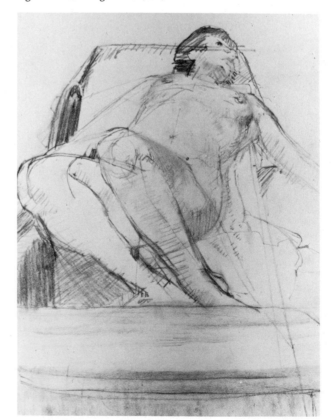

Fig. 270. *An Elk* by Dürer (Trustees of the British Museum).

Fig. 271. *Study for Returning to the Trenches* by Nevinson (Tate Gallery, London).

153

showed how facts that had previously been accepted were proved to be wrong once the camera could be used to check precisely what happened when movement occurred. There are many kinds of movement that a camera can record which are far outside the scope of the human eye, but the camera does not have the selectivity or versatility of the human eye and drawing, in spite of limitations in this respect, can still produce quite impressive illusions of movement. This is just as well, because unless you restrict yourself to a very narrow range of subjects, the difficult problem of movement is one you will often have to confront.

I have already suggested drawing water movement and from this you should go on to examine groups of trees and shrubs where the rhythms and much smaller physical movements can be identified. From there it is very much up to you. Drawings could be made of domestic animals and birds – goldfish make an interesting subject – or there is subject matter in zoos or at a dancing school (figs. 275–6). Dancing rehearsals are useful because the same movements are repeated and

Fig. 272. *The Deluge* by Leonardo da Vinci (Reproduced by Gracious Permission of H.M. Queen Elizabeth II).

they offer a greater possibility of identification of particular aspects of movement. It can be interesting (and difficult) to make studies of a very ordinary domestic task (ironing, for example) where, again, the same kinds of movements are repeated over and over again. For many people the human figure offers probably the most interesting movement problems. The figure itself contains the tensions and dynamics that I have already discussed, and some preliminary studies could be carried out by having a model perform a very simple action in a limited area of space. For example, to stand for about a minute on one spot (marked) and then to walk slowly a few feet to a low box and sit down on it. This movement could be repeated and the student draw both the starting point of the movement and the box which is involved in the completion of it. The drawing could include not only the start and finish but also several studies of actions in between. You would then be producing a series of drawing which would have to be worked on in order and continued as each successive movement is followed, identified and analysed.

Fig. 273. *Coastline* by John Minton.

Fig. 274. *A Study of Rocks* by Dürer (Trustees of the British Museum).

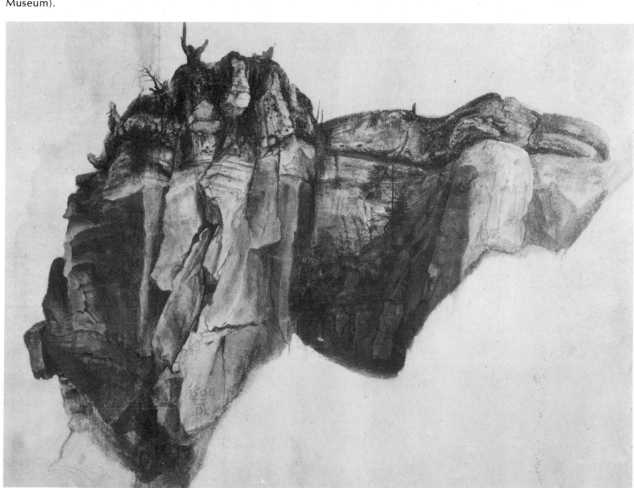

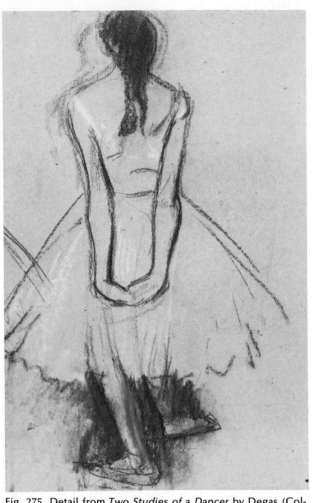

Much of the drawing of physical movement is, inevitably, drawing from memory but, as I have pointed out previously, all observational drawing is to some degree drawing from memory. It is only that in movement drawing more information has to be retained and the time gap between observing and drawing is longer than in drawing a group of still-life objects in the studio.

Fig. 276. *Study of Two Dancers* by Degas (Arts Council of Great Britain).

Fig. 275. Detail from *Two Studies of a Dancer* by Degas (Collection of Sir Max Rayne).

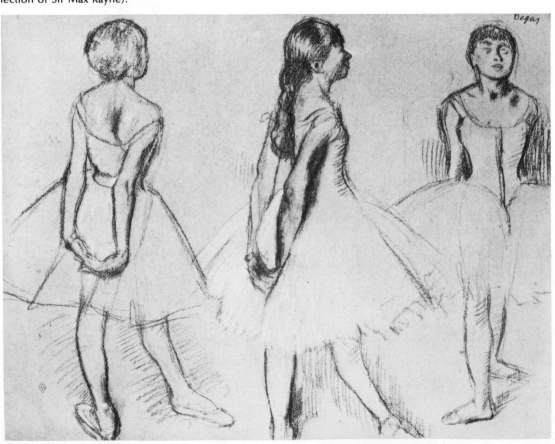

# 16 DEVELOPING A PERSONAL LANGUAGE

If you look at figs. 277 and 278 there is no mistaking the artists who made these particular drawings. Each has developed a distinctive way of using the language of drawing. This personal language is developed over a period of time and cannot be produced without a great deal of experience and practice in both looking and drawing. Fluency and the ability to co-ordinate quickly eye, brain and hand come from practice and it is essen-

Fig. 278. *Mont Sainte Victoire* by Cézanne (Tate Gallery, London).

Fig. 277. *Caroline, 1965* by Giacometti (Tate Gallery, London. Rights reserved A.D.A.G.P. Paris 1972).

tial to draw constantly and from as varied subject matter as possible. I have frequently warned against the dangers of mannerism, and there are also the dangers of developing a superficial slickness that makes all forms look similar and produces, at first glance, reasonable but too generalized statements. The only way to guard against these difficulties is to retain the basic concept of drawing that I have underlined in every chapter, that of observation, analysis and translation. Added to this is the search for the particular elements in the subject that make it unique, discovering something not seen at first sight or demonstrating the extraordinary in the ordinary. The part played by the eye and the brain in this complex combination of abilities is the most important, but this is not to be taken as an argument supporting the theory that visual awareness and sensitivity can be acquired by just going around with your eyes wide open. There are, I am sure, exceptional people who have acquired a visual sensibility by some not readily identifiable means, but in general your ability to see can only be checked against your ability to translate and communicate visual information.

It is, of course, debatable whether this information has to be communicated only to yourself or to other people. There have been many developments in visual language that were ahead of their time and eventually readily comprehended, but it is essential to make sure that

Fig. 280. *Drawing of Dartmouth Road Studio, Autumn 1956* by John Bratby (Tate Gallery, London).

Fig. 279. *Lower Thames Street* (I.S.).

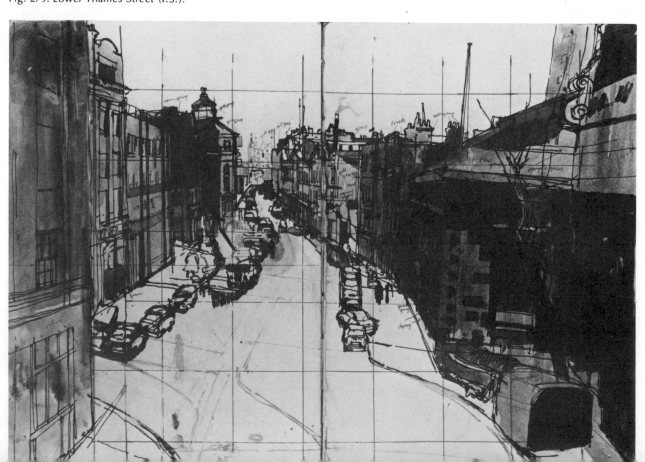

that you are critical of their results. Emotion, accident, in fact everything should be exploited, but it is necessary to stand aside periodically and examine what has appeared on the paper. It is easy at this point to try to justify what you have drawn. 'I must have felt something like that or I wouldn't have drawn it in that way' is a frequent cry. Of course there have been great drawings in which this intense emotion has been everything and the truth to observation secondary, but this is moving to the fringe areas of drawing from direct observation and, in my opinion, is dangerous ground for students. Accident is quite a different matter. You should always be prepared to exploit effects that are achieved accidentally, and part of the purpose of developing an actual visual awareness is not only so that you are aware of what is out there in front of you in the visual world but also so that you look hard at your drawing as it develops, directing it and being prepared in some instances to let it direct you. As soon as you begin to draw, a complex chain of events commences and while the aim is to remain in control, it is not unusual to be pleased by some aspect of a drawing that has been arrived at by no way that you could adequately explain. Often you look back on work produced and wonder how on earth it ever happened. This is not to say that you consider it to be particularly good or bad, but that there are elements in it that you cannot imagine yourself having done.

Fig. 281. *Head and Shoulders of a Girl* by Emilio Greco (Tate Gallery, London).

your drawing means something very precise to you although it apparently means nothing to other people. I would expect developments of this kind not to come until long after the lessons of this book had been thoroughly explored and digested.

The part played by the hand in developing a personal language is also important and just as I have stressed the need for the widest possible range of subject matter, it is equally important to use the complete range of drawing media. You should experiment with the different media and be prepared to use a range of them in any one study. There is no particular virtue in using the same medium throughout the drawing, although the combination of the various media has to be carried out sensitively and with consideration particularly with regard to the tonal range that each is capable of making. Pencil, for example, generally extends only over a grey range of tones. Ink (unless diluted) operates as black only.

There is a danger in discussing the development of a personal approach to drawing of over-simplifying and suggesting that there is a logical conscious progression from the first marks made in learning to draw to the eventual personal use of language. In teaching (and in an instructional book) the emphasis must be on the logical and rational. It is difficult, if not impossible, to teach the illogical or the irrational, but these qualities are important and must be encouraged providing

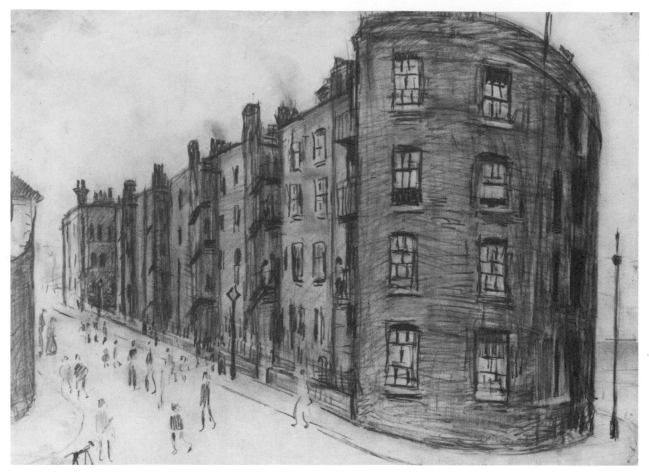

Fig. 286. *Study for Dwellings, Ordsall Lane, Salford* by L. S. Lowry (Tate Gallery, London).

you can say about the particular idea that you have been developing, but you can always start again and explore a different line of study.

The fact that drawing can be primarily considered as a training ground, a preliminary study area or a step on the way to something else, puts it in danger of being considered as something which only beginners do and which can be discarded at the earliest possible moment for the real stuff of painting, three-dimensional work, design or whatever. There are good reasons for believing that the output of 'finished objects' depends in terms of quality on the standard of the research, and while this may be obvious where the work is concerned with the visual appearance of people and things, it is less obvious where the finished object is abstract or, in the case of design, functional. It is also highly probable that our response to abstract and functional forms is conditioned by the extent to which we have been involved with the external visual world. Our reactions gained by experiencing space sensuously, by measuring it and recreating it, and our contact with laws governing appearances in the real world determine our attitudes, and I have come to the conclusion that only someone who has been deeply involved in the space and forms of the

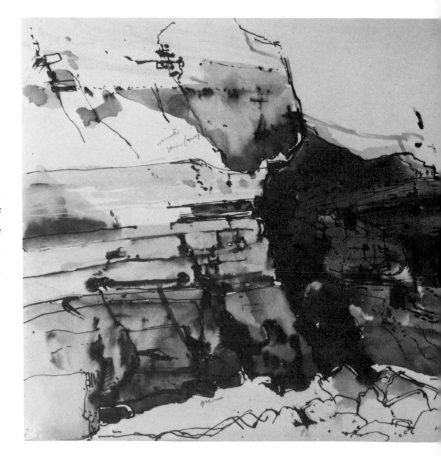

162

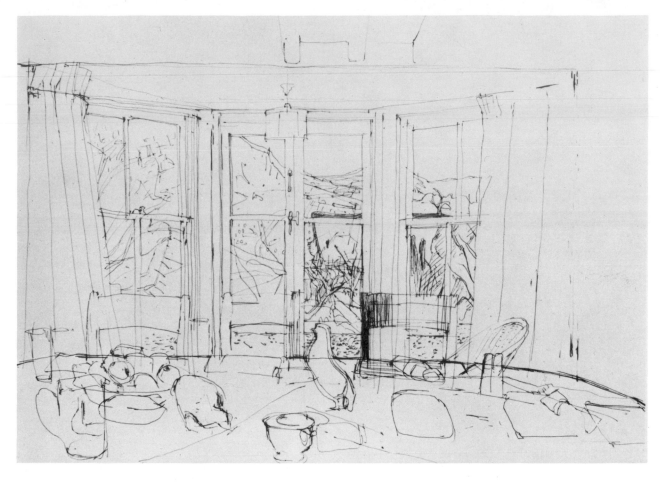

Fig. 288. *A View Through a Window* (I.S.).

external visual world can hope to produce either meaningful non-figurative work or design which will in any way enhance our environment. To whatever end your drawing is intended, if you have got as far as this, keep going and never allow the production of the end product to persuade you that this research element is unnecessary.

Fig. 287. *Studies of Cliffs* (I.S.).

# 17 SUMMARY

This book has taken you through a systematic investigation of the basic elements of the visual world that can be readily isolated, observed and translated into drawing. It is based on the belief that this procedure will give you the means by which you can confidently approach any drawing problem. This summary is intended as a reminder of the overall aims and construction of the book.

The first chapters were concerned with defining the kind of drawing that the book would deal with, that is, drawing directly from observation, and then with explaining the nature of seeing and the way in which your observations could be translated into drawing. After information on drawing materials, the practical chapters began by examining, first of all, two dimensions, height and width. I then went on to examine the third dimensions, depth, in relation to two basic geometric forms, the cube and the cylinder. These two forms were chosen as they underlie a wide range of objects, and their relationship to a variety of objects in the visual world was indicated. From the study of geometric forms I moved to considering natural forms and with the more complex forms came more complex uses of the means of translation, which up to this point, had been line only. Next, forms with curved surfaces were studied and with them the use of tone, as a means of describing form, was introduced. This covered the basic forms which underlie all forms in the visual world, the cube, the cylinder and the sphere, and the sphere was related, in particular, to the human figure.

Chapter 11 was concerned with perspective and the relationship of this geometric system of space definition to actual observation. Surface qualities were then studied and, following this, more complex situations involving a detailed consideration of light and then the problems of movement. Finally, the development of a personal visual language was examined.

The whole gives an introduction to visual problems and, through them, to different areas of subject matter. The emphasis is on encouraging certain specific attitudes to drawing and not on demonstrating how to draw any particular object or area of subject matter.

The aims of the book can be stated very briefly. It is necessary to learn to see, and it is possible to draw what is observed. I believe most emphatically that the process of translating observation into drawing can be taught, and if you have followed me so far I should have proved my point. You may not have achieved startling results to date, but it is necessary to bear in mind that an artist's development is a process that occupies years, not months, weeks or days; and development is not steady and gradual but often goes in leaps and bounds interspersed with long static periods. This book gives you a basis on which to build. Where you go from here is very much in your hands.

# SELECT BIBLIOGRAPHY

Rudolph Arnheim. *Art and Visual Perception.* Faber, London, 1956.

Lecoq de Boisbaudran (translated by L. D. Luard). *The Training of the Memory in Art.* Macmillan & Co. Ltd., 1911.

Calvin Burnett. *Objective Drawing Techniques.* Reinhold, 1966.

Rex Vicat Cole. *Perspective.* Seeley, Service & Co. Ltd., 1941.

J. J. Gibson. *The Perception of the Visual World.* Allen & Unwin/Houghton Mifflin, 1950.

E. H. Gombrich. *Art and Illusion.* Phaidon, MCMLVII, 1957.

E. H. Gombrich. *The Story of Art.* Phaidon, 1960

R. L. Gregory. *Eye and Brain.* Weidenfeld and Nicolson, 1966.

R. L. Gregory. *The Intelligent Eye.* Weidenfeld and Nicolson, 1970.

H. F. Hollis. *Perspective Drawing.* English University Press, 1965.

Paul Klee. *The Thinking Eye.* Lund Humphries, 1961.

P. and L. Murray. *A Dictionary of Art and Artists.* Penguin, 1959

M. de Sausmarez. *Basic Design, The Dynamics of Visual Form.* Studio Vista, 1964.

D'arcy Wentworth Thompson. *On Growth and Form.* Cambridge University Press, 1942.

M. D. Vernon. *The Psychology of Perception.* Penguin, 1962.

Walters and Bromham. *Principles of Perspective.* Architectural Press, 1970.

White. *The Birth and Rebirth of Pictorial Space.* Faber & Faber, MCMLVII, 1957.

# INDEX